CONTEMPORARY ILLUSTRATION AND ITS CONTEXT

gestalten

The Art of Illustration?

On the Ambivalent Self-Image of Illustration *by Claudia Mareis*

"The basis of the profession, the very beginning of all these manual operations, is drawing and painting."........ *Cennino D'Andrea Cennini, Treatise ca. 1390[1]*

Is illustration an advanced artistic discipline, a skilled handiwork or a commercial service that has only little to do with art? However logical and illuminating an analysis of illustrative work may be, the debate surrounding the classification of the practice of illustration remains no less controversial and complex. The wide range of working methods and strategies of contemporary illustrators make classification all the more difficult. Graphic designers, for example, become known as illustrators, while artists produce illustrations for magazines on the side and illustrations are presented in exhibition spaces under the heading of "Art". The dividing line between the disciplines of art and design has become permeable—and probably always has been. Yet the self-image of contemporary illustration is a highly ambivalent one.

The following introduction will discuss several aspects of this situation and deal with selected points of the historically interwoven relationship between illustration and art[2]. Visually, *Illusive 2: Contemporary Illustration and its Context* presents a comprehensive range of contemporary styles and trends in illustration based on selected works. Since the publication of *Illusive*, international interest in illustration has continued to grow, as the widespread presence of illustrative works in the press (newspapers, magazines and periodicals), animated advertising campaigns and websites confirms. Recent exhibitions of illustrations also bear witness to the contemporary relevance of the genre—as well as to its self-proclaimed affinity with the art context.

The present volume explores these phenomena and provides a selection of the most exciting and innovative contemporary trends in illustration, while deliberately refusing to draw a line between commercial and artistic illustration. Instead, the resulting tensions should stimulate readers to rethink the current categories of art and design, and consider the self-image of contemporary illustration in all its ambivalence. Only thus can new and productive questions about art and design be formulated.

The selection of works in this publication makes no claim to be exhaustive, but intends to fulfil the aims stated above by introducing very different, but highly sophisticated positions. The collection of artwork is complemented by interviews with illustrators that provide interesting, and at times surprising glimpses into art and design methods, techniques and motivations, as well as the conditions of illustration work and its modern contexts.

Between Idea and Execution

Illustration and the fine arts have always been intimately connected, although the relationship between them varied greatly in different cultures and periods. A definition of illustration as a way of approaching objects by means of *drawing* and *sketching* quickly leads to weighty art-historical and theoretical discussions.

During the Renaissance and Early Baroque, the value of drawing was the subject of heated debate, provoking a veritable artistic competition (*paragone*) between the disciplines of architecture, sculpture and painting. The question at stake was determining whether drawings and sketches had an artistic value of their own, or whether they were mere preliminaries to the actual work of art or architecture. The term *disegno* (from which the term "design" was later derived) played a major role in these debates. The meaning of *disegno* does not correspond to the present-day notion of drawing, but included the dimension of the *mental concept*. The famous Italian art theorist Giorgio Vasari (1511–1547) proclaimed *disegno* the basic principle of all artistic endeavours. He described this principle as follows:

"DISEGNO… father of our three arts, architecture, sculpture, and painting, proceed[s] from the intellect, extracts from many things an universal judgment, like a form or an idea of all the things in nature, who is most specific in her measurements."[3] Subsequently, one may conclude that *disegno* means nothing less than a clear design and representation of the picture that one has in mind, which one imagines and creates as an idea[4]. More specifically, the sketches of the artist or plans of the architect bring complex conceptual ideas onto paper by means of simple, economic

lines: they are, in a manner of speaking, materialized figurations of the idea. Drawing has more than just an executive function (as in the merely mechanical translation of a finished idea onto paper), for the act of sketching or drawing itself generates knowledge. In turn, this knowledge can influence our imagination and modify, modulate or reshape the design during the process of drawing itself. Accordingly, in the act of drawing, as well as in the finished drawing, the intellectual activity of designing *and* the manual execution of these ideas are inextricably linked and subject to a reciprocal influence.

The interweaving of the mental idea and its manual execution, of thought and action, is also found on many levels in the practice of illustration. Firstly, specific art and design methods and techniques are not only preserved in illustration but continuously deepened, expanded and updated, making illustrators a sort of "living archive". With their experience, they guarantee the preservation of the illustration methods and techniques that have been handed down, while contributing to their further development and adaptation to new processes of production and reproduction. In particular, they also stimulate the transfer from manual to digital design methods and techniques.

For another thing, what is commonly called the concrete "craft" of illustration — the actual work, both manual and digital, employing the most varied drawing and painting utensils, the use of complex collage techniques, the experimentation with and revival of traditional printing processes, etc. — goes much further than the subsequent execution or application of an idea. The process of illustration produces an additional measure of knowledge that is not to be underestimated. In the same way that thoughts and ideas are constantly modified and refined in the act of speaking or writing — where they may even be articulated fully for the first time — something new is also generated in the act of drawing. Illustrations do not merely translate "prefabricated" ideas into pictorial form; the idea *itself* finds its final form in the process of illustration and visualization. Seen in this light, illustrations are neither accompaniments, nor complements, but an integral part of the process of visualising thoughts and ideas — thus contributing to our understanding of the text and the image.

The Art of Illustration

As we have seen, the relationship between illustration and art is not a new phenomenon. On the contrary, historically speaking, the border between independent artistic production and commercial illustration was frequently blurred. The ongoing specialization of art and design practices in art, illustration and graphic design was established only during the course of the 20th century as a result of increasing professionalisation.

Still at the end of the 19th century, for example, poster-design was an art form in its own right. In France especially, its character was strongly marked by the fine arts. Works of art were sometimes directly transposed into poster form; posters were exhibited as works of art and designers deliberately used a painterly style. Artists like Jules Chéret (1836–1932), Henri Toulouse-Lautrec (1864–1901) and Pierre Bonnard (1867–1947) combined their painted compositions with text on posters[5]. In 1921, in a publication titled *The Art of Illustration*[6], the English illustrator Edmund J. Sullivan (1869–1933) presented the range of this genre in his day. He included important examples of illustration from the past, as well as individual artistic positions, rounding off his anthology with chapters about the methods, techniques and theory of illustration[7].

The connection between illustration and art described here can be historically situated within the context of the trade reforms initiated in the middle of the 19th century, specifically in the Art Nouveau and Jugendstil schools, as well as in the "Arts and Crafts" movement in England. In searching for new forms of artistic expression, these reform movements were reacting to the upheavals caused by the spread of industrialization. Accordingly, new means of manual and artistic production were developed to counterbalance industrial mass-production. Referring to the example

of working methods in the Middle Ages, William Morris, the founder of the "Arts and Crafts" movement, strove to achieve a closer cooperation between the fine arts and the crafts. He considered the former a "purely manual matter"[8] and stressed instead the importance of *craftwork*. Book and literary illustration in particular achieved a high level of quality at this time.

So much for history. Now what are suitable criteria to distinguish between illustration and art in our day? Polemically phrased: what makes illustration art today?

A number of exhibitions featuring illustration seem to have found an answer. The illustrations presented there are explicitly proclaimed to be art; thus, it is not the work of graphic designers or illustrators that is being exhibited, but the *work of artists*—at least according to the promotional jargon. The criteria for selection vary from event to event, but often adhere to a very traditional understanding of art. This can be couched in terms of finding the "artists among the artisans", or of showing illustrators who "have found an individual, distinctive handwriting despite commercial pressures and the variety of jobs."[9] Following this rationale, the criteria to distinguish artistic illustration from "profane handicraft" would be simple: the originality of expression in terms of design and its resistance to commercial "appropriation". In other words, for illustration to become art, it has to be as original and remote from everyday life as possible, a stance known as *L'art pour l'art*: purely aestheticized art, devoid of intention or utility. It remains to be seen whether this "promotional strategy" for illustration will succeed. This line of argument clearly shows the ambivalence that colours the self-image of contemporary illustration, as well as the danger of comparing art and illustration on the basis of outmoded clichés. Not only do some of the illustration-as-art exhibitions fall short of the fine arts on the formal-aesthetic plane, but their engagement with issues relevant to art is rather wanting. Considering the fact that distinctions between high culture and popular culture have become practically obsolete, the question also remains whether the criterion of originality in art has lost its pertinence, not to mention whether the distinction between art and craft is still topical. Last but not least: is an illustration art simply because it was not motivated by commercial demand? Are the fine arts not subject to enormous commercial pressure themselves and are they not equally obliged to hold their own in the case of certain commissions?

On Contexts and Playing Fields

The issue of what separates and what unites art and illustration raises far-reaching questions that, unfortunately, cannot be addressed here. However, this much has become clear: in order to make a differentiated statement about the relationship between art and illustration, one cannot avoid questioning the motivation and pertinence of the understanding of both art and illustration that underlies their comparison. In the same way that art cannot be reduced to "know-how", the artificial-sounding distinction between artistic and commercial illustration runs the risk of lagging behind current discussions in art.

Nor should different culturally determined conceptions of art be ignored. For example, the distinction between art and illustration is treated in much more pragmatic terms in the Anglo-American world, where the gap between the two disciplines does not seem to be as significant. While the concept of *artistic authorship* remains the pivotal point of the discussion in Europe, in Anglo-American circles it is the artistic or commercial *application* of a work that determines its classification.

A related, but differently motivated version of this thought is the distinction between *method* and *context*. It has long become accepted practice in the fine arts to use methods and techniques from illustration and design for artistic purposes—and vice versa. Still, the contexts of art, illustration and design remain clearly distinct. Each genre has specific goals, working conditions and means of promotion. In whatever context a work is produced, it is connected to its respective "chain of use". In the context of art, a work ideally progresses from a gallery via a curator to a museum or

private collection. Within the context of commercial design, however, this progression is influenced by the client, the communication objectives and the commercial application.

To refer to the work of the French sociologist Pierre Bourdieu[10], each of these contexts, or each of these *fields* has its own rules and its own symbolic capital. A move from one playing field to another always requires knowledge of the rules that prevail there. Thus it can be assumed that the distinction between art and illustration will become obsolete only when illustrators stop promoting themselves in isolated, self-contained exhibitions and assert themselves instead confidently and self-evidently on the playing fields of art—with all the risks and consequences this implies.

Content

1 Cennino D'Andrea Cennini. *The Craftsman's Handbook*. The Italian "Il Libro dell'Arte."
 Trans. by Daniel V. Thompson, Jr. New York, Dover Publications, Inc. 1933,
 Yale University Press, p. 3.

2 Unfortunately, a deeper and more exhaustive discussion of this very wide-ranging topic lies
 beyond the scope of this article.

3 Giorgio Vasari, *Lives of the Most Excellent Painters, Sculptures and Architects*, 2nd ed., 1568.

4 Ibid.

5 Lewandowsky, Pina, *Schnellkurs Grafik-Design*, Cologne, 2006, p. 38

6 Sullivan, Edmund J., *The Art of Illustration*, London, 1921

7 He included the work of artists such as Hans Holbein, Aubrey Beardsley, William Blake,
 James McNeill Whistler and others.

8 Cited in Pevsner, Nikolaus, *Wegbereiter moderner Formgebung von Morris bis Gropius*, Cologne,
 1983, p. 13

9 Ibid.

10 Bourdieu, Pierre, *Rules of Art: Genesis and Structure of the Literary Field*,
 Stanford University Press 1996

Naïve & Basic

The artists assembled in this chapter delight in the sheer joy of simplification. Their origins are intertwined across cultures, influences and continents, but they are all part of a global and globalised creative force. Uprooted illustrators everywhere are currently finding themselves turning back to their youth, to the pure, unspoilt figures, patterns and colour schemes of childhood. Reduced to their bare essentials with a few strokes, clicks or flicks of the wrist, this work takes us back to the basics, back to the roots, even back to our own pasts, to naïve approximations of former inspirations.

Naturally, many of these unassuming, yet highly recognisable creations—from Finnish folklore to fairytale landscapes—have made their way into children's books. Yet they prove equally popular in poster design, where the limitations of silkscreen printing have shaped the genre's stylistic vocabulary. Here, big, bold and beautiful blocks of colour meet 1950s nostalgia, a sprinkling of Pop Art and generous swashes of candy explosions. Others dabble in overprinting and the secret joy of going over the edges, of disregarding the rules of the colouring book and creating one's own reality. In a similar vein, comic culture rears its head, albeit with a different approach to storytelling and layout. By condensing the narrative into a single, central motif, characters are themselves reduced to their outlines and filled with new meaning. Pared down even further, we find a range of (monochromatic) cut-outs and silhouettes of simple objects deprived of all context—and these images are all the more powerful for it.

Deceptively simple, yet never amateurish, this "professional dilettantism" takes seemingly naive visual translations to a highly professional standard. Sometimes finished works in their own right, sometimes mere sketched precursors to future creations, these sprightly, spirited scribbles exploit the creative and aesthetic leeway more formal works may lack. In doing so, they give Susan Sontag's postulate "On Photography" (the greater the illusion of perceived reality, the greater the lie) a new lease on life. Unfettered by formal constraints, their simple, yet never simplistic depictions of people, objects and scenes thrive on omissions to capture the essence and spirit of what is being portrayed.

Re:verse
Designer: Kazuhiro Imai
Client: Resona Bank
Credits: Resonart
Technique: Cutout
2006

Re:verse
(4 illustrations)
Designer: Kazuhiro Imai
Technique: Cutout
2006

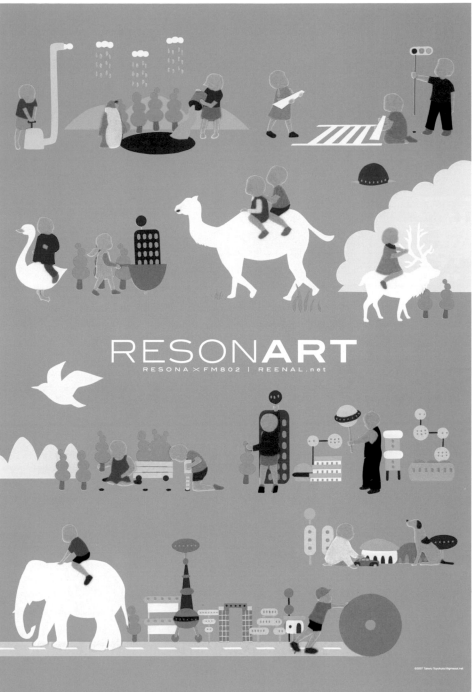

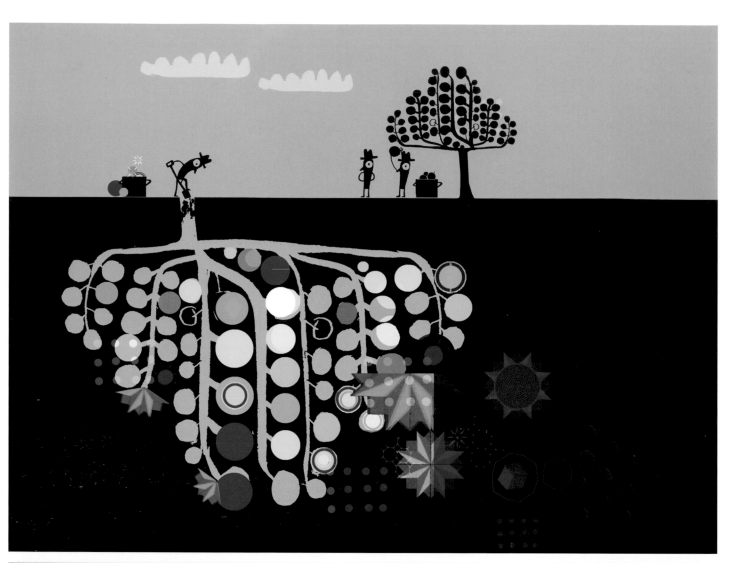

Chris Haughton
"Digital Digging"
Client: Res Magazine
Art Director: Juliette Cezzar
Format: Magazine
Technique: Digital
2007

Chris Haughton
(left)
Technique: Digital
2007

Chris Haughton
(2 illustration)
"Butterflies"
Client: Studioaka
Art Director: Grant Orchard
Format: Still for animation
Technique: Digital
2007

Carolina Melis
(5 illustrations)
"Io Vado"
Client: Smart / Rojo
Technique: Digital
2006

INFASHION
GET IN TOUCH WITH YOUR OUTER SELF.

BEAUTY, FITNESS, LIFESTYLE, FASHION, SHOPPING
Introducing the new Thursday Styles section, for men and women. Every Thursday in The New York Times.

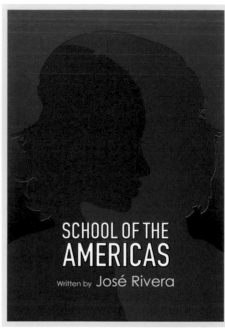
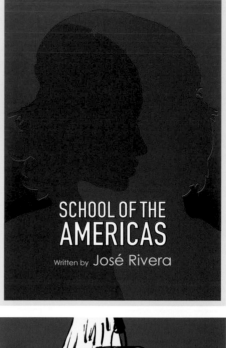

SCHOOL OF THE AMERICAS
Written by José Rivera

Chris Rubino
(right)
"School of the Americas"
Client: The New York Public
Theater, Labyrinth Theater
Format: Poster ad
Technique: Illustrator
2006

Chris Rubino
(7 illustrations)
"Thursday Styles"
Client: The New York Times
Art Director: Jeff Honea
Format: Advertisement
Technique: Hand-drawn,
digital colour
2005

Chris Rubino
(middle)
"Kissing Giraffes"
Client: Banana Republic
Art Director: Paul G. Kagiwada
Format: Packaging
Technique: Hand-drawn,
digital colour
2006

Chris Rubino
"Arts & Leisure"
Client: The New York Times
Format: Advertisement
Technique: Hand-drawn,
digital colour
2005

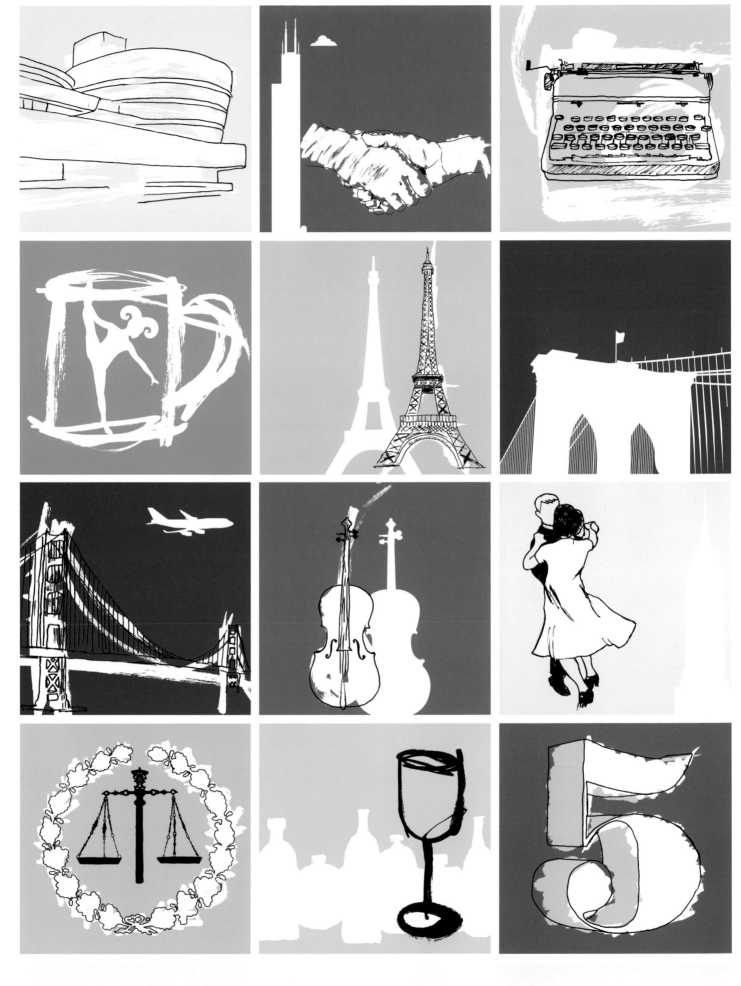

Bo Lundberg
"Manhattan"
Self promotion
Technique: Illustrator
2006

Bo Lundberg
(right)
"Magic, Cilla and Baby"
Designer: Jenny Salmson
Client: Vilda Publisher
From a children's book.
Author: Eva Lundgren
Technique: Illustrator
2007

Bo Lundberg
(right)
"Kids"
Designer: Bo Lundberg,
Alison Oliver
Client: Citibabes
Technique: Illustrator
2005

Bo Lundberg
"Store"
Designer: Bo Lundberg,
Alison Oliver
Client: Citibabes
Technique: Illustrator
2005

Bo Lundberg
"Home"
Unpublished
Technique: Illustrator
2007

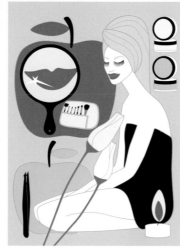

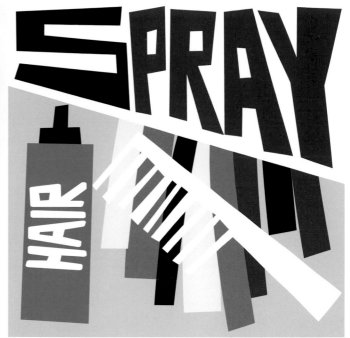

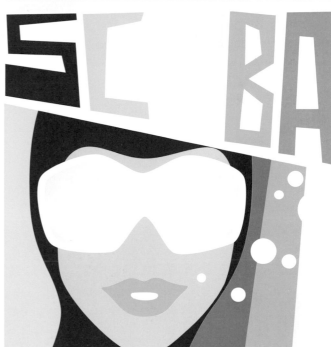

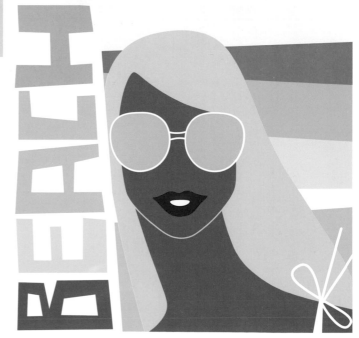

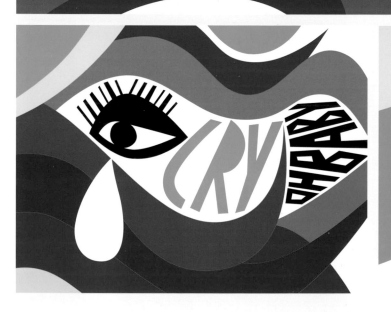

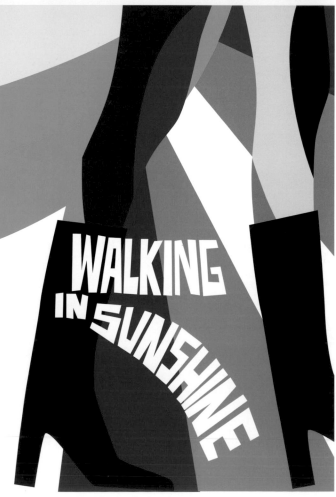

Kari Modén
"Catwalk"
Unpublished
Technique: Illustrator
2003

Kari Modén
"Window Display"
Client: Diesel
Technique: Illustrator
2002

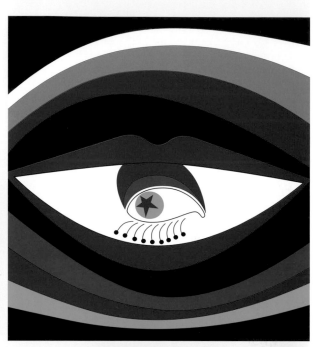

Kari Modén
(left)
"Cry Baby"
Unpublished
Technique: Illustrator
2003

Kari Modén
(right)
"Walking"
Unpublished
Technique: Illustrator
2003

Kari Modén
"Black Girl"
Unpublished
Technique: Illustrator
2007

Kari Modén
"Aura"
Client: The Guardian Weekend
Magazine, UK
Technique: Illustrator
2007

Kari Modén
(left)
"Sun"
Unpublished
Technique: Illustrator
2003

Kari Modén
(right)
"Cheers"
Unpublished
Technique: Illustrator
2007

Kari Modén
"Glasses"
Client: King Magazin, Sweden
Technique: Illustrator
2006

Interview Sanna Annukka

Finnish illustrator and printmaker Sanna Annukka might have swapped her native shores for the British seaside town of Brighton, yet for inspiration, her heart, mind and pen often return to the unspoilt nature and rich folklore of her Nordic roots. The perfect antidote to long Arctic nights, the colourful brightness of her bold trademark patterns and "Maiden" characters adds a welcome twist of naïve simplicity to record sleeves and fashion editorials alike.

Background

Most of my childhood summers were spent in Finland and these spells in the night-less Lapland wilderness hold some of my fondest memories. The forests, lakes and wildlife of the region were incredibly inspirational and, back then, I would roam the forests, sketchbook in hand, to draw the trees and foliage. Surrounded by beautiful lakes and forests, it should come as no surprise that nature remains such a key element in my work. Furthermore, my childhood was infused with wonderful illustrated books like those by Tove Jansson, creator of the Moomins. Her picture books made me dream about becoming an illustrator myself and producing my own range of picture books.

Skills and Techniques

My passion for screen printing evolved as I worked toward my degree in illustration at the University of Brighton. Back in those days, I would spend all my spare time in the print rooms and came up with my ongoing range of limited edition silkscreen "Maiden" designs. Silkscreen printing remains my favourite outlet and has resulted in many beautiful limited edition prints. Due to the often tight and demanding deadlines of client commissions, screen printing is not a viable option for commercial purposes. For commissioned work, I therefore scan my initial sketches into either Photoshop or Illustrator and use digital means for the final artwork. Photoshop is great because it allows you to recreate and retain the screen-printed look.

Inspiration and Influences

Naturally, my Finnish background is the biggest driving force behind my style. For decades, Scandinavia has been at the forefront of design and, from a very young age, I found myself surrounded by excellent examples of architecture, furniture, textiles and product design. Many homes came with traditional, bold-patterned Marimekko curtains and decorative kitchenware. These patterns and my love of folklore are reflected in all my work. I am particularly fond of Finland's national epic The Kalevala, a collection of spellbinding folk songs. My new range of prints will depict ten different scenes from The Kalevala.

Featured Works

In 2006, my work was spotted by the British group Keane and this led to a very memorable collaboration for their best-selling album "Under the Iron Sea". During this period I also joined forces with London-based creative consultancy Big Active; first on the above-mentioned album design and then as part of their select number of represented artists.

I really loved the Keane campaign because their lyrics remind me of extracts from an enchanting fairytale, which in turn inspired me to create this magical underworld beneath the horses in the sea.

Since then, my product range has expanded to textiles, decorative tins and other illustrated objects. I have also set up my own company Sanna Annukka Ltd and launched an online shop selling limited edition silkscreen prints of my artwork. I'm also excited about writing and illustrating my own range of picture books—realising my long-cherished childhood dream!

Sanna Annukka
"Maidens of the Midnight Sun"
Personal work
Format: Limited edition
screen print
Technique: Photoshop,
screen print
2007

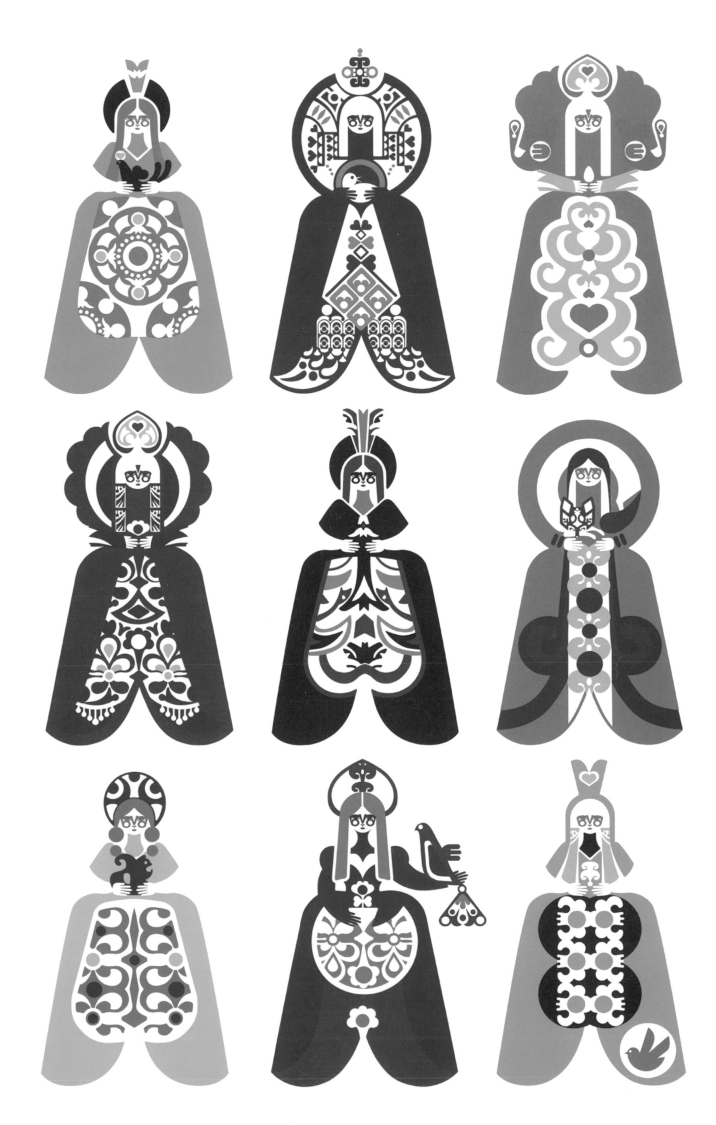

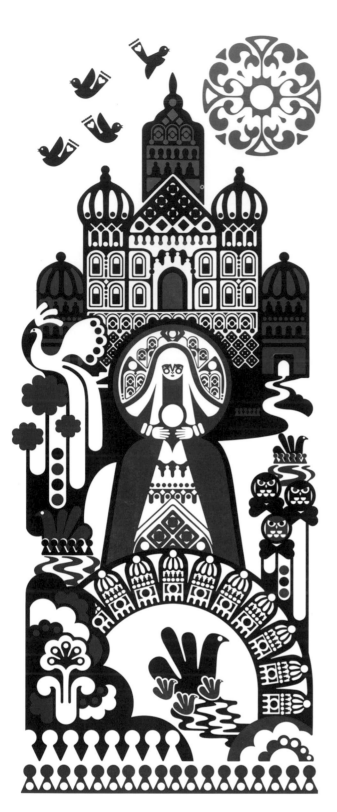

Sanna Annukka
(left)
"Sunrise"
Personal work
Format: Limited edition
screen print
Technique: Photoshop,
screen print
2007

Sanna Annukka
(right)
"Autumn Garden"
Personal work
Format: Limited edition
screen print
Technique: Photoshop,
screen print
2007

Sanna Annukka
(left)
"The Magic Peacock"
Personal work
Format: Digital print
Technique: Photoshop
2007

Sanna Annukka
(right)
"The Midnight Sun"
Personal work
Format: Digital print
Technique: Photoshop
2007

Sanna Annukka
Client: Wallpaper Magazine
Format: Cover illustration
for Dutch Discoverer 2007
supplement
Technique: Photoshop
2007

Sanna Annukka
"Under the Iron Sea"
Client: Universal Island Records
Art Direction by Richard Andrews
and Gez Saint at Big Active
Format: Diverse CD sleeves for
the band Keane
Technique: Photoshop
2006

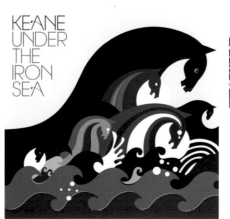

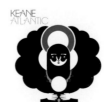
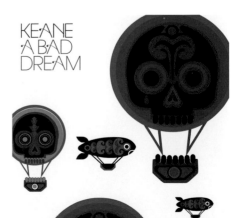

Sanna Annukka

Julie West
"Squeeze"
Client: Flow Snowboards
Format: Image for Giclee Print
Technique: Hand-drawn, vector
2007

Julie West
(left)
"Cherry Bird"
Client: Flow Snowboards
Format: Image for
snowboard graphic
Technique: Hand-drawn, vector
2006

Julie West
(right)
"Wheee!"
Format: Image for Gocco Print
Technique: Hand-drawn, vector
2007

Julie West
(left)
"Blast Off"
Format: Image for DJ Slip Mat
Technique: Vector
2006

Julie West
(right)
"Speaking of Clouds"
Format: Image for screen print
Technique: Hand-drawn, vector
2007

Julie West
"Static Rocket"
Client: Static Bikes
Format: Bike tube sticker
Technique: Vector
2007

Anke Weckmann
"Bjork"
Client: Plan B Magazine
Format: Editorial
Technique: Ink drawing,
digitally coloured
2007

Anke Weckmann
(right)
"Bunny"
Personal work
Technique: Ink drawing,
digitally coloured
2007

Anke Weckmann
(left)
"Your Cloud"
Client: No Cover Magazine
Format: Editorial
Technique: Ink Drawing,
digitally Coloured
2006

Anke Weckmann
(right)
"Tea Party"
Personal work
Technique: Ink drawing,
digitally coloured
2007

Anke Weckmann
"Sleep Leaves"
Personal work
Technique: Ink drawing,
digitally coloured
2007

Jules
"Seed Girl"
Designer: Jules
Private commission
Technique: Hand-drawn,
Illustrator
2007

Eva Mastrogiulio
"Christmas Song"
Self-promotion
Technique: Handmade collage,
Photoshop
2007

Katharina Leuzinger
"The Little Girls"
Client: Viewpoint Magazine
Format: Poster
Technique: Illustrator, Photoshop
2006

Jules
(right)
"Leaf Girl"
Designer: Jules
Private commission
Technique: Hand-drawn,
Illustrator
2007

Eva Mastrogiulio
(left)
"Little Red Riding Hood Blooms"
Personal project
Technique: Acrylic on cardboard
2005

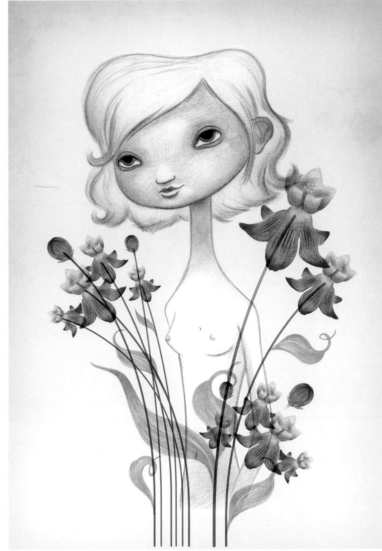

Katharina Leuzinger
"The Little Girls"
Client: Viewpoint Magazine
Format: Poster
Technique: Illustrator, Photoshop
2006

Katharina Leuzinger
Eva Mastrogiulio
Jules

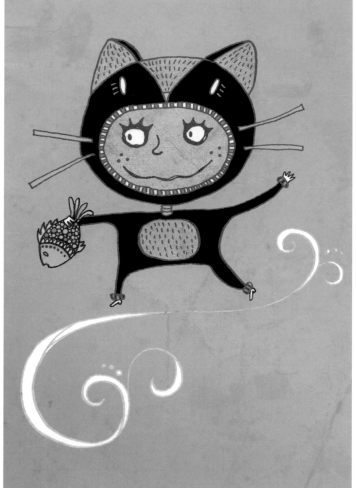

Laura Varsky
"Cat Boy"
Client: Estudio Cabina
Format: Editorial
Technique: Ink and digital
2007

Laura Varsky
"I want to kill you"
Client: Die Gestalten Verlag
Format: Calendar
Technique: Ink and digital.
2005

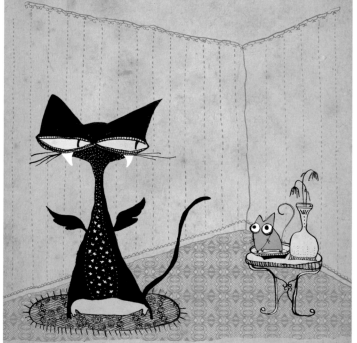

Laura Varsky
(left)
"Help me!"
Client: Die Gestalten Verlag
Format: Calendar
Technique: Ink and digital.
2005

Laura Varsky
(right, 3 illustrations)
"Her tea", "Her little bird",
"Her closet"
Technique: Ink and digital
2005

Uwe Eger
(right)
Client: Head Snowboards
2005

Uwe Eger
Client: Thomsen
Credits: Illustration
for a 7 inch record cover
2007

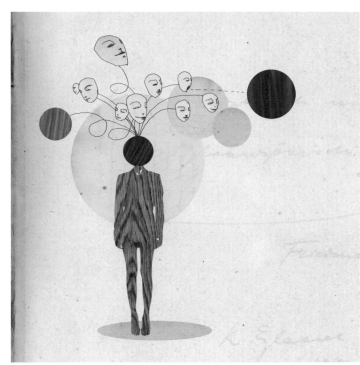

Uwe Eger
(left)
Client: Thomsen
Credits: Illustration for a CD
booklet and tour promotion
2007

Uwe Eger
(right)
Client: Head Snowboards
2005

Jules
"Underwater"
Personal work
Technique: Illustrator
and Photoshop
2007

Jules
"Daisy Yellow"
Personal work
Technique: Illustrator
and Photoshop
2007

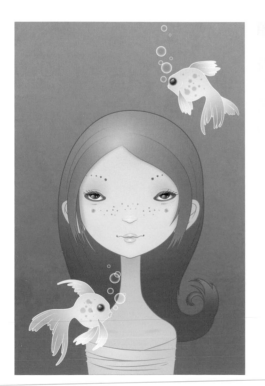

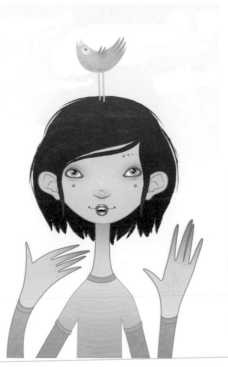

Jules
(left)
"Bird Girl"
Personal work
Technique: Illustrator
2007

Jules
(middle)
"Flower Girl"
Personal work
Technique: Illustrator
and Photoshop
2007

Jules
(right)
"Goldfish"
Personal work
Technique: Illustrator
2007

Tina Mansuwan
Client: Vodafone
Format: Poster
Technique: Illustrator
2007

Tina Mansuwan
Client: Vodafone
Format: Direct mail
Technique: Illustrator
2007

Tina Mansuwan
Client: Vodafone
Format: Direct mail
Technique: Illustrator
2007

Tina Mansuwan
Client: Vodafone
Format: Poster
Technique: Illustrator
2007

Interview Judith Drews

Judith Drews takes simple shapes and 1950s shades on a whirlwind ride of childish abandon. With a sleight of hand honed during her croupier past, the Berlin-based illustrator enchants her captive young audience with a string of irresistibly cheeky creations. Whether paper doll or yoga guide, Drews' cute characters are at home in children's books, women's magazines and serious newspapers alike. They also inject a welcome breath of fresh air into clothing lines, youth TV and award-winning teen websites.

Background

Storytelling and picture books have always been an important part of my family's nightly tuck-in routine, and I am sure those stories and images have made a strong impression on my later life. I still enjoy Ali Mitgutsch's picture books, teeming with discoveries; and even today, I can still recite every word of "The Mouse Seeks a House" or "Message in a Bottle". Their images still make my heart beat faster, just like they did when I was a little girl, perched on my mum's lap, clamouring for the self-same story for the hundredth time... Now it is my daughter, who loses herself in Sendak's world like many generations before her and those still to come.

Never one to take the easy way, I first passed through hotel management training, restaurant management and a stint as a croupier in various gambling establishments before I went on to study illustration in Hamburg and earned my keep as a junior art director in a local advertising agency. Now based in Berlin, I can't remember a time when I didn't want to spend my life drawing, but after school, I simply couldn't stand the idea of any more time in education or university.

Signature Style

Nowadays, more and more people are inquiring about what shaped my style. I guess that means that I have developed my own distinctive "handwriting", which is great! One of the folders on my desktop is actually titled "My World"...

I never change or adjust my technique to suit clients or target audiences because everyone I work for hires me for this specific signature style. It has always been my aim to defy the one-dimensional, cutesy children's book clichés prevalent in the German book market. My contours are never black. Looking back, I guess my fondness for limited colour schemes and the way I deal with areas, structures and patterns stems from my love of silkscreen printing. And ever since college, one of my enduring maxims has been "A great poster should work equally well on a matchbox".

Inspiration and Influences

During my studies, I actually almost abandoned my goal to create children's books. Inspired by people like Anke Feuchtenberger and Atak, I discovered comic strips and illustrated narrative; there was also silkscreen printing and the irresistible lure of the silkscreen studio. Most of my work from that period was about experimenting, not content.

Current sources of inspiration include patterns, eBay, picture books from the 1950s and 60s, English picture books from around 1900–1920, volumes on animals and flowers, packaging, toys, Osamu goods... Not to mention all the people I admire: Walter Trier, Yoshitomo Nara, Nathalie Lété, Margret Rey, Zdenek Miller, Walter Crane and Maurice Sendak, to name just a few.

Featured Works

Most of my ideas sneak up on the fly: when I'm stuck in traffic, when I do chores around the house or when I join my daughter in a nursery rhyme. The more fun and freedom I enjoy, the better the outcome! I am an adult and a parent, but also small Judith, a kid at heart. Torn between those fleeting, immersive memories of my wonderful childhood and the knowledge that this time is gone for good, I really cherish the luxury of picking up where I left off and delving back into "My World". Whatever I draw, I always try to ensure that there is plenty to be discovered, that not everything is revealed at first glance.

Judith Drews
"Zoo"
Client: Sven Meier-Wiedenbach
www.keine-kunst-hannover.de
Format: Limited edition
screen print
Technique: Acrylic, digital
2006

Judith Drews
(left)
Client: Inkognito
Format: Christmas card
Technique: Acrylic, digital
2007

Judith Drews
(middle)
Client: Gecko
Format: Children's magazine
Technique: Acrylic, digital
2007

Judith Drews
(right)
Client: Inkognito
Format: Dress-up dolls
Technique: Acrylic, digital
2007

Judith Drews
(left)
"Emil"
Personal publishing project
Format: Children's book
Technique: Screenprint
2004

Judith Drews
(middle)
"My Favourite Game"
Client: revistacolectiva, Costa Rica
Format: Book
Technique: Acrylic, digital
2007

Judith Drews
(right)
"Pippi Langstrumpf"
Client: Illustrakids 2007,
Sardinia
Format: Graphic for
Astrid Lindgren exhibition
Technique: Digital print
2007

Judith Drews

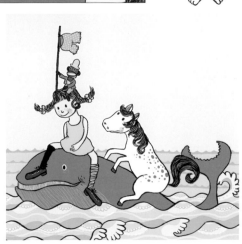

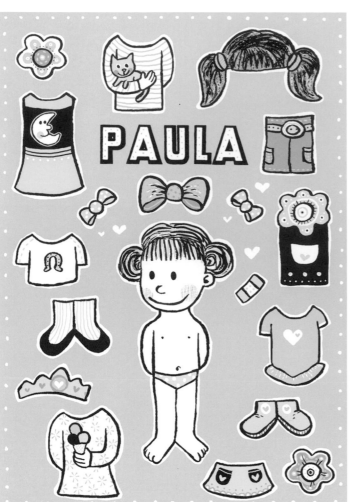

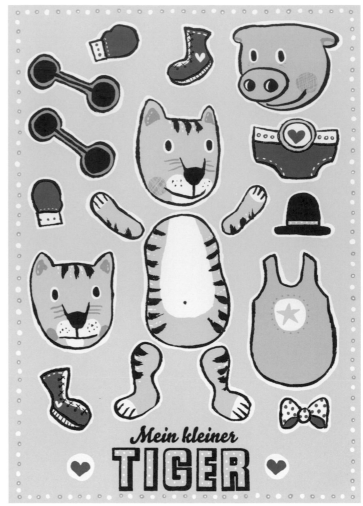

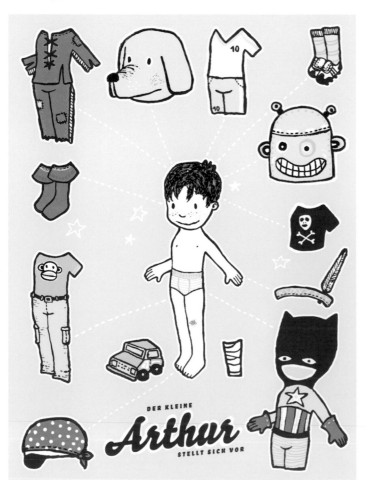

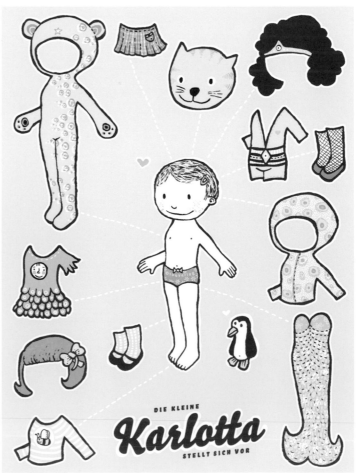

Judith Drews
(left)
"Paula"
Client: Inkognito,
www.inkognito.de
Format: Magnetic
dress-up dolls
Technique: Acrylic, digital
2007

Judith Drews
(right)
"Tiger"
Client: Inkognito,
www.inkognito.de
Format: Magnetic
dress-up dolls
Technique: Acrylic, digital
2007

Judith Drews
(left)
"Arthur"
Client: 104 Verlag
Format: Magnetic
dress-up dolls
Technique: Screenpint
on magnetic foil
2006

Judith Drews
(right)
"Karlotta"
Client: 104 Verlag
Format: Magnetic
dress-up dolls
Technique: Screenpint
on magnetic foil
2006

Judith Drews
Naïve & Basic | 30

Judith Drews
Self-promotion
Format: Game
Technique: Acrylic, digital
2007

Judith Drews
(left)
Client: Agentur Susanne Koppe
Format: Stamps
Technique: Acrylic, digital
2007

Judith Drews
(right)
"Fahrrad Typen"
Client: jetzt.de
Format: Editorial
Technique: Acrylic, digital
2006

Judith Drews
(left)
Client: Berliner Zeitung
Format: Editorial
Technique: Acrylic, digital
2005

Judith Drews
(right)
"Weihnachtsmarken"
Client: Agentur Susanne Koppe
Format: Stamps
Technique: Acrylic, digital
2007

Judith Drews

31 | Naïve & Basic

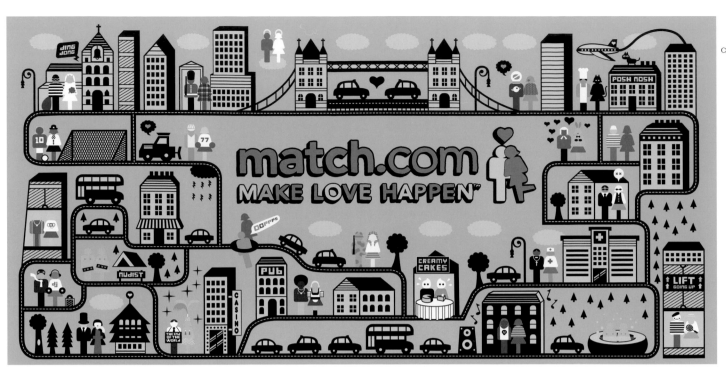

Serge Seidlitz
"Make Love Happen"
Client: match.com
Credits: Hanftraboy & Partner, NYC
Format: Billboard,
London underground and
train stations
Technique: Vector
2007

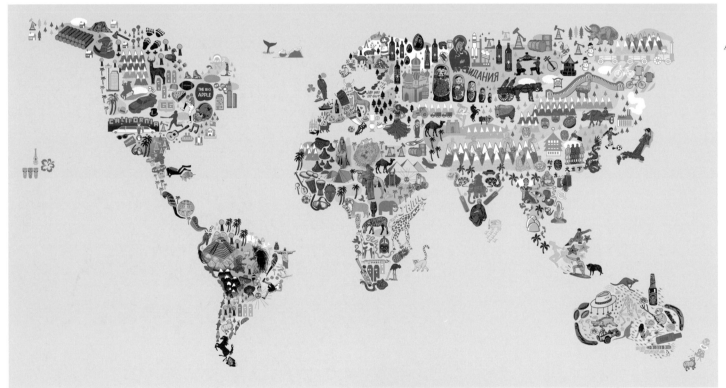

Serge Seidlitz
"World Map –
Make the Most of Now"
Client: Vodafone
Art Director: Mark Reddy at BBH
Format: Billboard
Technique: Hand-drawn,
Photoshop
2006

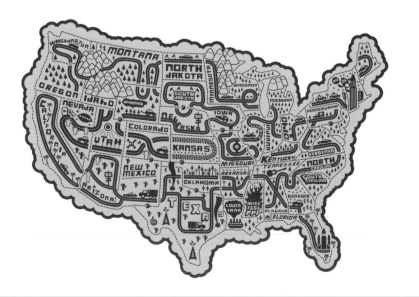

Serge Seidlitz
"USA Road Map"
Designer:
Self-promotion
Technique: Vector
2005

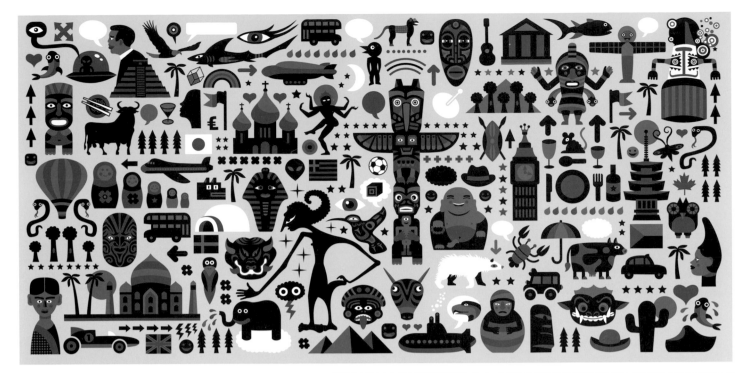

Serge Seidlitz
"Many Cultures – One World"
Client: Vodafone
Art Director: Mark Reddy
Technique: Vector
2007

Serge Seidlitz
(left)
"Designing for Charity"
Client: Computer Arts Magazine
Format: Editorial
Technique: Vector
2006

Serge Seidlitz
(right)
"Technology special cover"
Client: Restaurant Magazine
Format: Magazine cover
Technique: Vector
2005

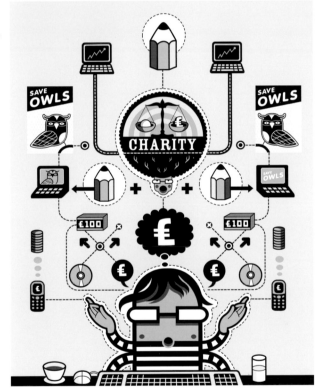

Serge Seidlitz
(left)
"London Map"
Client: London Architecture Week
Technique: Vector
2006

Serge Seidlitz
(right)
"Iceland"
Client: Vodafone
Credits: Fiton, Iceland
Technique: Hand-drawn,
Photoshop, collage
2007

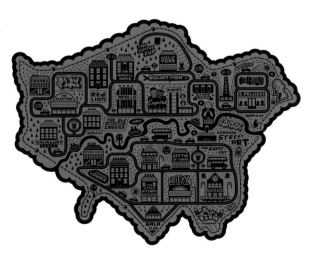

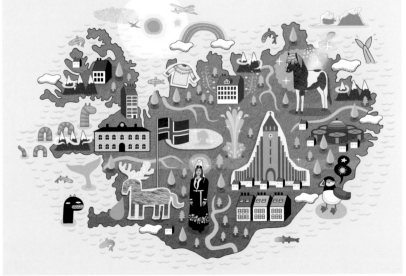

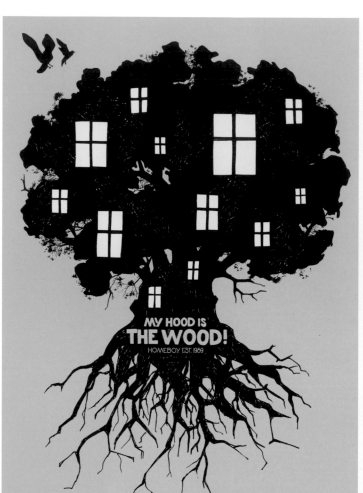

Typeholics
"My Hood is the Wood"
Designer: Typeholics: Kakrow
Client: Homeboy
Format: T-shirt print
Technique: Hand-drawn,
Photoshop
2007

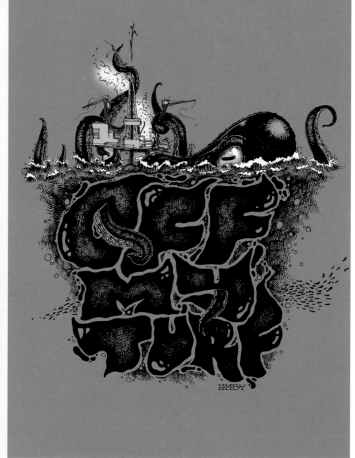

Typeholics
"Off My Turf"
Designer: Typeholics: Rohde
Client: Homeboy
Format: T-shirt print
Technique: Hand-drawn,
Photoshop
2007

June Kim
(right)
"Adventure"
Designer: Kai Ristilä
Client: Res Magazine
Format: Editorial
Technique: Pen, ink, Photoshop
2005

June Kim
"Explosions in the sky"
Designer: Ken Miller
Client: Tokion Magazine
Format: Editorial
Technique: Pen, ink,
Photoshop
2005

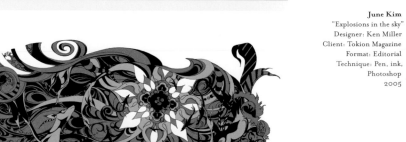

Apfel Zet
"Tree"
Designer: Roman Bittner
Client: Bacardi
Technique: Freehand
2007

Apfel Zet
"Japanese Garden"
Designer: Roman Bittner
Client: Bacardi
Format: T-shirt illustration
Technique: Freehand
2007

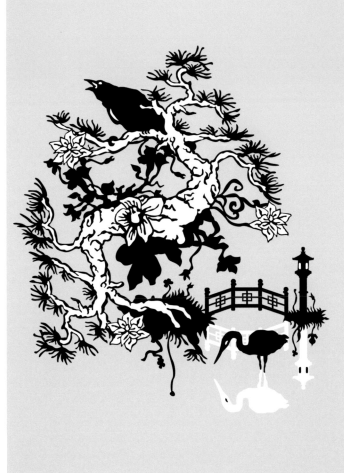

June Kim
"Storm"
Designer: Kai Ristilä
Client: Res Magazine
Format: Editorial
Technique: Pen, ink, Photoshop
2005

June Kim
"Paranoia"
Designer: Kai Ristilä
Client: Res Magazine
Format: Editorial
Technique: Pen, ink, Photoshop
2005

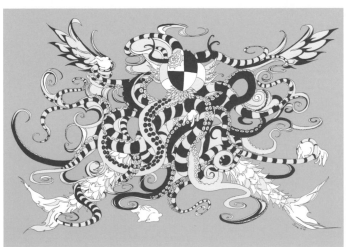

Fashion & Style

Without its tireless hunt for styles and ideas, fashion itself would cease to exist — and the same applies to fashion illustration. Firmly rooted in contemporary culture, these images of future visions sketch out (un)wearable dreams and lofty ideas. They present a fleeting promise of style and chic captured in all its ephemeral glory.

More distinct than photography, illustrations have reclaimed their rightful place in fashion reporting, adding their unmistakeable flavour, attitude and personality to voguish editorials. And yet, fashion illustration has always been about more than a mere depiction of fashion itself. Hinting at the promise of a more glamorous life, illustration enjoys the luxury and freedom of stylish exaggeration, of turning life as we know it into an opulent utopia just within reach — the popular fallacy and defining principle of fashion and women's magazines around the globe.

Although still influenced by fashion's seminal five-stroke sketches, most works in this chapter have graduated from mere depictions of stylish attire to works of art in their own right. These works pick up on fashion's core characteristics, its tangible seams, fabrics, layers, patterns and textures; they follow the contours of the body from well-rounded to angular, jagged and smooth. In doing so, these works reflect — and expand on — the human shape, yet they continue to honour the aesthetic codes of fashion design.

Although occasionally assembled, colour-adjusted and shape-shifted on the computer, a purely digital approach remains the exception. Like fashion itself, it is the hand-crafted appeal, the stitch in time, that adds the necessary charm and seductive lure to fashion's transient appeal.

Plenty of materials and techniques have been appropriated from distant shores and exotic cultures. Whether done using coloured paper, silhouettes or elaborate embroideries, there seems no limit to styles, techniques or media involved. Blending nature with skilful artifice, the designers and artists shown here pick and mix from the broadest palette of possible sources — from pencil and brushstroke to scissor and sewing machine. Held together by the glue of inspiration and a generous dash of decadent opulence, we marvel at the delicate transparency of water colours, carefully dissected paper collages, meticulous stylus exercises and plenty of unravelling fabrics, tantalising loose ends and all.

And yet, even the wildest forays into artsy abstraction remain inexorably linked to the eye of the beholder. To this day, the audience's projected reception plays an essential part in the creative process and overall aesthetic of fashion illustration.

Anja Kröncke
(5 illustrations)
"Wings of Desire"
Designer: Anita Mrusek
Client: Squint Magazine
Format: Editorial
Technique: Mixed media
2007

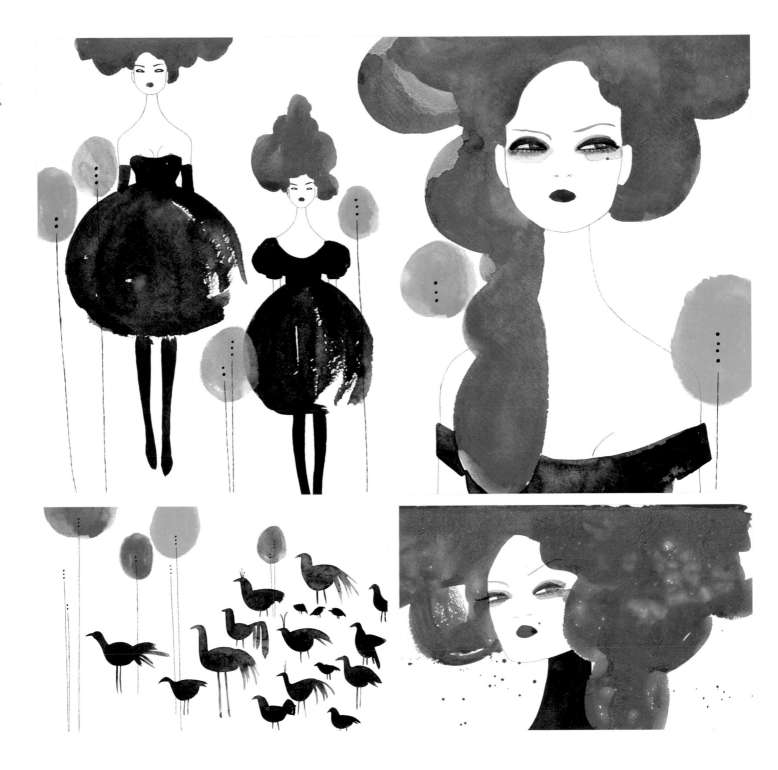

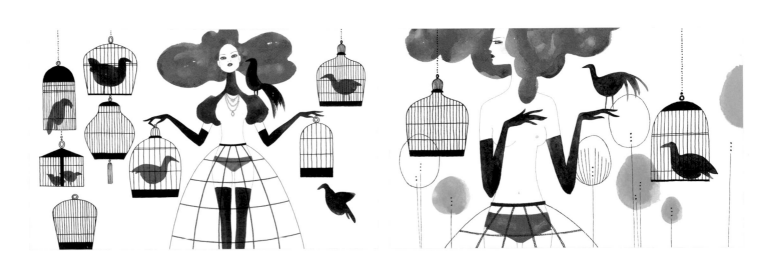

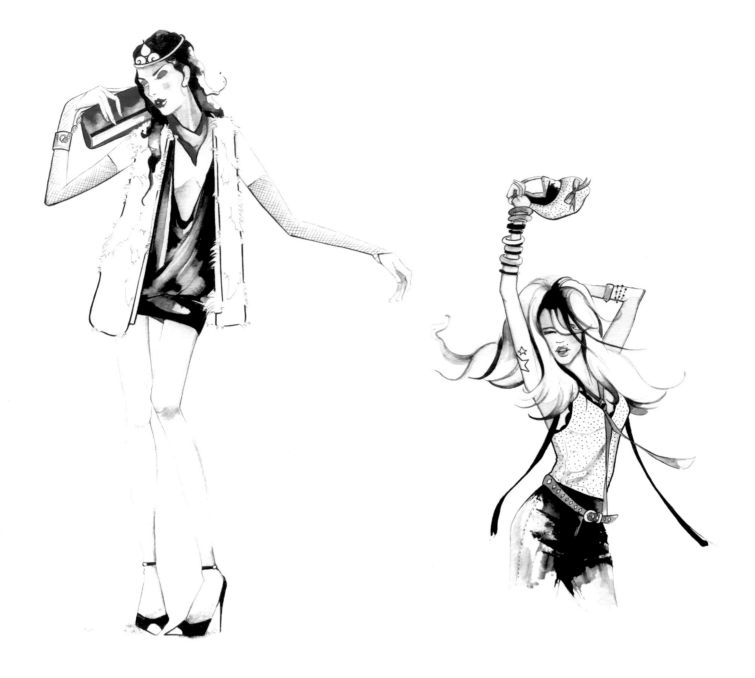

Sophie Varela
Client: Clélia Altair
Format: Web illustration
Technique: Watercolour
2006

Sophie Varela
"Rock"
Client: Neo-head
Format: Editorial
Technique: Watercolour
2007

Zebby
(3 illustrations)
"This little piggy went to Prada"
Designer: Bloom Design
Client: Spy Publishing
Format: Hardcover gift book
Technique: Watercolour, ink,
coffee, Photoshop
2005

Sophie Varela
Zebby

Sophie Varela
"College"
Client: Bastardmagazine
Format: Editorial
Technique: Watercolour
2006

Sophie Varela
"La dolce vita"
Client: Kiss me
Format: Editorial
Technique: Watercolour
2007

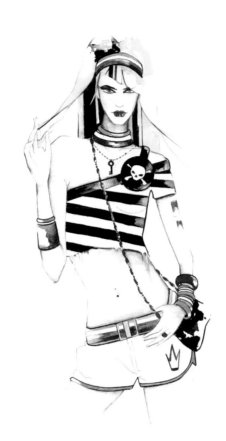

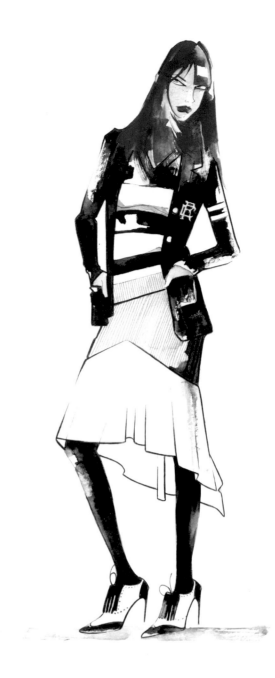

Zebby
(3 illustrations)
"This little piggy went to Prada"
Designer: Bloom Design
Client: Spy Publishing
Format: Hardcover gift book
Technique: Watercolour, ink,
coffee, Photoshop
2005

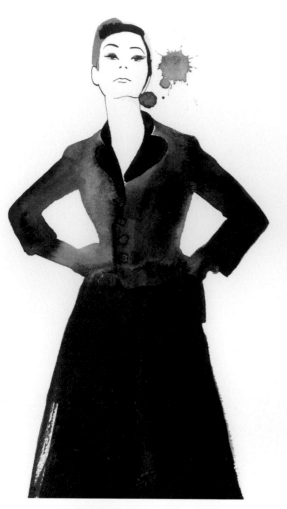

Zebby
(4 illustrations)
"The Look Book"
Designer: Nigel Soper
Client: Mike Shen
Credits: Illustrated look book
for fashion designers
Technique: Ink, Photoshop
2007

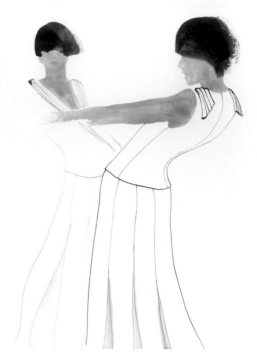

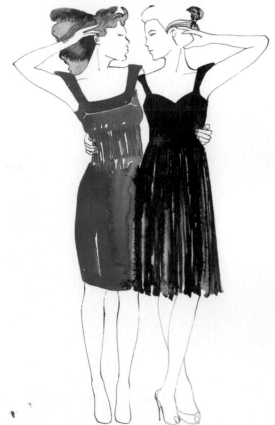

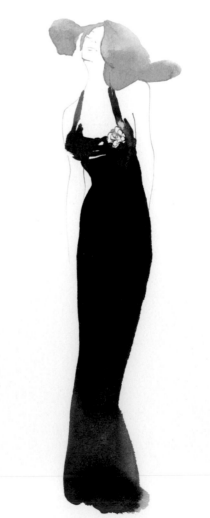

Toril Bækmark
Personal work
Technique: Hand-drawn, ink and
watercolour
2004

Toril Bækmark
(left)
"Bubbleflower"
Personal work
Technique: Black ink on paper
2006

Toril Bækmark
(right)
"Flowers"
Personal work
Technique: Black ink on paper
2006

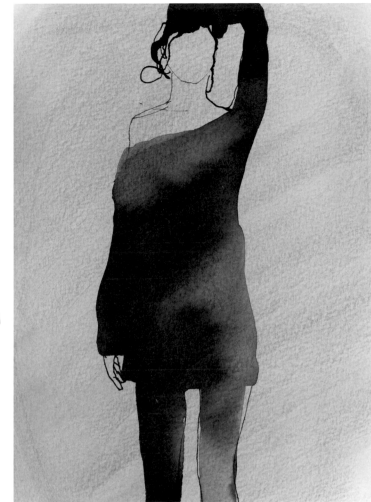

Toril Bækmark
(left)
Personal work
Technique:
Hand-drawn, ink and watercolour
2004

Toril Bækmark
(right)
Client:
Heartmade by Julie Fagerholt
Format: Catalog sleeve
Technique: Hand-drawn,
grey ink on paper
2004

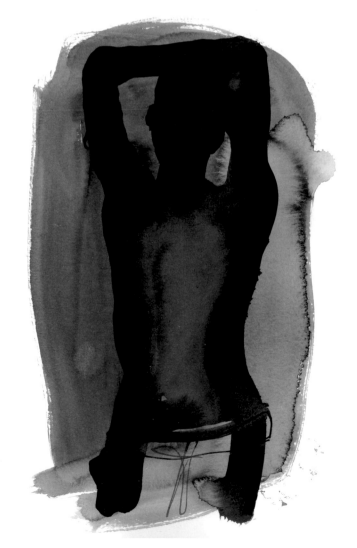

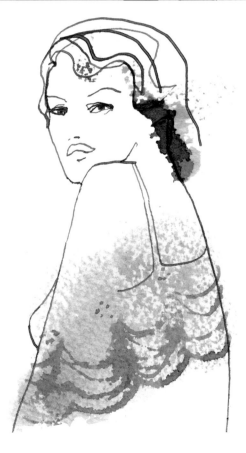

Toril Bækmark

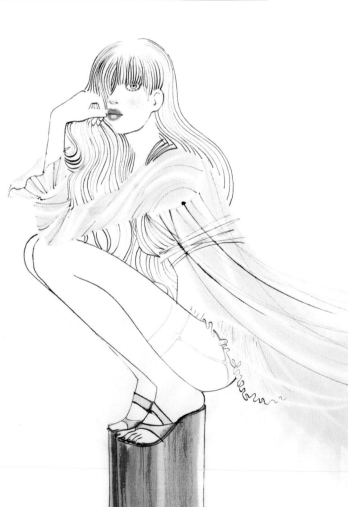

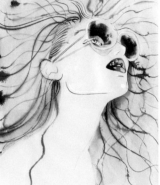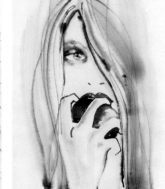

Margot Macé
Client: Woman Magazine,
Germany
Technique: Watercolour, ink-pen
2007

Margot Macé
(left)
Client: Woman Magazine,
Germany
Technique: Watercolour, ink-pen
2007

Margot Macé
(right)
Client: Officiel, Japan
Technique: Watercolour, ink-pen
2007

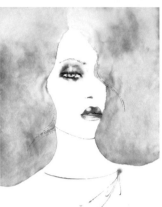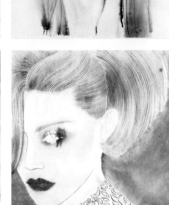

Margot Macé
(2 illustrations)
Client: Officiel, Japan
Technique: Watercolour, ink-pen
2006, 2007

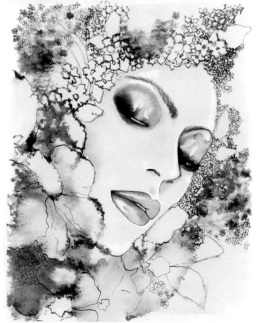

Margot Macé
(left)
Client: DPI Magazine, Taiwan
Technique: Watercolour, ink-pen
2007

Margot Macé
(right)
Client: Officiel, Japan
Technique: Watercolour, ink-pen
2006, 2007

Margot Macé
"Freistil",
Verlag Hermann Schmidt Mainz
Format: Book illustration
Technique: Watercolour, ink pen
2007

Margot Macé
(2 illustrations)
Client: Officiel, Japan
Technique: Watercolour, ink pen
2007

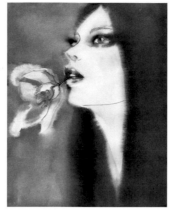

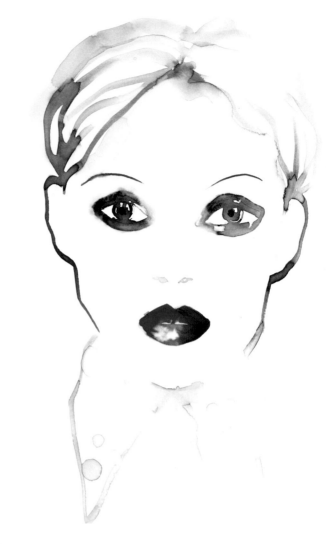

Margot Macé
(left)
Client: "Illustration Now!",
Taschen Verlag
Technique: Watercolour, ink pen
2007

(right)
Client: Officiel, Japan
Technique: Watercolour, ink pen
2006, 2007

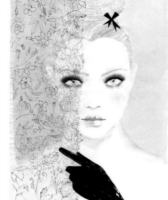

Margot Macé
(left)
Client: Officiel, Japan
Technique: Watercolour, ink pen
2006

Margot Macé
(right)
Client: "Illustration Now!",
Taschen Verlag
Technique: Watercolour, ink pen
2007

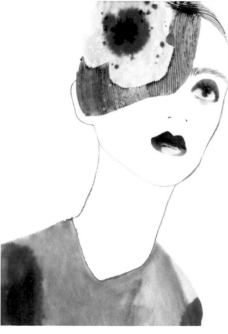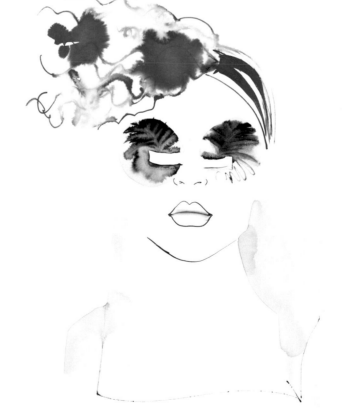

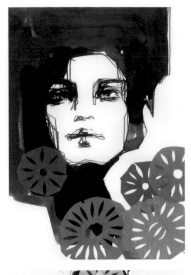

Stina Persson
"Filomena"
"Colombina"
"Fortunata"
Personal work
Format: Original artwork
created for the New York solo show
"Immacolata and Her Friends"
Technique:
(Hand-drawn) watercolour,
inks, coloured tracing paper and
µexican papel picado collage
2007

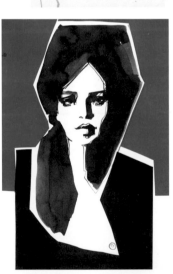

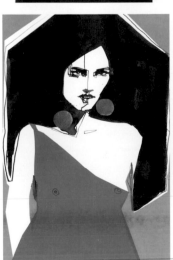

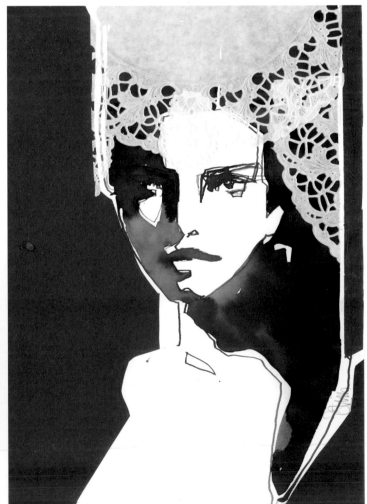

Stina Persson
(left)
"Cosima"
Personal work
Format: Original artwork
created for the New York solo show
"Immacolata and Her Friends"
Technique:
(Hand-drawn) watercolour, inks,
coloured tracing paper and mexi-
can papel picado collage
2007

Stina Persson
(right)
"Ermenegilda"
Format: Original artwork
created for the New York solo show
"Immacolata and Her Friends"
Technique: (Hand-drawn)
watercolour, inks, tissue paper
and doily
2007

Stina Persson
"Salvinuzza"
Format: Original artwork
created for the New York solo show
"Immacolata and Her Friends"
Technique:
(Hand-drawn) watercolour, inks
and coloured tracing paper collage
2007

Stina Persson
(3 illustrations)
"Music for Lovers"
Dinah Washington
Sarah Vaughan
Joe Williams
Client: Blue Note Records
Format: CD cover
Art Director: Burton Yount
Designer: Amanda Wray
Technique: Watercolour,
Photoshop
2006

Stina Persson
(right)
"Circled"
Personal work
Technique: Watercolour, inks,
Photoshop
2007

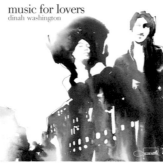

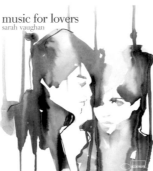

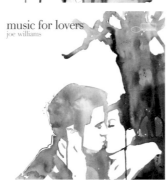

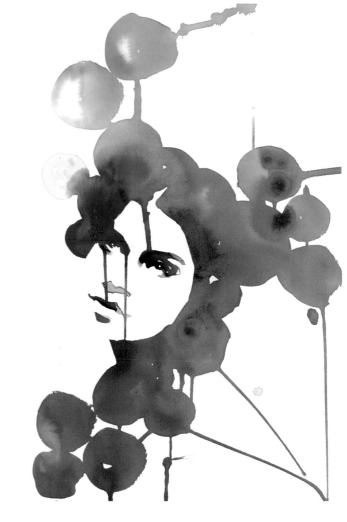

Stina Persson
(left)
"Lilies"
Personal work
Technique: Watercolour,
Photoshop
2007

Stina Persson
(right)
"Incoronata"
Format: Original artwork
created for the New York solo show
'Immacolata and Her Friends'
Technique: Watercolour
2007

Stina Persson
Client: W Magazine Korea
March 2007 issue
Format: Editorial
Technique: Watercolour,
Photoshop
2006

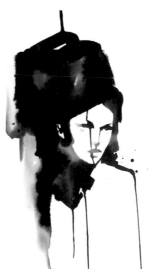

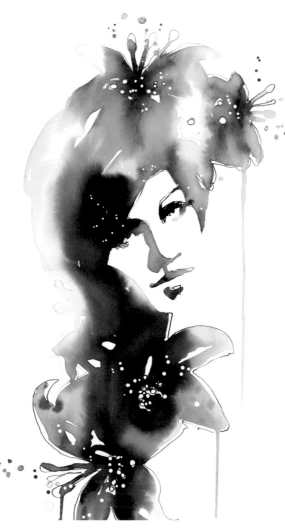

Stina Persson
45 | **Fashion & Style**

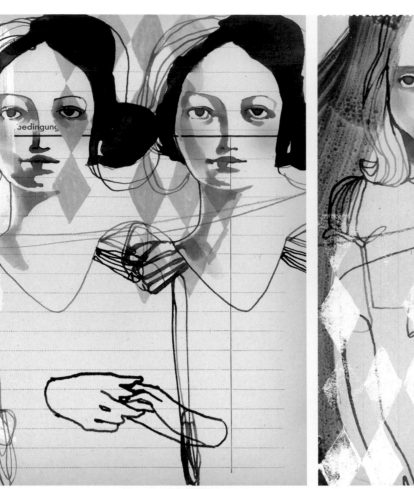

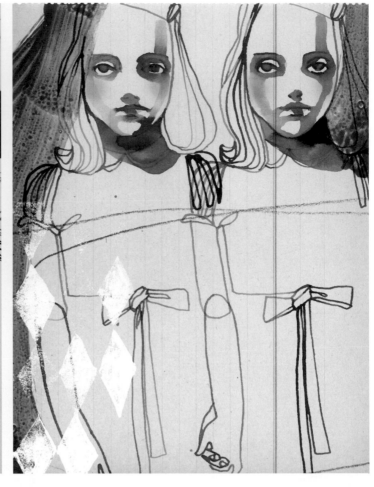

Tina Berning
"Eineiig II" & "Eineiig II"
Designer: Jörn Schwarz
Client: 2Agenten
Credits: Contribution to repre-
sentative's publication ONE
Format: A5
Technique: Mixed
2007

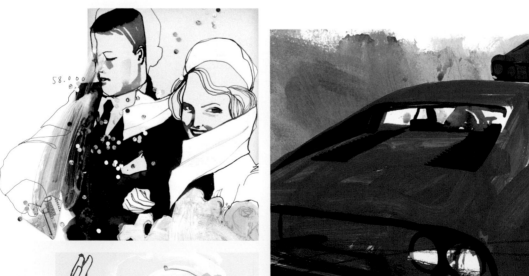

Tina Berning
(left)
"Eine wahre Liebesgeschichte"
Designer: Katja Kollmann
Client: Zeit Magazin LEBEN
Format: Editorial
Technique: Mixed
2007

Tina Berning
(right)
"Hotel Stories II"
Art Direction: Alexander Aczel
Client: Park Avenue
Format: Editorial
Technique: Mixed
2007

Tina Berning
"The Anti-Securalist"
Art Direction: Arem Duplessis
Client: New York Times Magazine
Format: Cover illustration
Technique: China ink, old paper
2007

Lulu *Plasticpirate
"Kindstot"
Personal work
Technique: Collage
2007

Lulu *Plasticpirate
"Plume"
Client: booklet#3 / GoSee.de
Technique: Collage
2006

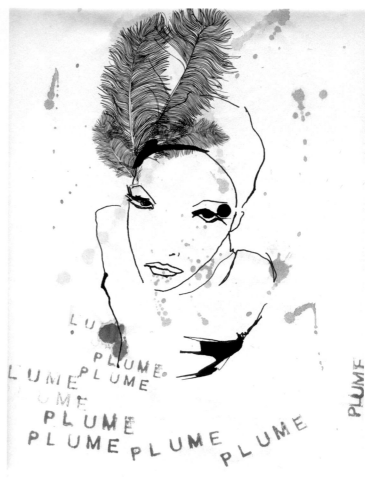

Stephane Tartelin
"Dreams and Nightmares"
Client: Inkthis 2 (group show
in UK)
Technique: Pencil on paper,
digital
2007

Stephane Tartelin
Personal work
Technique: Pencil, ink, digital
2007

Lulu *Plasticpirate
"Swimsuit"
Personal work
Format: Ongoing illustration
project – www.bilderklub.de
Technique: Collage
2007

Chico Hayasaki
"Falling in love with Mimosa"
Format: Original work for solo
exhibition "Yururela Mood"
Technique: Pen, colour ink,
composed in Photoshop
2005

Chico Hayasaki
"The Sunshine Blend Tea"
Client: Hotel Wonder / Milano
Salone's La Perla
Format: Showroom exhibit piece
Technique: Pen, colour ink,
composed in Photoshop
2006

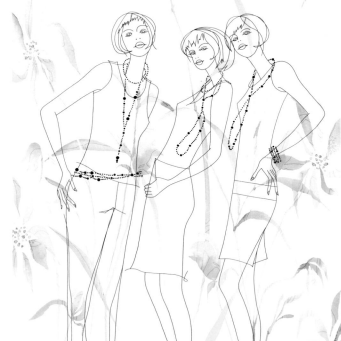

Chico Hayasaki
(left)
Client: Orbis Inc.
Art Direction & Design: Fivesenses
Format: Pamphlet
Technique: Pen, colour ink
composed in Photoshop
2006
Chico Hayasaki
(right)
"Sisters"
Format: Original work for solo
exhibition "Yururela Mood"
Technique: Pen, colour ink
composed in Photoshop
2005

Chico Hayasaki
"Dandelion"
Personal work
Technique: Pen, colour ink,
composed in Photoshop
2005

Chico Hayasaki
Client:
Presentation for Nordstrom
Technique: Pen, colour ink,
composed in Photoshop
2004

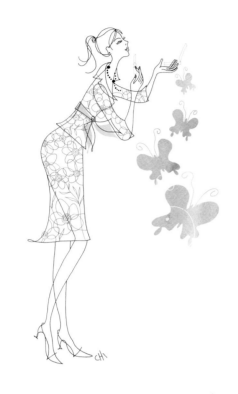

Chico Hayasaki
"Glimmer of Autumn"
Personal work
Technique: Pen, colour ink,
composed in Photoshop
2006

Chico Hayasaki
(right)
Client:
HPV Tell Someone Campaign
Format: E-Card / Magazine Card
Technique: Pen, colour ink,
composed in Photoshop
2005

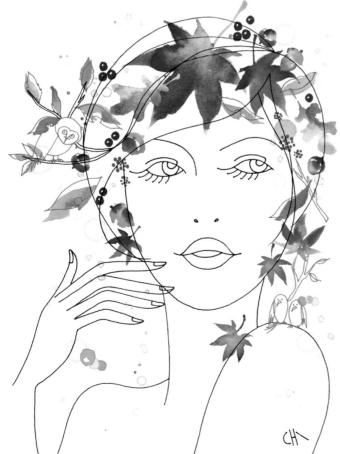

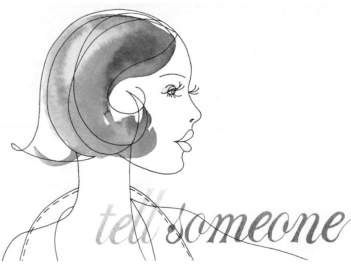

Chico Hayasaki

Denise van Leeuwen
Client: CJP – Culturele Jongeren Pas
Format: Campaign
Technique: Hand-drawn,
Photoshop
2006

Denise van Leeuwen
"Kiss"
Client: CJP – Culturele Jongeren Pas
Format: Campaign
Technique: Hand-drawn,
Photoshop
2006

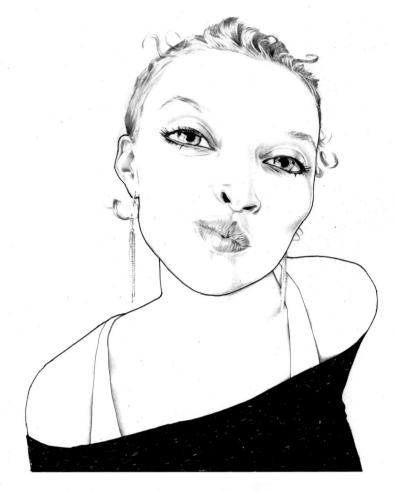

Denise van Leeuwen
(left)
"High Heels"
Client: ELLE Netherlands
Art Direction: Linda Meeuwissen
Format: Editorial
Technique: Hand-drawn,
Photoshop
2007

Denise van Leeuwen
(right)
"Gemini"
Client: ELLE Netherlands
Art Direction: Linda Meeuwissen
Format: Editorial
Technique: Hand-drawn,
Photoshop
2007

Denise van Leeuwen
"De Vonk"
Client: Rails
Art Direction: Vanessa Brouwer
Format: Editorial
Technique: Hand-drawn,
Photoshop
2006

Nani Serrano
Personal work
Technique: Mixed media
2007

Nani Serrano
Client: Revista Magazine –
Primera Linea
Technique: Mixed media
2007

Nani Serrano
(2 illustrations)
Personal work
Technique: Mixed media
2007

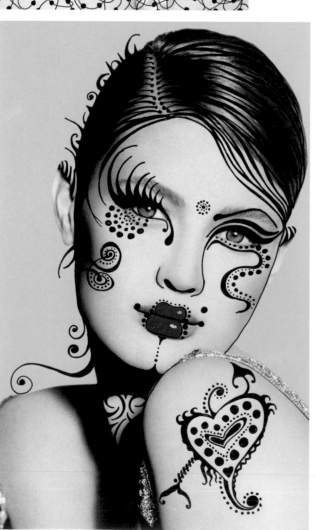

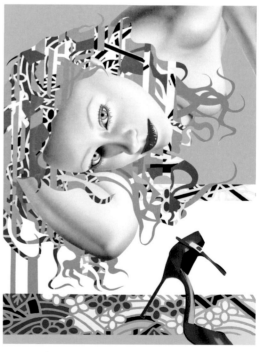

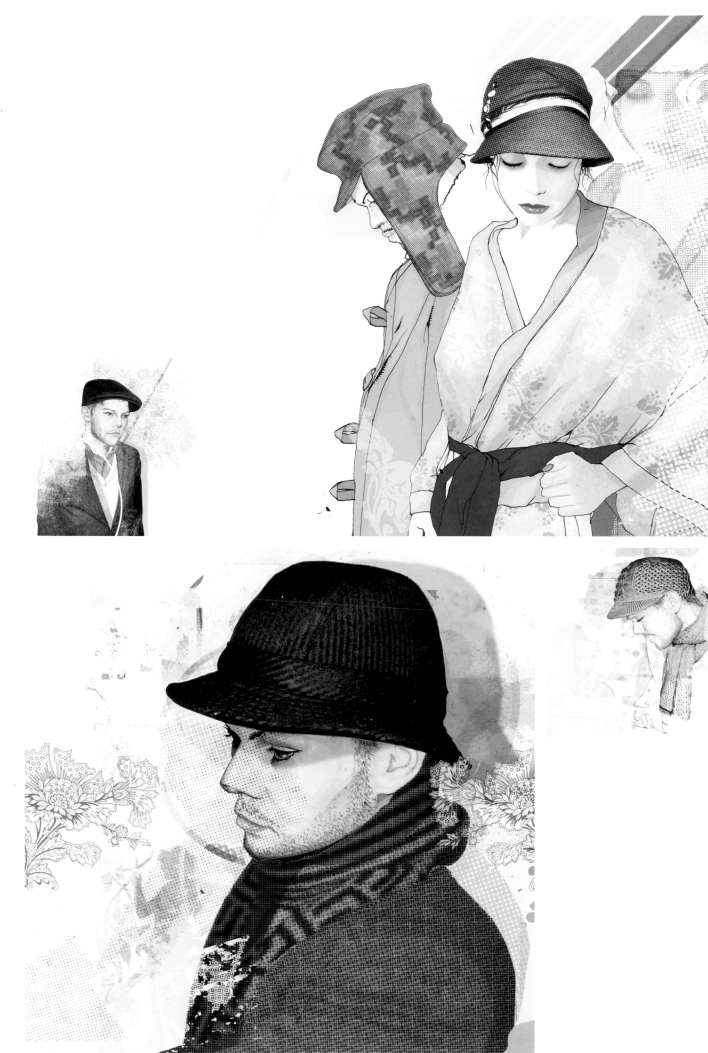

PPaint
(4 illustrations)
Kangol Autumn Winter
2007 Campaign
Client: Kangol
Format: Look book,
point of sale and
worldwide advertising
Technique: Hand-drawn,
collage, ink pen, spray paint,
Illustrator, Photoshop
2006

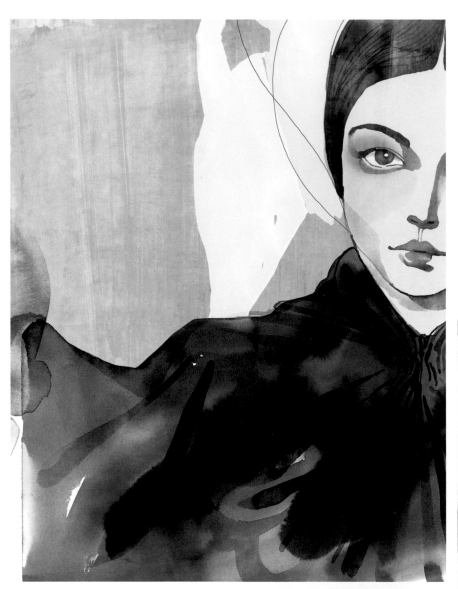

Tina Berning
"Marni"
Designer: Frank Müller,
metaforms
Client: Branche & Business
Fachverlag GmbH
Credits: Forecast Winter 2008
Format: Cover illustration
"Fashion Trends"
Technique: Mixed
2007

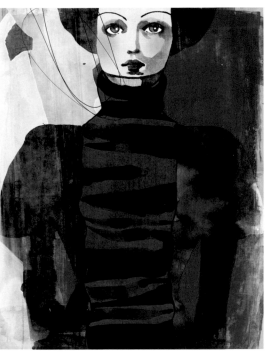

Tina Berning
"Sacral"
Designer: Frank Müller,
metaforms
Client: Branche & Business
Fachverlag GmbH
Credits: Forecast Winter 2008
Format: Editorial
Technique: Mixed
2007

Tina Berning
"Understatement"
Designer: Frank Müller,
metaforms
Client: Branche & Business
Fachverlag GmbH
Credits: Forecast Winter 2008
Format: Cover illustration
"Fashion Trends"
Technique: Mixed
2007

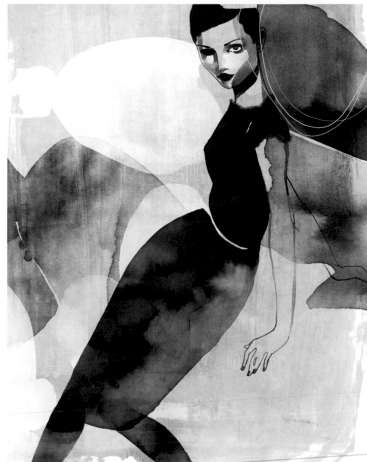

Charlotta Havh
"Miss Green"
Personal work
Technique: Acrylic on canvas
2007

Charlotta Havh
"Vamp"
Personal work
Technique: Mixed media
2007

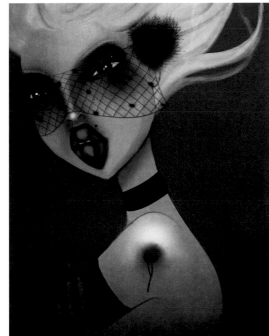

Charlotta Havh
"Autumn"
Personal work
Technique: Print on canvas
2007

Charlotta Havh

I'm JAC | Irene Jacobs
"Weblog Irak"
Client: BLVD
Technique: Photoshop, ink, pen
2006

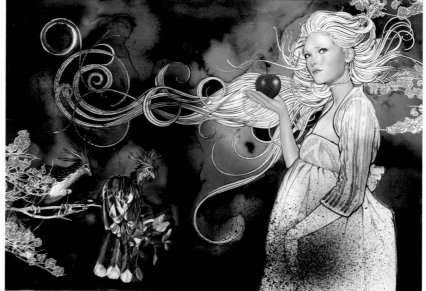

I'm JAC | Irene Jacobs
Client: Computer Arts Magazine
Art Editor: Richard Llewellyn
Format: Cover illustration
for animation issue
Technique: Photoshop, ink, pen
2007

I'm JAC | Irene Jacobs
"Have you ever done something
good in secret"
Client: Jason Schragger
Technique: Pencil, ink, Photoshop
2007

I'm JAC | Irene Jacobs
"Us"
Client: LACE Magazine
Format: Editorial
Technique: Pencil, ink, Photoshop
2006

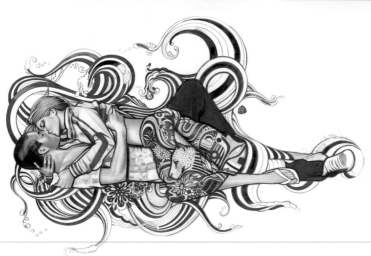

Yoshi Tajima
(left)
"Summer Girl"
Private work
Technique: Drawing,
watercolour, Photoshop
2007

Yoshi Tajima
(right)
Personal work
Technique: Drawing,
watercolour, Photoshop
2007

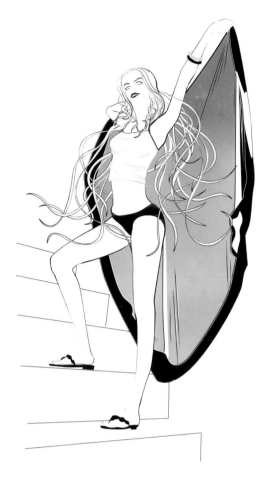

Yoshi Tajima
"Nichika" – 2nd single
Client: R and C Ltd. (Japan)
Format: CD booklet
Technique: Drawing,
watercolour, Photoshop
2007

Yoshi Tajima
"Dream Girl"
Personal work
Technique: Drawing,
waterolour, Photoshop
2006

Yoshi Tajima
"Dancer"
Personal work
Technique: Drawing,
watercolour, Photoshop
2007

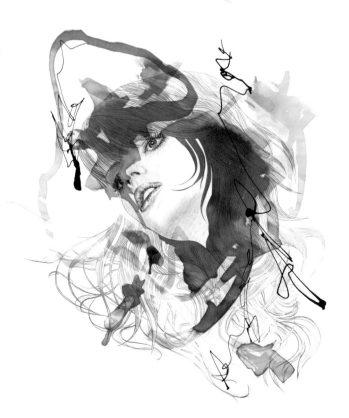

Mirage
"femme assisse"
Designer: Yoshi Tajima,
Takeshi Yonemochi
Client: Gas As Interface
Technique: Drawing, ink,
Photoshop
2006

Yoshi Tajima
"Forest Girl"
Private work
Technique: Drawing,
watercolour, Photoshop
2006

Mirage
Designer: Toshifumi Tanabu,
Takeshi Yonemochi
Client: Gas As Interface
Technique: Drawing, ink,
Photoshop
2005

Yoshi Tajima
"Dreaming"
Private work
Technique: Drawing,
watercolour, Photoshop
2006

Yoshi Tajima
"Butterfly Girl"
Private work
Technique: Drawing,
watercolour, Photoshop
2006

Yoshi Tajima
"8am"
Client: The Creator Studio
(Spain)
Technique: Drawing,
watercolour, Photoshop
2007

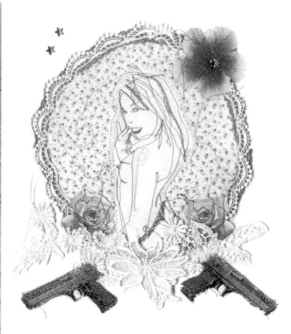

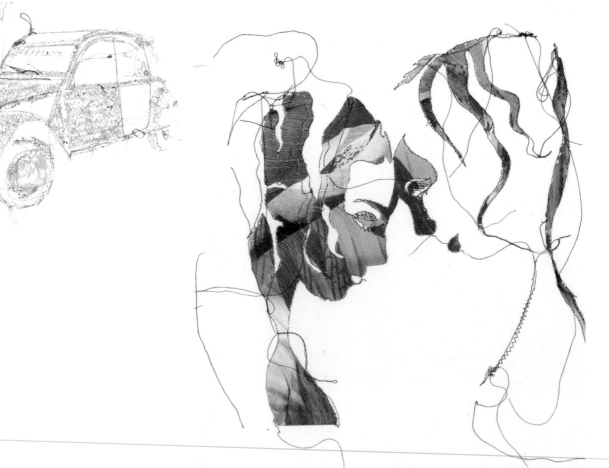

Marloes Duyker
(left)
"Voyez-moi"
Personal work
Technique: Fabrics, Threads
2007

Marloes Duyker
(right)
"Sweet Guns"
Personal work
Technique: Fabrics, threads
2007

Marloes Duyker
Client: Vodafone
Technique: Fabrics, threads
2007

Marloes Duyker
(left)
"2CV"
Personal work
Technique: Fabrics, threads
2007

Marloes Duyker
(right)
"Mothers & Daughters"
Client: Catherine magazine
Technique: Fabrics, threads
2007

Marloes Duyker
"Gold fish"
Personal work
Technique: Fabrics, threads
2007

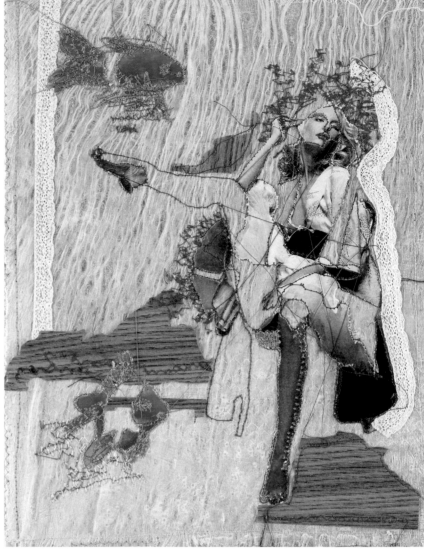

Marloes Duyker
"Volvo"
Client: Volvo Classics Club
Technique: Fabrics, threads
2007

Marloes Duyker
(left)
"Sweet Sixteen"
Client: Young Dogs
(Young Dutch Creatives)
Technique: Fabrics, threads
2007

Marloes Duyker
(right)
"Toxic waste"
Personal work
Technique: Fabrics, threads
2007

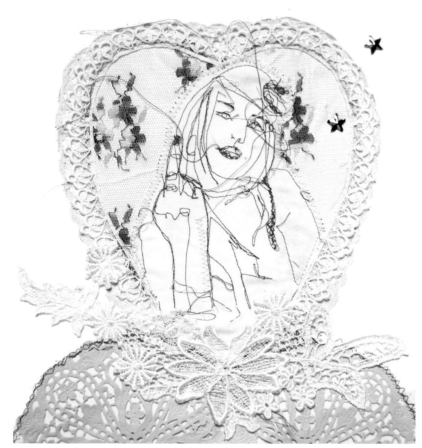

Marloes Duyker

Interview Sandrine Pelletier

Swiss graphic designer and seamstress extraordinaire Sandrine Pelletier loves to refashion life as we know it. After discarding the briefly-held notion of becoming a puppet maker and master, the Paris-based artist and illustrator now makes thread, fabric and society dance to her own tune. Unravelled by her expert eye, everyday situations and snapshots of reality find themselves stripped bare, plucked apart and stitched back together with gossamer threads of twisted identity. Never one to tie up loose ends, she invites us to spin our own stories and enjoy these (un)finished tapestries and excursions into subculture's thriving underbelly.

Background

Drawing has always been a major part of my life. Looking back, I remember early finger-painting exercises of corpses, insects, dragons and monsters. I also recall a strange obsession with hair—my first Barbie dolls were pencil-customised with extreme effusions of body hair. No idea where this might have come from as I enjoyed a very sweet, tolerant and peaceful upbringing in tranquil Switzerland. However, I was always transfixed by my grandparents' weird and greatly humorous and grotesque stories on the absurdities of everyday life.

Not terribly popular or attractive at school, I spent a lot of time on my own comic strips and satirical cartoons. Years later, as part of an arts course in Lausanne, I started to experiment with many different techniques, from etch-a-sketch and mosaic to pencil, vector images and graphic design. My current staple, the sewing machine, made its first appearance during my graduate project on British backyard wrestlers. I wanted to portray them like warriors on ancient heroic tapestries, yet combine this aesthetic with an underground sociological study.

Skills and Techniques

In addition to my formal training, I also taught academic drawing for several years. I still consider classical training an important basis for future development. Naturally, it can only ever be a springboard, but it helps. Besides a firm grasp of the tools of the trade, it is mostly about the ability to spend hours on end focussed on one point, one canvas, to repeat the same process, the same gesture a thousand times.

At the same time, I thrive on the curiosity that comes with learning the ropes and acquiring a new skill. If I feel that my work requires knitting, I'll watch, learn, and try to keep up with my grandma's incredible techniques, then attempt to recreate them with my own subjects and perspectives. I have a great respect for traditional skills, craft and arts.

Inspiration and Influences

Although my degree makes me a graphic designer, I have always had a strong affinity to all things tactile and 3D. Before the graphic design, I worked as a display designer and got involved with Muppet manufacture. I guess all this—plus my fascination for popular and traditional art mixed with contemporary subjects—has shaped my current style.

Further important influences include folklore from different cultures, all kinds of subcultural ramifications, the alternative music and underground scenes of my youth plus outstanding literature, art and illustrations by the likes of John Martins, Carlos Schwabe, William Morris, Moebius, Ernst Haeckel, Jim Henson and Aubrey Beardsley. And, lest we forget, I grew up right next to Lausanne's impressive Art Brut Museum.

My current aesthetics are also shaped by Alexandra Ruiz, my partner in crime from Madame Paris, and still-life wizard Erwan Frotin. We all met at ECAL (University of Art and Design Lausanne) and continue to share ideas, projects and envies for future world domination (laughs).

Featured Works

I don't limit myself to needle and thread, but clearly most people remember me for my textiles and embroideries. For example, recent collaborations with fashion stylists such as Tsumori Chisato and Vanessa Bruno resulted in installations with 3D objects and Muppets. I don't consider myself a "textile artist", but rather someone who uses a sewing machine, arts and craft techniques and folkloristic, mundane sources for her illustrations. At the same time, I continue to explore other techniques, e.g. rough and simple black and white drawings with established Swiss typefaces. Sometimes, a good, "dry" vector drawing can be very relaxing after all those fabrics and laces... Branching out even further, I am currently working on an animated movie and a ceramics project for future exhibition.

Sandrine Pelletier | Maskara
"IC Perfume Advert"
Client: Isabela Capeto
Art Direction: Surface to Air, Paris
Photography: Erwan Frotin
Technique: Fabrics, threads,
installation
2007

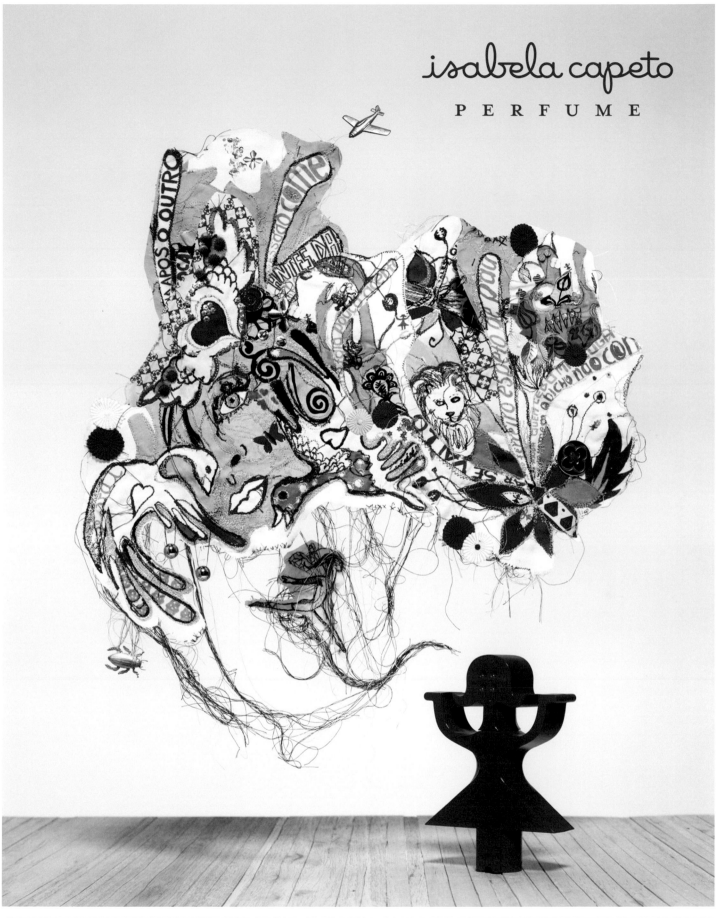

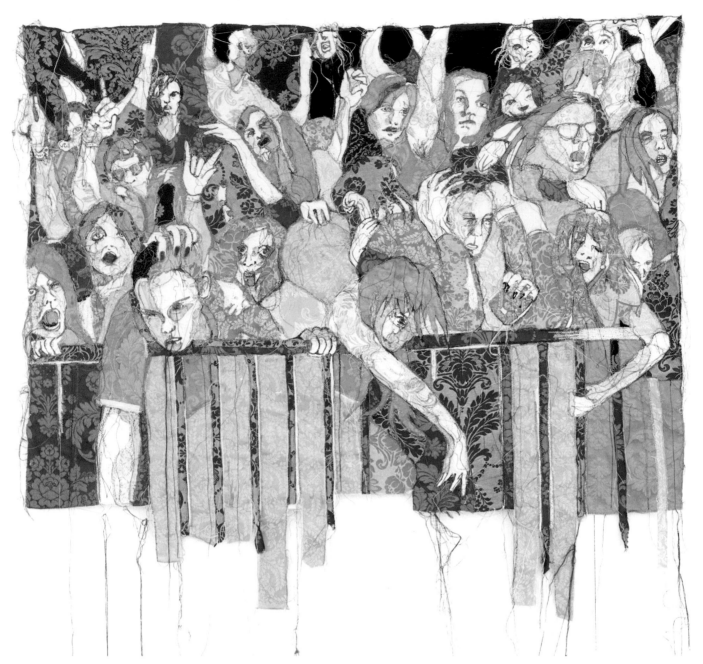

Sandrine Pelletier | Maskara
"Fleisch"
Client: Galerie Lucy Mackintosh,
Lausanne
Technique: Fabrics, threads
2007

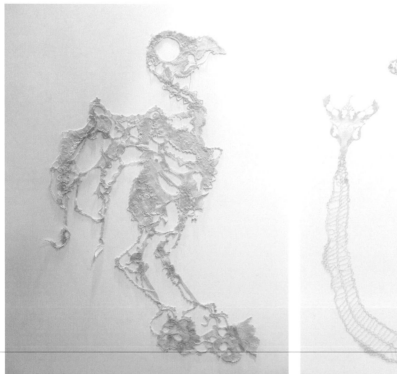
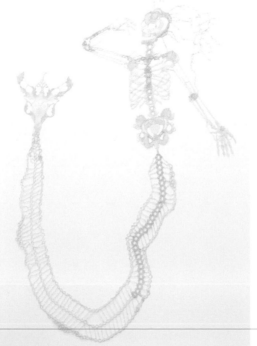

Sandrine Pelletier | Maskara
(left)
"Skeleton 1 (Bird)"
Client: Gallery Taché-Levy,
Brussels
Credits: Art Brussels 07
Technique: Lace, latex, resin
2007

Sandrine Pelletier | Maskara
(right)
"Nage Macabre"
Client: Gallery Taché-Levy,
Brussels
Credits: Volta Show 07, Basel
Technique: Lace, latex, resin
2007

Sandrine Pelletier | Maskara
"Gloomy Sunday"
Client: Gallery Taché-Levy,
Brussels
Credits: Art Brussels 07
Technique: Fabrics, threads, lace
2007

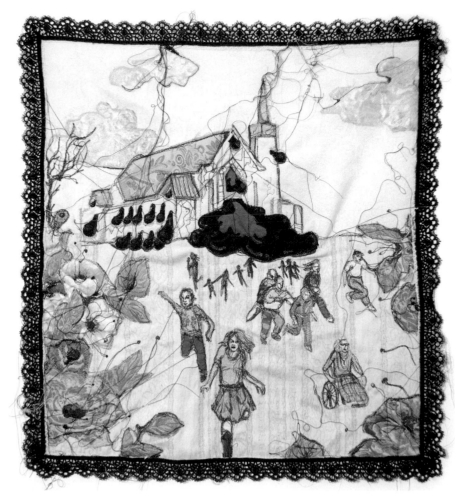

Sandrine Pelletier | Maskara
"Hirschkind"
Client: Gallery Taché-Levy,
Brussels
Credits: Art Brussels 07
Technique: Embroidery,
watercolour, tea, animal blood
2007

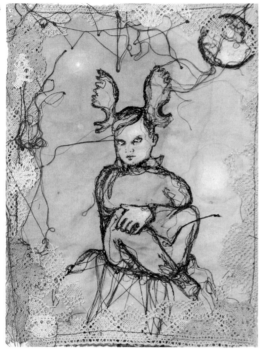

Sandrine Pelletier | Maskara
(left)
"Zombie 2"
Client: Gallery Lucy Mackintosh,
Lausanne
Technique: Embroidery,
watercolour, tea, animal blood
2007

Sandrine Pelletier | Maskara
(right)
"Les Pisseuses"
Client: Gallery Taché-Levy,
Brussels
Technique: Fabrics, threads,
lace
2005

Sandrine Pelletier | Maskara

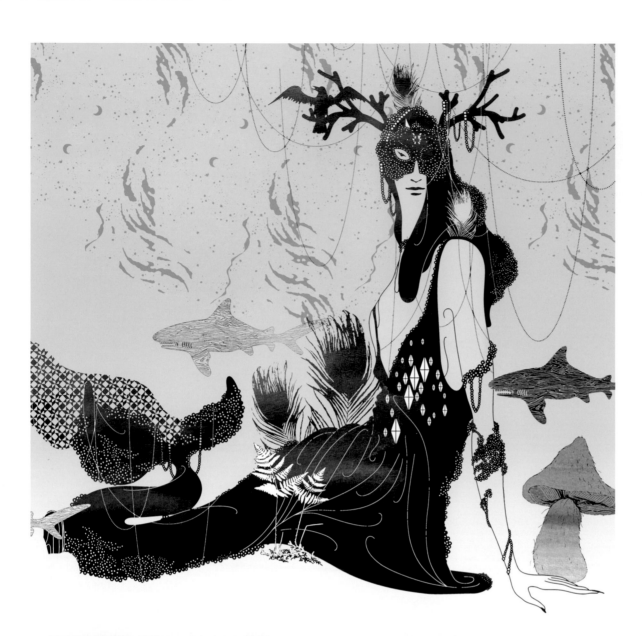

Kustaa Saksi
"Mermaid"
Client: Catskills Records,
Husky Rescue
Format: Sleeve design
Technique: Mixed media
2007

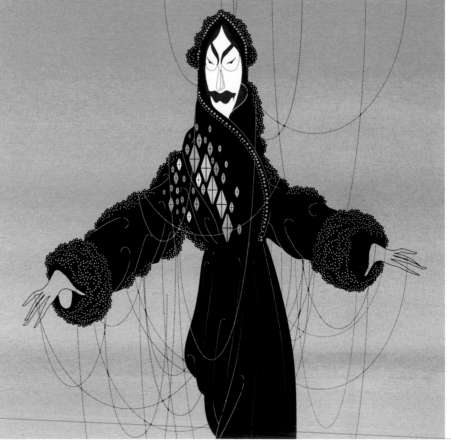

Kustaa Saksi
(left 1)
"Crabs
Client: Nuke
Format: Editorial
Technique: Mixed media
2007

Kustaa Saksi
(right)
"Homeghost
Client: Catskills Records
Husky Rescue
Format: Sleeve design
Technique: Mixed media
2007

Kustaa Saksi
"Glamour
Client: Swarovski
Format: Promotional
Technique: Mixed media
2007

Jan Oksbøl Callesen
"New Diplomacy Cover"
Client: DJØF
Format: Magazine cover
Technique: Mixed media,
Photoshop
2006

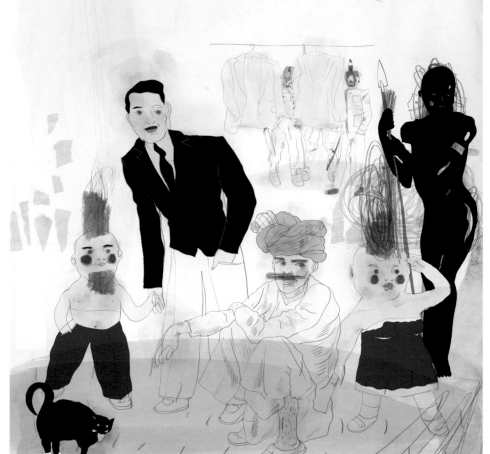

Jan Oksbøl Callesen
"Tropical Shadows"
Client: CIFF
Format: Fashion illustration
Technique: Mixed media,
Photoshop
2006

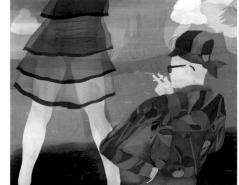

Jan Oksbøl Callesen
(left)
"New Diplomacy"
Client: DJØF
Format: Editorial
Technique: Mixed media,
Photoshop
2006

Jan Oksbøl Callesen
(right)
"North Summer Light"
Client: CIFF
Format: Fashion illustration
Technique: Mixed media,
Photoshop
2006

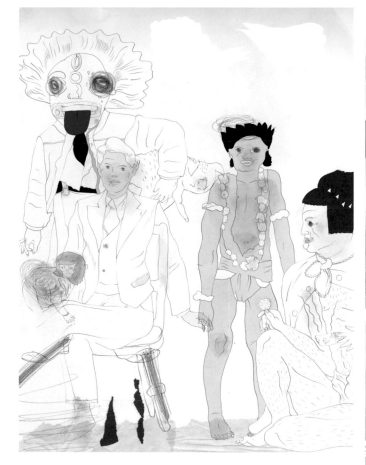

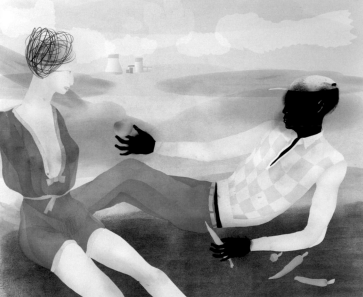

Jan Oksbøl Callesen
"First Class Cruise"
Client: CIFF
Format: Fashion illustration
Technique: Mixed media,
Photoshop
2006

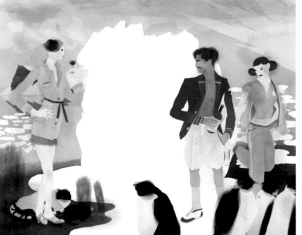

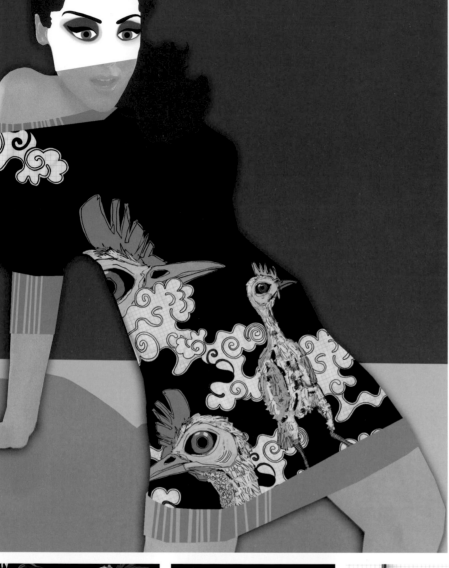
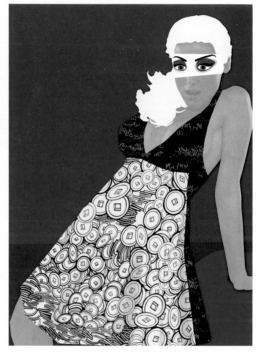

Vicki Fong
(5 illustrations)
Technique: Pen, ink, gouache,
collage and Photoshop
2006

Linn Olofsdotter
(right)
"The Bouquet"
Client: Samsung
Credits: AD Fredrik Svalstedt /
Leo Burnett Stockholm
Format: Ad campaign
Technique: Mixed media
2007

Linn Olofsdotter
Client: Plaza Magazine
Format: Editorial
Technique: Mixed media
2007

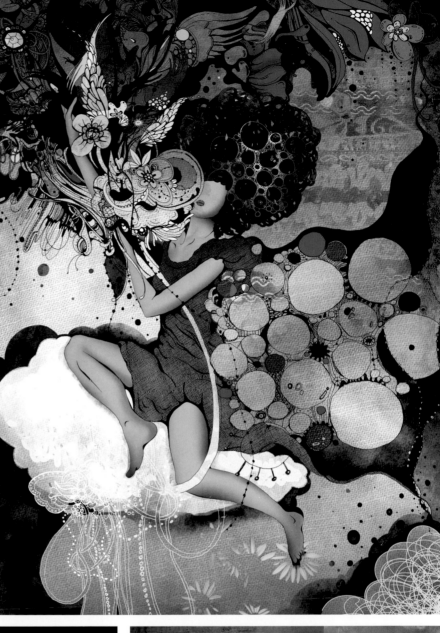

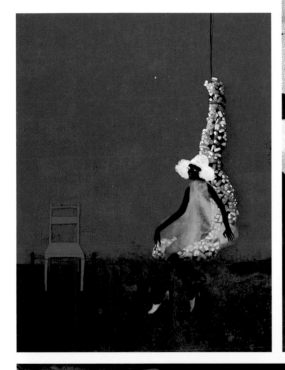

Linn Olofsdotter
(left)
"Dive"
Client: Samsung
Credits: AD Fredrik Svalstedt /
Leo Burnett Stockholm
Format: Ad campaign
Technique: Mixed media
2007

Linn Olofsdotter
(right)
Client: Plaza Magazine
Format: Editorial
Technique: Mixed media
2007

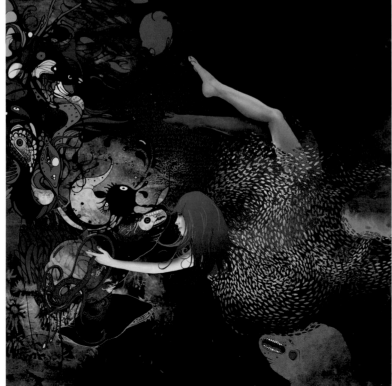

Linn Olofsdotter
69 | Fashion & Style

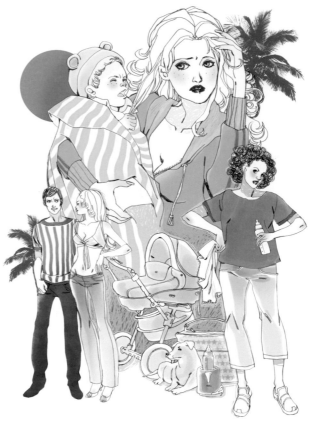

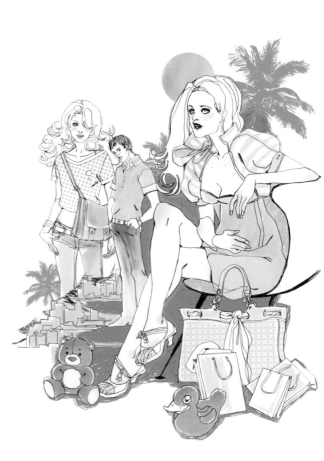

Marguerite Sauvage
(left)
"These blond beauties coming
from cold countries in the 70s"
Client: Senso Magazine
Technique: Hand-drawn with
pencil, colour in Photoshop
2005

Marguerite Sauvage
(right)
"Girls in the city: a mum in LA"
Client: Marabout Publishing/
Hachette
Format: Book cover
Technique: Hand-drawn with
pencil, colour in Photoshop
2007

Marguerite Sauvage
"Girls in the city: a baby in LA"
Client: Marabout Publishing/-
Hachette
Format: Book cover
Technique: Hand-drawn with
pencil, colour in Photoshop
2007

Marguerite Sauvage
"Cups of Tea" & "Pudeur"
Client: Exquise Design
Exhibition of women artists
around the topic of female self
fantasy and sexuality
Technique: Hand-drawn with
pencil, colour in Photoshop
2007 Fashion & Style

Marguerite Sauvage
"Mother(s) Nature" &
"In a woman life"
Client: Grafuck book
Technique: Hand-drawn with
pencil, colour on Photoshop
2007

Sofia Dias
"Aquarius"
Personal work
Technique: Digital
2007

Lotie
"Bag U should I & II"
Client: Dialect Recordings, Paris
Format: Record sleeves
Technique: Hand-drawn,
Photoshop
2005

Sofia Dias
"The Mistress"
Client: NS'
Format: Magazine
Technique: Digital
2007

Sofia Dias
(left)
"Astrological sign: Aquarius"
Personal work
Technique: Digital
2007

Sofia Dias
(right)
"Umbrella"
Designer: Raquel Porto
Client: silva Designers!
Format: Cover of Lisbon's
Cultural Agenda (April)
Technique: Digital – vectorial
2007

Maya Shleifer
Self-promotion
Technique: Digital
2006

Maya Shleifer
(2 illustrations)
"Dog's Star" by Hagar Yanay
Client: www.maarav.co.il
Technique: Hand-drawn,
Photoshop
2007

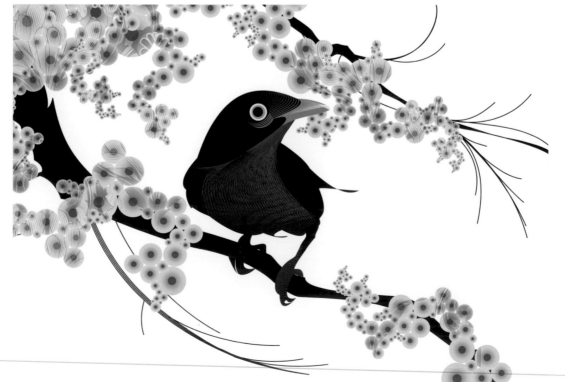

Maya Shleifer
Self-promotion
Technique: Digital
2006

Stephane Tartelin
"She's so fine"
Personal work
Technique: Digital
2004

Stephane Tartelin
"The poet you never were"
Personal work
Technique: Pencil, digital
2004

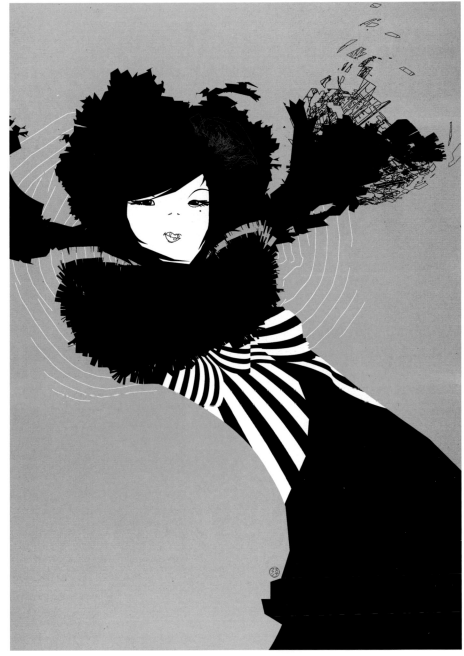

Stephane Tartelin
"Give me a cloud"
Personal work
Technique: Pencil, digital
2004

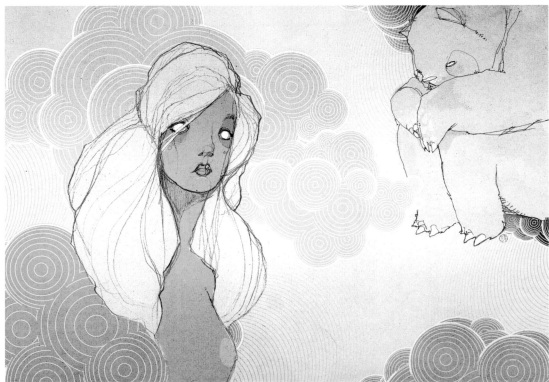

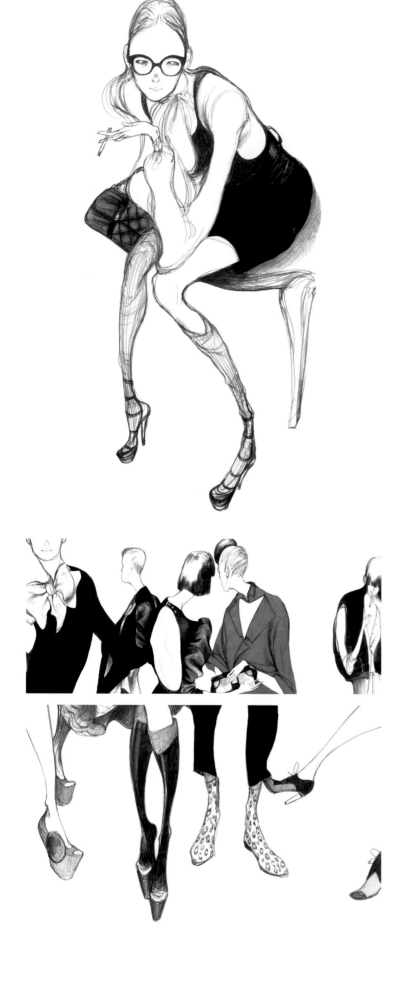

Laura Laine
(5 illustrations)
Client: Pap Magazine
Format: Editorial
Technique: Hand-drawn
2006

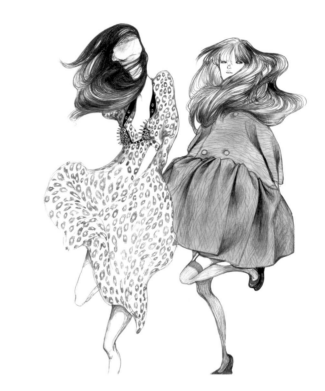

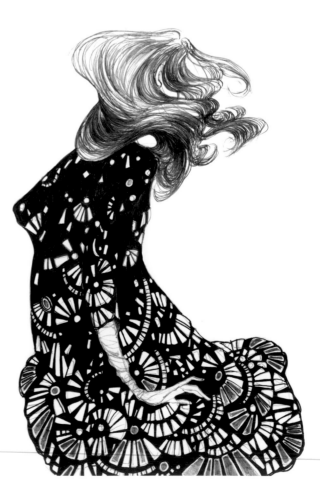

The Dead Pony
"Lost and weak"
Designer: Raphaël Vicenzi /
Mydeadpony
Personal work
Technique: Photoshop
and watercolours
2007

The Dead Pony
(left)
"Spoiled"
Designer: Raphaël Vicenzi /
Mydeadpony
Personal work
Technique: Photoshop,
watercolours and Illustrator
2007

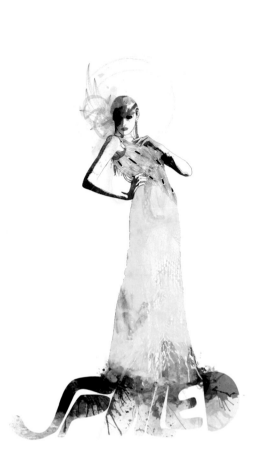

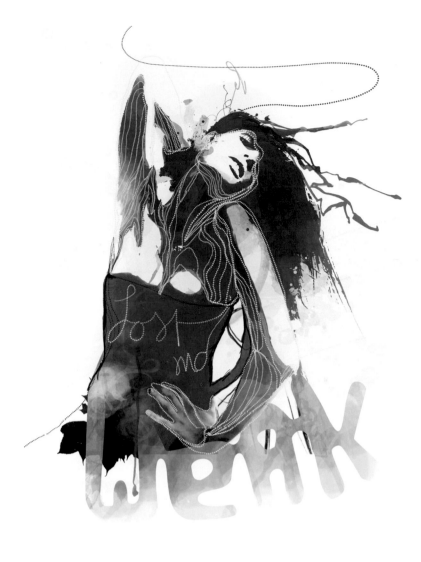

The Dead Pony
(left)
"The Economy"
Designer: Raphaël Vicenzi /
Mydeadpony
Personal work
Technique: Photoshop
and watercolours
2007

The Dead Pony
(right)
"The Gods of fashion hate me"
Designer: Raphaël Vicenzi /
Mydeadpony
Personal work
Technique: Photoshop
and watercolours
2007

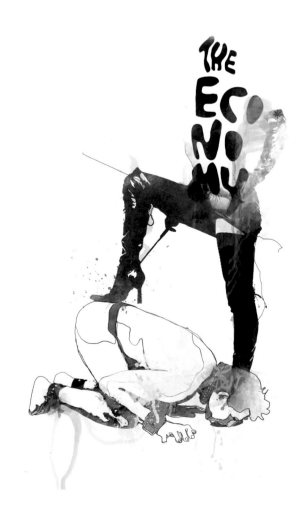

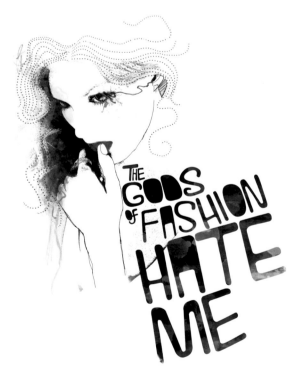

Lotie
(left)
Personal work
Technique: Hand-drawing,
Photoshop

Underwerket
(right)
Client: Ana Sui
Technique: Ink
2007

Underwerket
(2 illustrations)
Personal work
Technique: Mixed media
2007

Underwerket
(left)
Personal work
Technique: Mixed media
2007

Underwerket
(right)
Client: Nylon Magazine, USA
Format: Editorial
Technique: Mixed media
2007

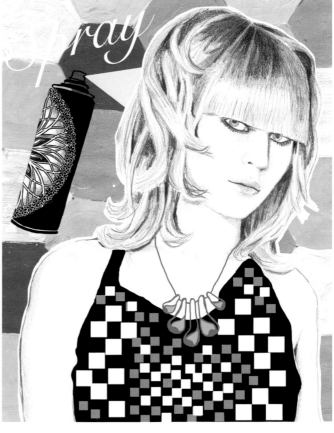

Ivan Soldo
(3 illustrations)
Client: Blanco
Format: Exhibited in Spanish
Technique: Mixed
2005

Ivan Soldo
"Gallaino"
Client: Vogue Spain – Bebraury
Format: Editorial
Technique: Mixed
2007

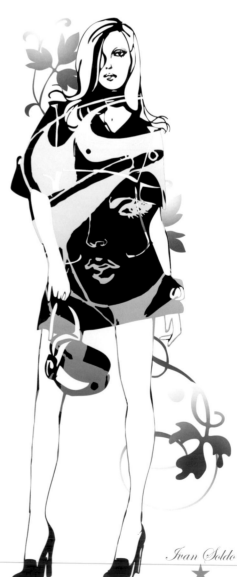

Dirk Rudolph
"Ich & Ich"
Client: Universal
Format: CD-covers, rejected
Technique: Mixed media
2007

Jun | Ufho
(left)
"Flood"
Client: BlackFlood book
Technique: Digital illustration
2005

Dirk Rudolph
Jun | Ufho

Anna Giertz
(left, 2 illustrations)
"Long before September"
Personal project
Drawings to poems by
Kristina Ribeiro
Format: Book
Technique: Drawings
2006

Anna Giertz
(right)
"060423"
Client: Co-op
Format: Magazine
Technique: Drawing
2006

Anna Giertz
(left)
"Long before September"
Personal project
Drawings to poems by
Kristina Ribeiro
Format: Book
Technique: Drawings
2006

Anna Giertz
(right)
"Goodnight"
Client: Dong Magazine
Format: Magazine
Technique: Graphite
2007

Anna Giertz

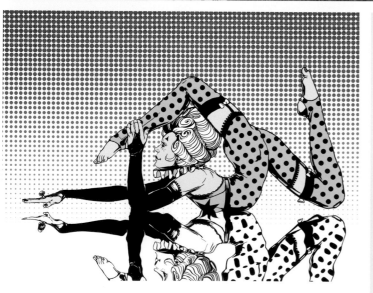

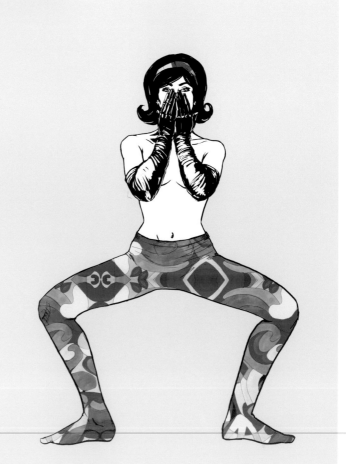

Zela Lobb
"Betty Page"
Client: Risen Magazine
Technique: Digital
2006

Zela Lobb
Technique: Digital
2007

Zela Lobb
(left)
"Contortionist"
Client: Renee Masoomian
Technique: Digital
2006

Zela Lobb
(right)
"Tights"
Self-directed
Technique: Digital
2007

Saeko Ozaki
(4 illustrations)
Client: The Sunday Times Style
Magazine
Format: Digital
Technique: Illustrator, Photoshop
2007

Saeko Ozaki
Self-promotion
Technique: Illustrator, Photoshop
2007

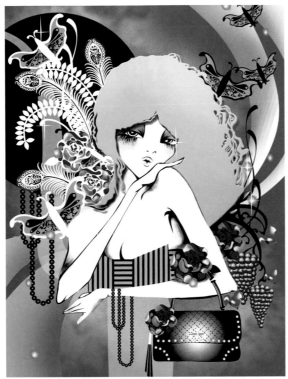

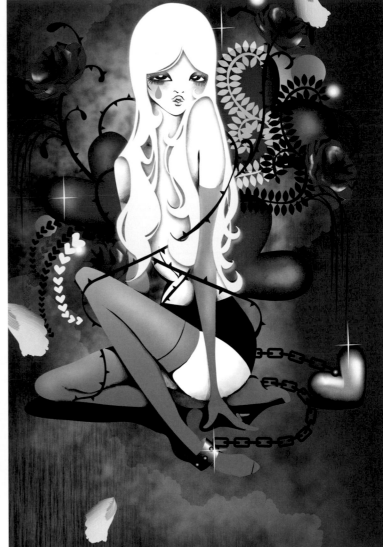

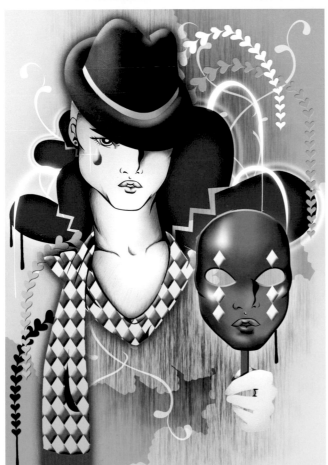

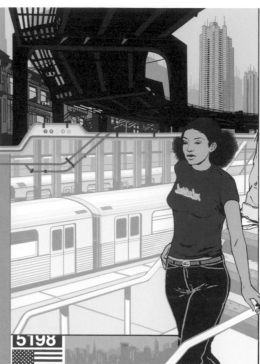

Ytje Veenstra
(left)
"Missy Elloitt"
Uncommissioned
Technique: Hand-drawn
in Photoshop
2006

Ytje Veenstra
(right)
"Tracey Towers"
Uncommissioned
Technique: Hand-drawn
in Photoshop
2005

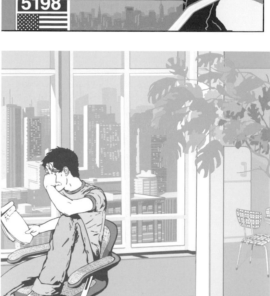

Ytje Veenstra
"Weihnacht"
Format: Personal Christmas card
Technique: Hand-drawn
in Photoshop
2006

Ytje Veenstra
(right)
"Little by Little"
Client: Harvey Danger (Seattle)
Art Direction: Aaron Huffman
Format: Album cover
Technique: Hand-drawn
in Photoshop
2005

Ytje Veenstra
"Lexington Ave, NYC"
Uncommissioned
Technique: Hand-drawn
in Photoshop
2005

Ytje Veenstra
" Jay-Z"
Uncommissioned
Technique: Hand-drawn
in Photoshop
2006

Ytje Veenstra
(left)
"Beyoncé"
Uncommissioned
Technique: Hand-drawn
in Photoshop
2007

Ytje Veenstra
(right)
"Berlin/Volksbühne"
Uncommissioned
Technique: Hand-drawn
in Photoshop
2006

Ytje Veenstra
(left)
"Gage"
Uncommissioned
Technique: Hand-drawn
in Photoshop
2007

Ytje Veenstra
(right)
Client: Playboy Germany
Art Direction: Parvin Nazemi
Format: Editorial
Technique: Hand-drawn
in Photoshop
2007

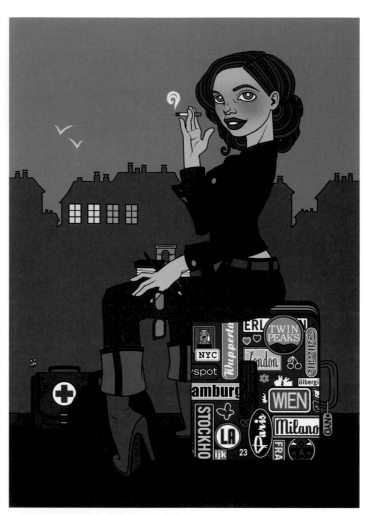

Iris Luckhaus
(left)
"Pearlie Mae Goes Shopping"
Client: Label Suite
Format: Flyer, stand-up
Technique: Pen and ink
2006

Iris Luckhaus
(right)
"Ich hab' noch einen
Koffer in Berlin"
Client: IO
Format: Postcard
Technique: Pen and ink
2007

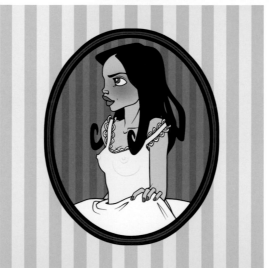
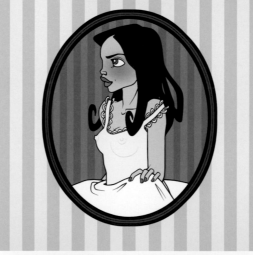

Iris Luckhaus
(left)
"Mein Leben mit Mitsu"
Designer: Iris Luckhaus,
Angels & Demons
Client: Brandneu Verlag
Format: Book cover
Technique: Pen and ink
2005

Iris Luckhaus
(right)
"Nana (Sleeping Beauty)"
Client: Druckstock
Format: Art print
Technique: Pen and ink
2007

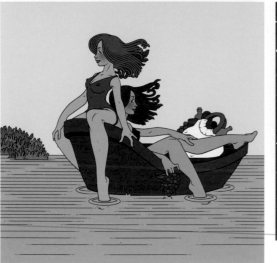

Iris Luckhaus
"Bootsausflug"
Client: Druckstock
Format: Art print
Technique: Pen and ink
2007

Iris Luckhaus
" Angie (Unique As A Snowball)"
Client: Posterlounge
Format: Art print
Technique: Pen and ink
2006

Iris Luckhaus
"Pirschjagd"
Designer: Andreas Rauth
Client: Jitter Magazin
Format: Art print
Technique: Pen and ink
2006

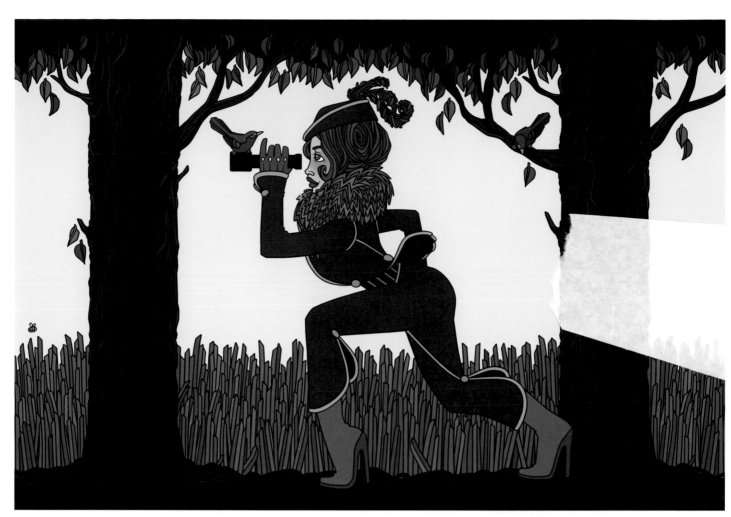

Iris Luckhaus
(left)
"Ginger (Aprés Soleil)"
Client: Druckstock
Format: Art print
Technique: Art print
2006

Iris Luckhaus
(right)
"Picknick"
Client: Druckstock
Format: Art print
Technique: Pen and ink
2007

Iris Luckhaus
"Orlando"
Client: Posterlounge
Format: Art print
Technique: Pen and ink
2006

Digitalink
"AlphaCat – Dead-End"
Designer: Timo Schlosser
Free work
Format: Print for exhibition
Technique: Digital
2006

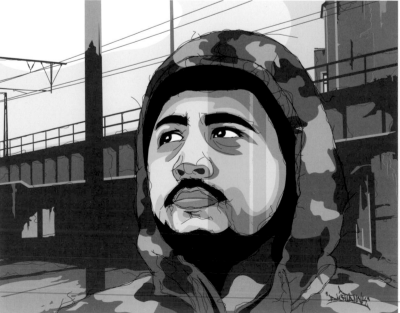

Digitalink
(left)
"Bacteria Babe"
Designer: Timo Schlosser
Free work
Format: Fine art print, poster
Technique: Digital
2007

Digitalink
(middle)
"Fuat – Backyard"
Designer: Timo Schlosser
Free work
Format: Print for exhibition
Technique: Digital
2006

Digitalink
(right)
"Vanessa Mayhem"
Designer: Timo Schlosser
Free work
Format: Print for exhibition
Technique: Digital
2007

Digitalink

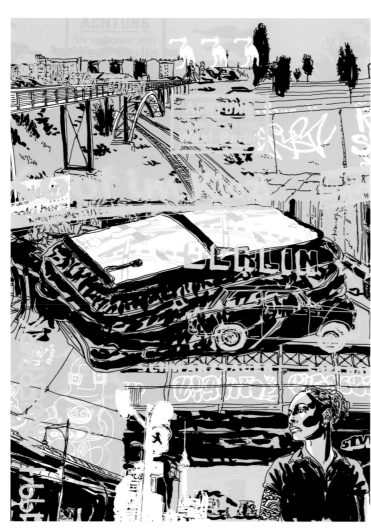

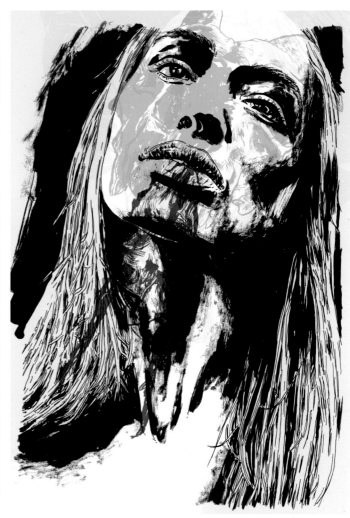

Jan Feindt
93 | Fashion & Style

Won ABC
(4 illustrations)
Client: Carhartt Europe
Format: Print campaign
Technique: Pencil, acrylic,
Photoshop
2007

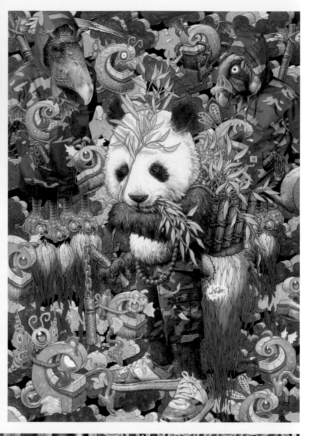

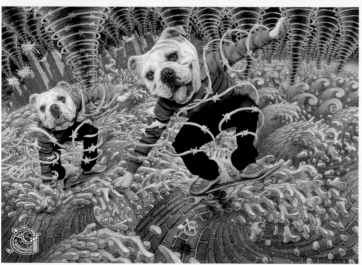

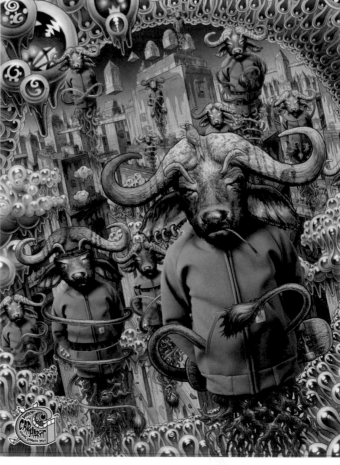

Won ABC
Client: Carhartt Europe
Format: Print campaign
Technique: Pencil, acrylic,
Photoshop
2007

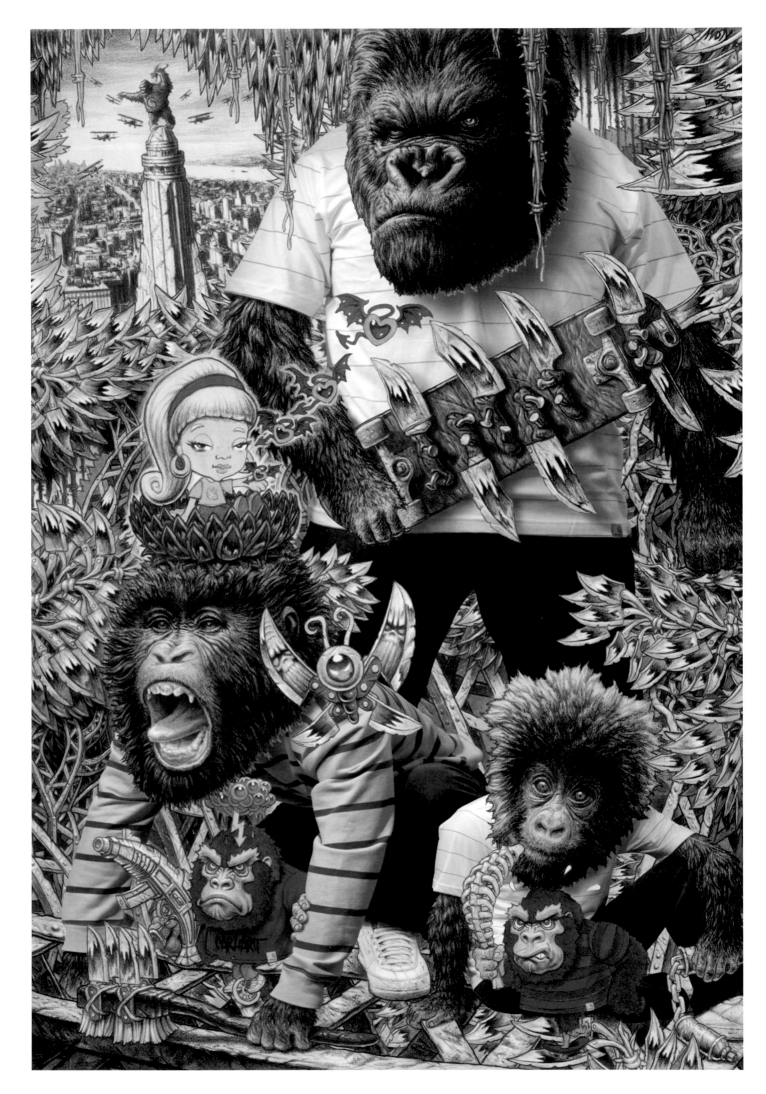

Pattern & Surfaces

Textile and surface design are among the oldest examples of applied illustration. Depending on an era's visual predilections, different aspects will move to the fore—think 1960s Op-Art or the bold floral effusions of the 1970s.

Picking up on a wealth of markers from antiquity to the digital age, our foray into the realm of patterns, textiles and abstract structures sees history repeating itself. This chapter also presents the wallpaper effect of self-replicating reel-to-reel illustrations and its countless variants on fabrics, murals and other surfaces.

Exceptionally well suited to these flat media, patterns require a different tack to stand-alone illustrations. Often based on limited colour schemes, the joy of encryption through fragmentation, repetition and juxtaposition is fuelled by the tension between the superficial image and its underlying meaning. Here, nothing is sacred: from wildlife and fossils to beautiful orchestrations of Hoovers and kitchen knives. From charming simplicity to overt extravagance, these different levels of perception—shifting focus between individual feature and overall pattern—add further complexity to the design.

In this spirit, many of the works assembled here savour their intricacy, their elliptical eddies and aesthetic detours. Assembling some truly timeless and timely examples, their organic proliferations grow into fascinating, self-evolving entities. The illustrator himself might take a back seat to let them explore their natural ramifications—a redundant luxury, but a delightful one.

Martin Nicolausson
"The Reach"
Personal work
Format: T-shirt print
Technique: Hand-drawn,
Illustrator
2006

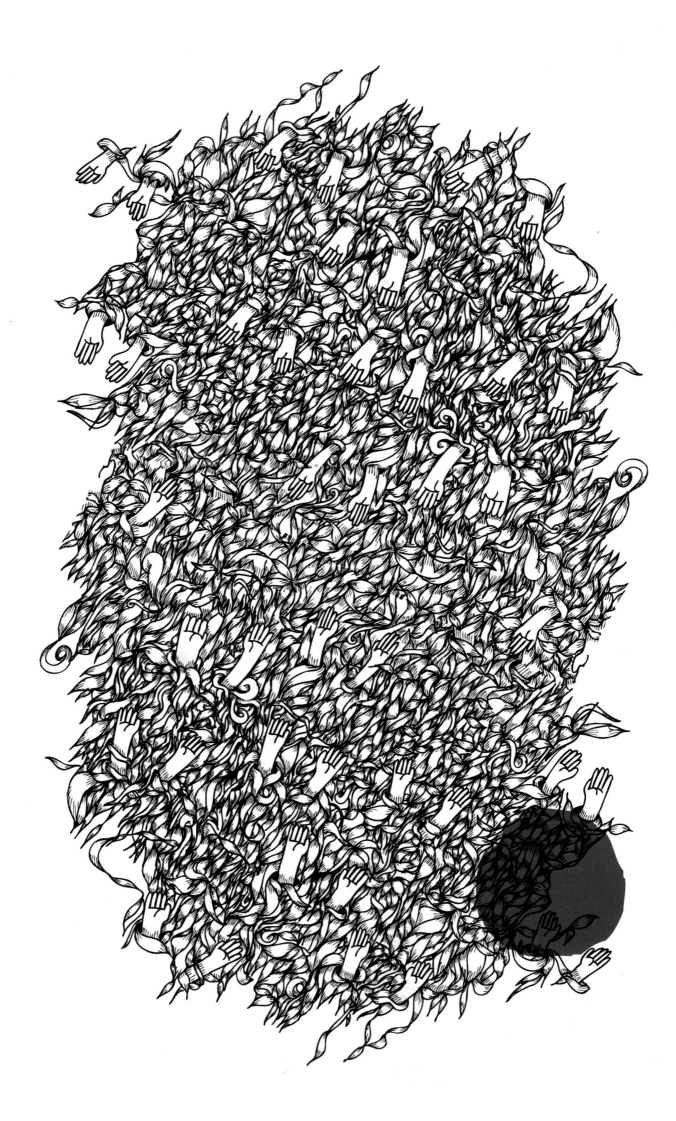

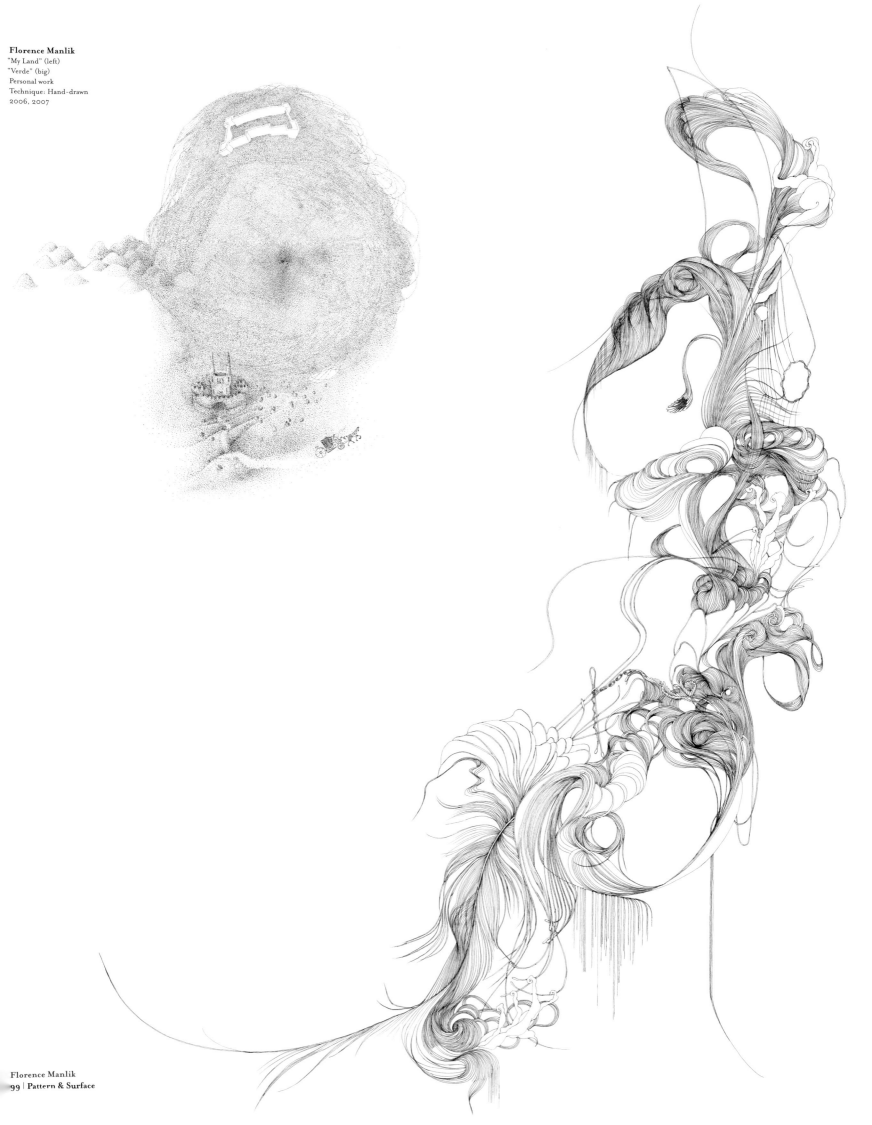

Florence Manlik
"My Land" (left)
"Verde" (big)
Personal work
Technique: Hand-drawn
2006, 2007

Paul Willoughby
"Willo Pattern"
Client: Little White Lies
Format: Editorial
Technique: Mixed media
2007

Paul Willoughby
"Romance Pattern"
Client: Little White Lies
Format: Editorial
Technique: Mixed media
2006

Kate Sutton
(2 illustrations)
Client: Urban Outfitters
Format: Cushion design
Technique: Hand-drawn
2007

Apfel Zet
Client: Plotki Magazin
Format: Endpaper pattern for
Plotki Magazine – Nightshift
Technique: Freehand
2006

Apfel Zet
Client: International Endohernia
Society
Format: Endpaper pattern for
Program 2nd Meeting
Technique: Freehand
2005

Paul Willoughby
"80's Icons"
Client: Little White Lies
Format: Editorial
Technique: Mixed media
2007

Paul Willoughhy
"Vollver pattern"
Client: Little White Lies
Format: Editorial
Technique: Mixed media
2006

Paul Willoughby
Apfel Zet

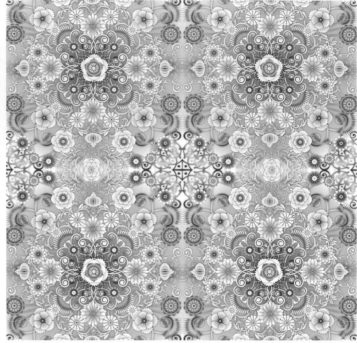

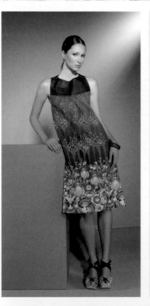

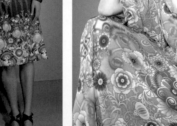

Catalina Estrada Uribe
"Animals"
Client: 1973
Format: Gift paper
Technique: Digital
2006

Catalina Estrada Uribe
"Anunciaçao Verao 08"
Client: Anunciaçao
Format: Textile pattern
Technique: Digital
2007

Catalina Estrada Uribe
(left)
"Animals in London parks"
Client: Paul Smith
Format: Textile pattern
Technique: Digital
2007

Catalina Estrada Uribe
(left & middle)
"Anunciaçao Verao 08"
Client: Anunciaçao
Designer: Maria Elvira Crosara
Photo: Rogerio Mesquita
Format: Textile pattern
Technique: Digital
2007

Catalina Estrada Uribe
"Mosquito & Swallows"
Client: Personal work
Format: Gift paper
Technique: Digital
2007

Catalina Estrada Uribe
"Bambi"
Client: 1973
Format: Gift paper
Technique: Digital
2006

Catalina Estrada Uribe
"Anunciaçao Verao 08"
Client: Anunciaçao
Format: Textile pattern
Technique: Digital
2007

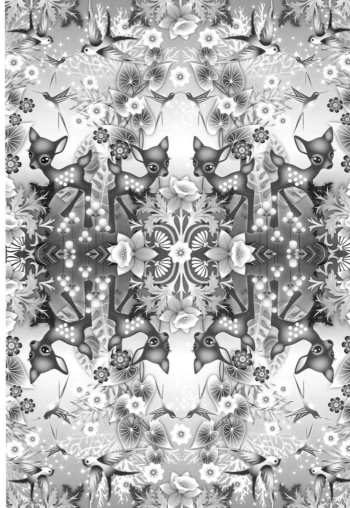

Catalina Estrada Uribe
(left & middle)
"Anunciaçao Verao 08"
Client: Anunciaçao
Designer: Maria Elvira Crosara
Photo: Rogerio Mesquita
Format: Textile pattern
Technique: Digital
2007

Catalina Estrada Uribe
(right)
Client: Paul Smith
Format: Textile pattern
Technique: Digital
2007

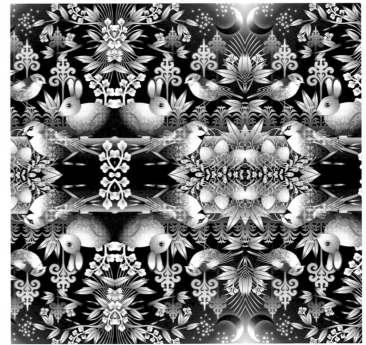

Catalina Estrada Uribe
"Dark Forest"
Client: Anunciaçao
Format: Textile pattern
Technique: Digital
2007

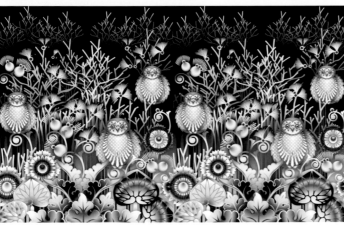

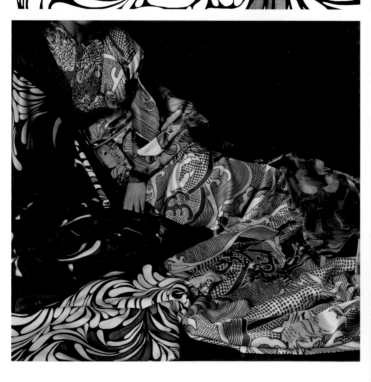

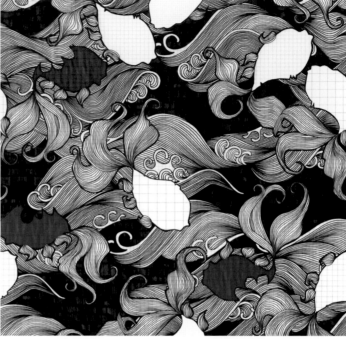

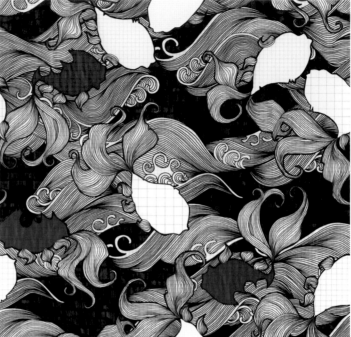

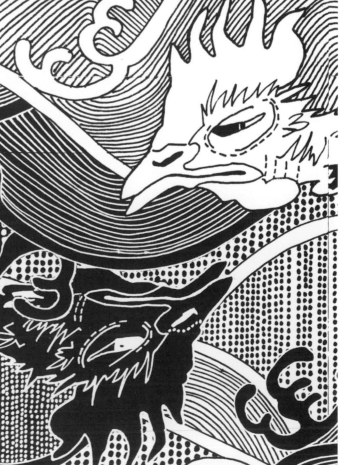

Vicki Fong
"Bird Nest Soup"
Technique: Gouache, ink and
Photoshop
2006

Vicki Fong
"The Unlucky Fish"
Technique: Pen and Photoshop
2006

Vicki Fong
(left)
"Kimono"
Photo: Simon Ward
Format: 11-foot digitally
printed kimono
Technique: Pen, ink, gouache and
Photoshop
2006

Vicki Fong
(right)
"Chicken Broth"
Technique: Pen and Photoshop
2006

Petra Börner
"Sea"
Client: Cacharel
Credits: S/S 2007 Women's Wear
Collection
Technique: Papercut
2006

Petra Börner
"Summer Field"
Client: Cacharel
Credits: S/S 2007 Women's Wear
Collection
Technique: Papercut
2006

Petra Börner
"Poppy Field"
Client: Cacharel
Credits: A/W 2006 Collection
Technique: Papercut
2005

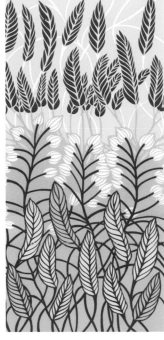
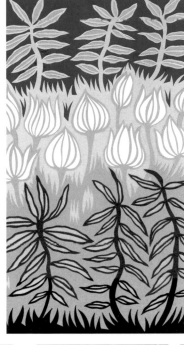
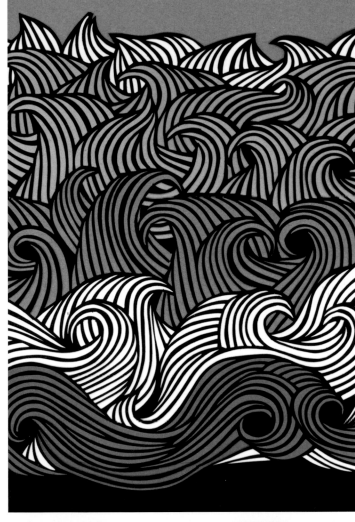

Petra Börner
(left)
"Birds"
Client: Cacharel
Credits: A/W 2006 Collection
Technique: Papercut
2005

Petra Börner
(middle left)
"Poppy Field"
Client: Cacharel
Credits: A/W 2006 Collection
Technique: Papercut
2005

Petra Börner
(middle right)
"Autumn Trees"
Client: Cacharel
Credits: A/W 2006 Collection
Technique: Papercut
2005

Petra Börner
(right)
"Birds"
Client: Cacharel
Credits: A/W/2006 Collection
Technique: Papercut
2005

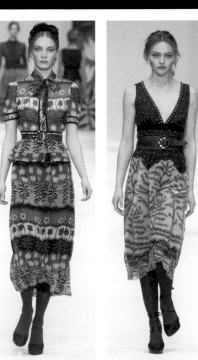

Sanna Annukka
"Audubon's Aviary"
Client: Medicom Toy
Format: Textile pattern
Technique: Photoshop
2007

Sanna Annukka
"Winding River"
Personal work
Format: Textile pattern
Technique: Photoshop
2007

Eva Mastrogiulio
(2 illustrations)
Client: 47 Street
Format: bags
Technique: Illustrator
2007

Bo Lundberg
"Adam"
Designer: Bo Lundberg, Kelly Hyatt
Client: Beaumonde
Format: Wrapping paper
Technique: Illustrator
2004

Bo Lundberg
"Fan pattern"
Personal work
Technique: Illustrator
2007

Hjärta Smärta
(2 illustrations)
Client: Telia
Advertising Agency:
Storåkers McCann
Art Directors: Sofia Ekelund and
Jonas Frank
Format: Cristmas campain
Technique: Collage made with
cristmas stickers
2006

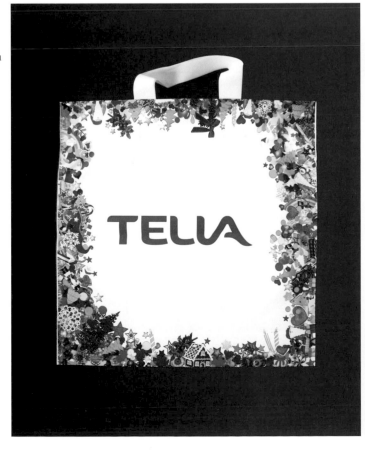

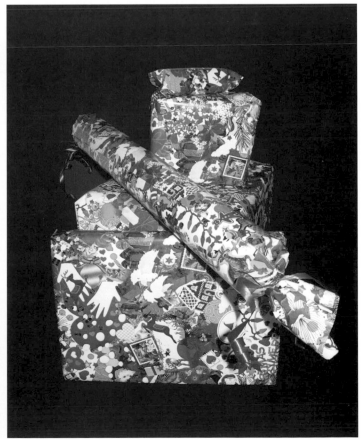

Rinzen
"Zimmermann Owls"
Client: Zimmermann
Format: Textile pattern
Technique: Digital
2007

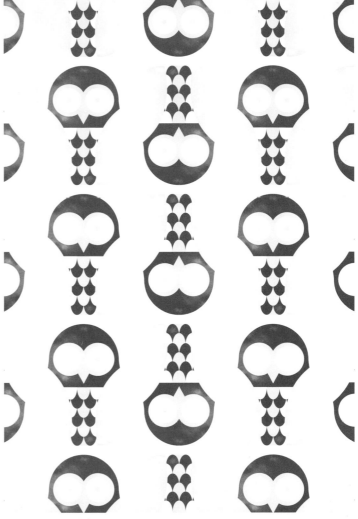

Rinzen
"Zimmermann Clouds"
Client: Zimmermann
Format: Textile pattern
Technique: Digital
2007

Rinzen
(left)
"In the Milky Night Carepack"
Format: Experiment
Technique: Digital
2006

Rinzen
(right, 2 photos)
"Zimmermann Owls" &
"Zimmermann Clouds"
Client: Zimmermann
Photo: Giovanni
Format: Textile pattern
Technique: Digital
2007

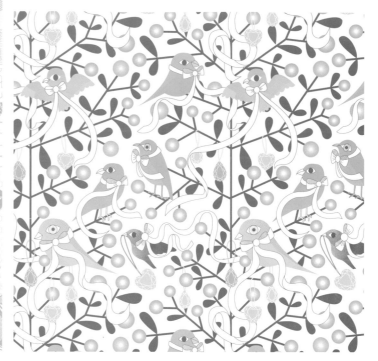

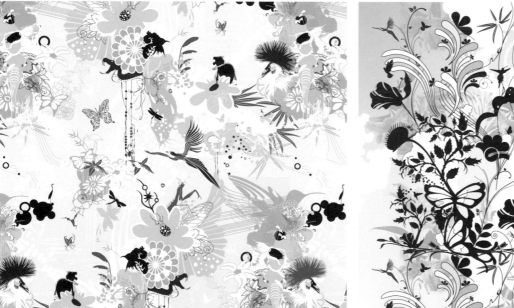

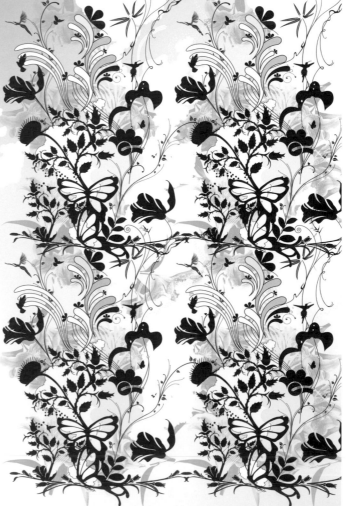

Maja Sten
"Scheherazade Remix"
Personal project
Technique: collage
2003

Maja Sten
Client: Apoteket / Kollo
Art Director: Anja Uddenfeldt
Format: Wrapping paper
Technique: Illustrator
2006

Vault 49
(left)
Client: Artful Dodger
Format: Apparel design
Technique: Digital
2006

Vault 49
(right)
Client: Bitter & Twisted
Format: Wrapping paper
Technique: Digital
2006

Florence Manlik
"Murano Pattern"
Client: Robert Normand
Technique: Hand-drawn
2006

Florence Manlik
"Purplevolutewall"
Client: Maxalot
Format: Wallpaper
Technique: Hand-drawn,
Photoshop montage
2006

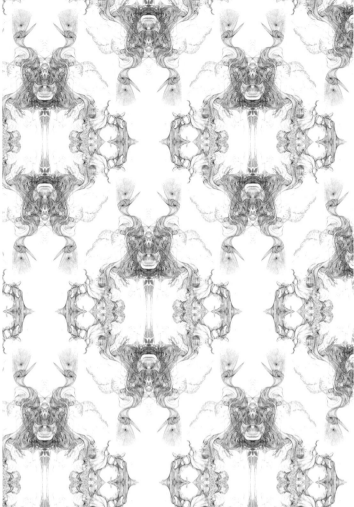

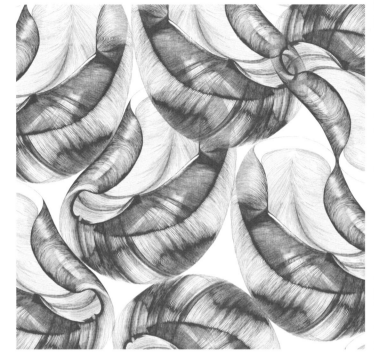

Fiodor Sumkin
(left)
"Glamour XMas Shrimps"
Client: Personal project
Technique: Hand-drawn
illustration in gel ink, Photoshop
2006

Vault 49
(right)
Client: Artful Dodger
Collaboration with Daryl Waller
Format: Apparel design
Technique: Digital
2006

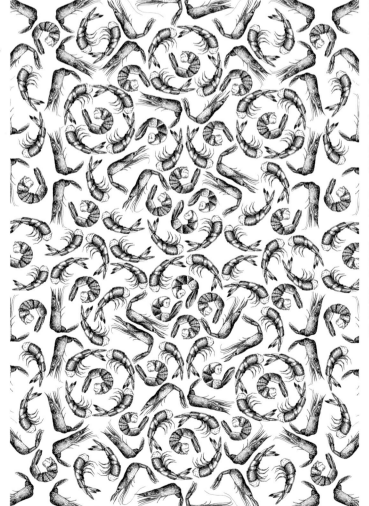

Vault 49
Florence Manlik
Fiodor Sumkin

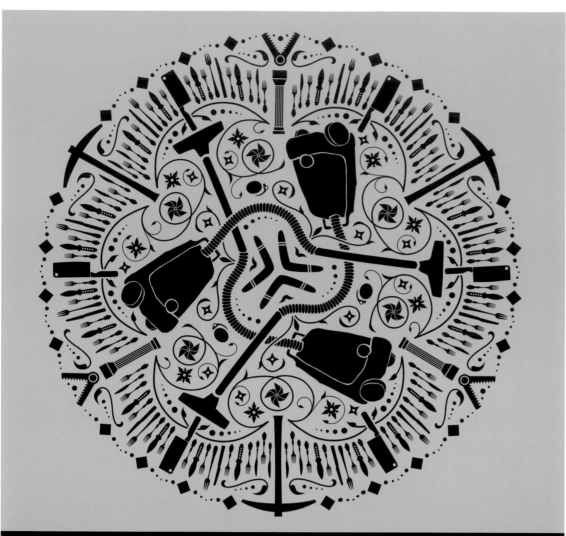

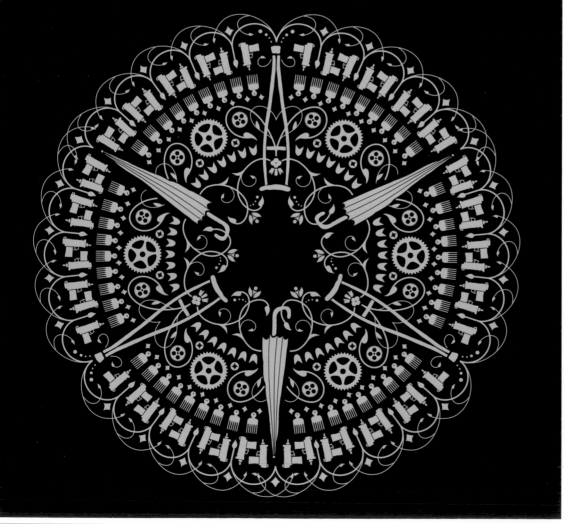

Dan Funderburgh
"Death from above"
Technique: Digital
2007

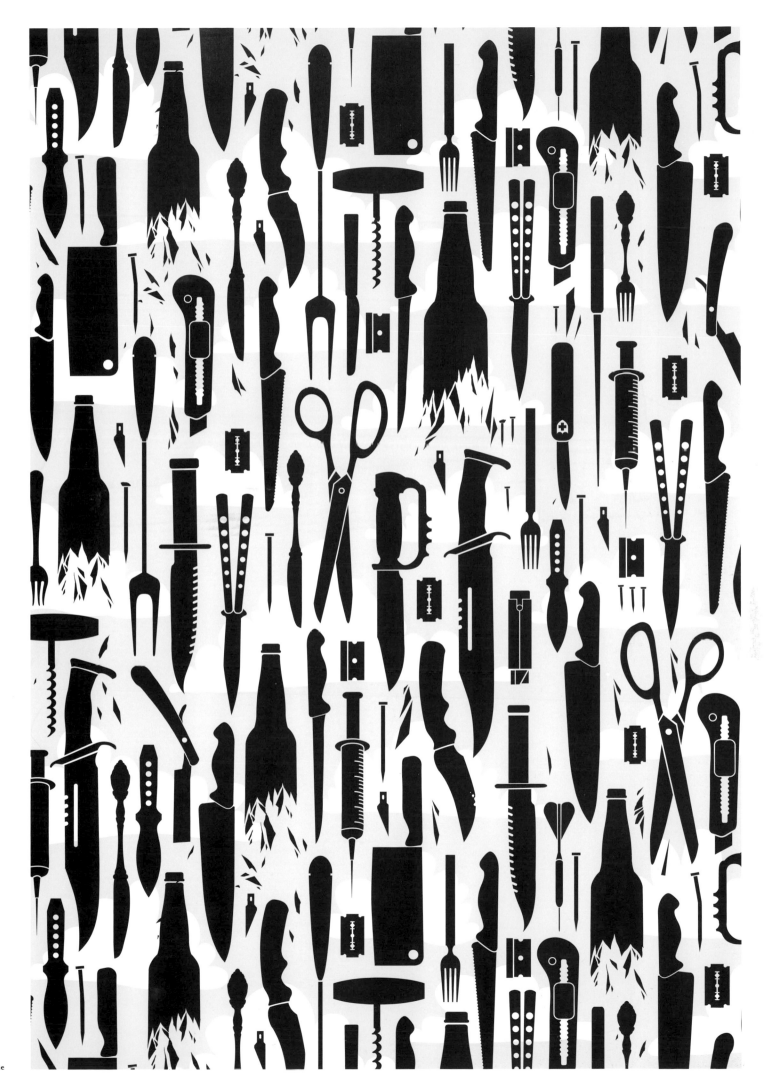

Typography & Illustrated Letterform

Computer technology and a heightened demand for individual typefaces have facilitated a recent deluge of DIY fonts. And this deluge has triggered an equally large and inevitable dissatisfaction with the constraints of digitised typefaces. Thanks to this rekindled interest in illustrated fonts, freeform hand lettering is enjoying its long-overdue comeback—from street art to high street. At the same time, graffiti has been seeping into everyday aesthetics and is no longer relegated to the underground; its unstoppable rise to mainstream art and culture has paved the way for more traditional, "legible" lettering in fringe and mass media alike, where hip new fonts lend distinction and street cred to advertising and editorials.

This chapter contains work ranging from free illustrations and those rooted in conventional typefaces to illustrations fashioned entirely out of text. Despite its diversity, it all indulges in an irreverent mix of styles and techniques that is eager to dissolve the traditional boundaries between image and text. And yet, as radical and contemporary as this approach might seem, illustrated fonts can look back on a long and impressive history. This history begins with medieval tomes, crafted in months of hunched-over dedication, where each chapter's initial letter would provide an elaborate, visual hint of things to come. And it also includes the hand-painted, illustrative letterforms of early shop facades, luring in customers with a less than firm knowledge of the alphabet.

Unlike these examples of practical signage, monkish creations or formal calligraphy, today's freestyle fonts are no longer encumbered by external rules or limitations. While the calligrapher takes pride in the most perfect match between pristine page and tidy, harmonious lettering, contemporary illustrators enjoy a more playful, experimental approach to style, text and content. This approach often elevates amateurish touches to the rank of deliberate, decisive and principal device. Even within a single design, restrictions to a particular font or style no longer apply. References culled from building blocks, book spines, signature logos, old album covers and other landmarks of adolescence find new homes in their lovingly exuberant exercises. So, in line with illustrated typography's illustrious heritage, expect scribbled tributes to Raymond Pettibon as well as plenty of references to the staples of psychedelia—to swirling eddies, lurid shapes and fantastic fonts at the limits of legibility, which dissolve and evolve into imagery far more descriptive than the text contained within it.

By exploring this colourful grey area between shape and significance, between flourish and information, illustrators invest their objects and scenes with more obvious meaning. Stuffed with statements and narrative, they flesh out the outlines of torsos and minds until the body itself becomes the story.

Serge Seidlitz
"Tiger Woods"
Client: Golf Punk
Format: Editorial
Technique: Vector
2005

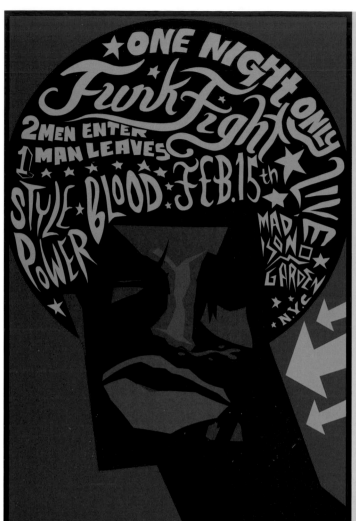

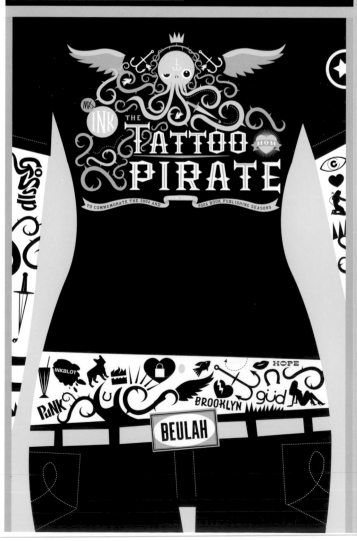

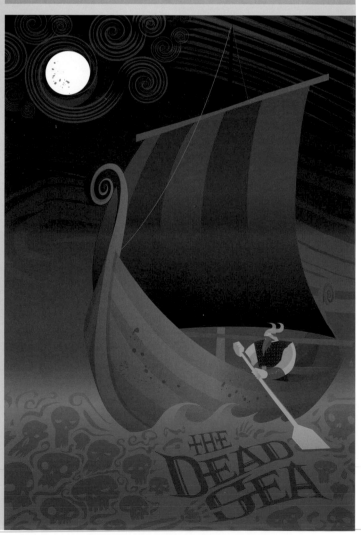

Will Staehle
(left)
"FunkFight"
Format: Poster
Technique: Vector
2005

Will Staehle
(right)
"Hope Lies"
Format: Poster
Technique: Vector
2005

Will Staehle
(left)
"Tattoo Pirate"
Format: Poster
Technique: Vector
2005

Will Staehle
(right)
"The Dead Sea"
Format: Poster
Technique: Vector
2006

Marcus Oakley
Client: Names Records
Format: Flyer
Technique: Hand-drawn,
coloured in computer
2007

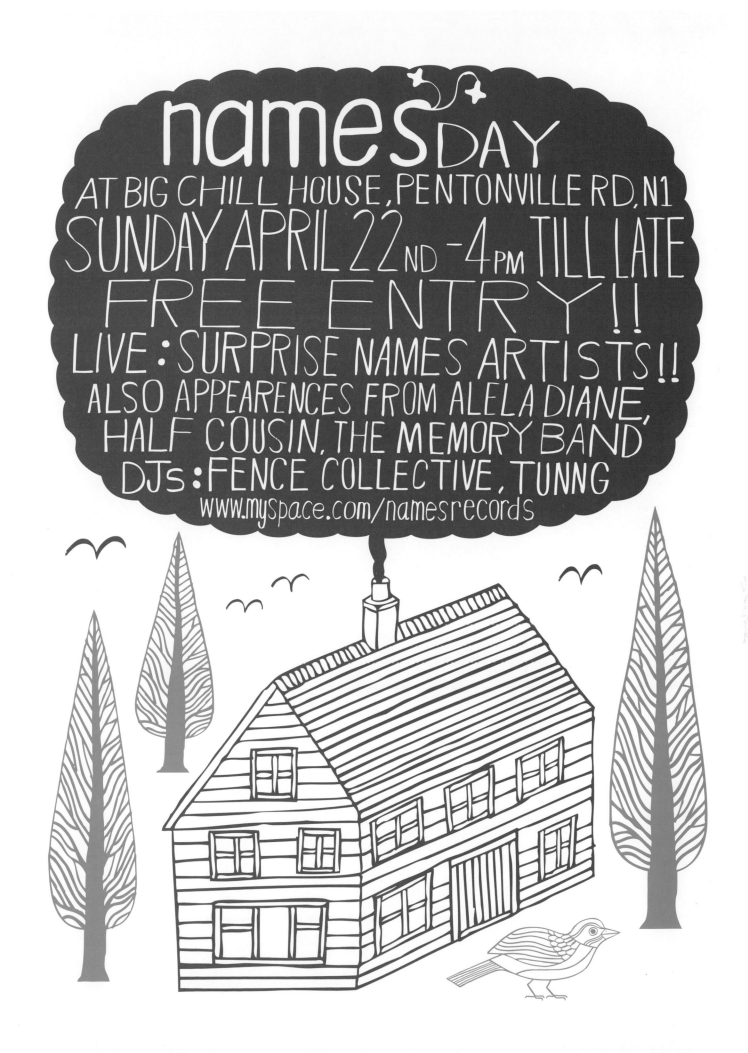

namesDAY
AT BIG CHILL HOUSE, PENTONVILLE RD, N1
SUNDAY APRIL 22ND - 4PM TILL LATE
FREE ENTRY!!
LIVE: SURPRISE NAMES ARTISTS!!
ALSO APPEARENCES FROM ALELA DIANE,
HALF COUSIN, THE MEMORY BAND
DJs: FENCE COLLECTIVE, TUNNG
www.myspace.com/namesrecords

Tara McPherson
(right)
"Isis"
Client: Isis
Format: Concert poster
Technique: 6-colour serigraph
2006

Tara McPherson
"Beck"
Client: Ideal Posters
Format: Concert poster
Technique: 5-colour serigraph
2005

Tara McPherson
(left)
"The Dull Sound"
Client: Punk Planet
Format: Magazine cover
Technique: 14-colour serigraph
2005

Tara McPherson
(right)
"Depeche Mode"
Client: Goldenvoice
Format: Concert poster
Technique: 5-colour serigraph
2005

Tara McPherson
"Shonen Knife"
Client: Shonen Knife
Format: CD cover
Technique: Graphite,
digital colour
2006

Tara McPherson
(left 2)
"Melvins"
Client: Melvins
Format: Concert poster
Technique: 5-colour serigraph
2006

Tara McPherson
"Queens of the Stone Age"
Client: PNE
Format: Concert poster
Technique: 9-colour serigraph
2005

Tara McPherson
(left)
"Mastodon"
Client: Mastodon
Format: Concert poster
Technique: 4-colour serigraph
2006

Tara McPherson
(right)
"Blues Explosion"
Client: Goldenvoice
Format: Concert poster
Technique: 5-colour serigraph
2004

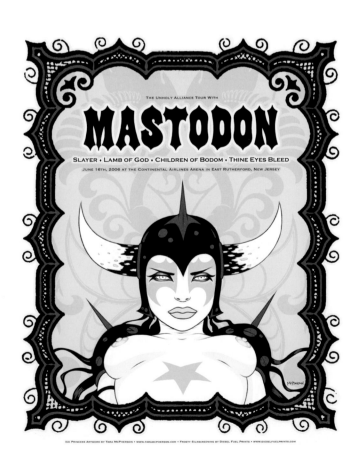

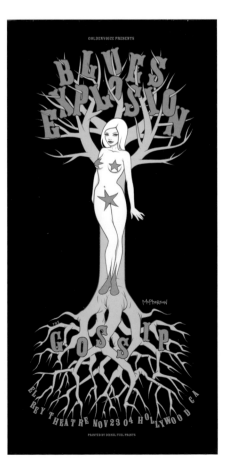

Serge Seidlitz
"Logo sheet"
Client: MTV, Toonami
Technique: Hand-drawn, vector
2003

Serge Seidlitz
"Would you rather..."
Client: The Times
Credits: RKCR/Y&R
Format: Postcards series
Technique: Vector, hand-drawn
2006

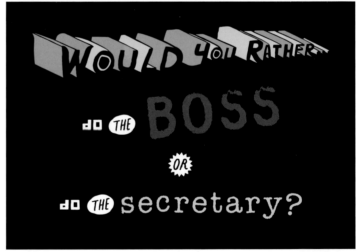

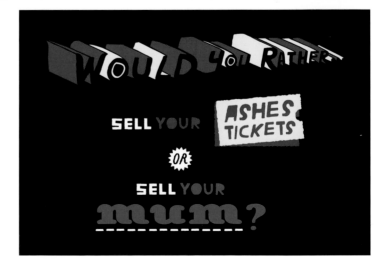

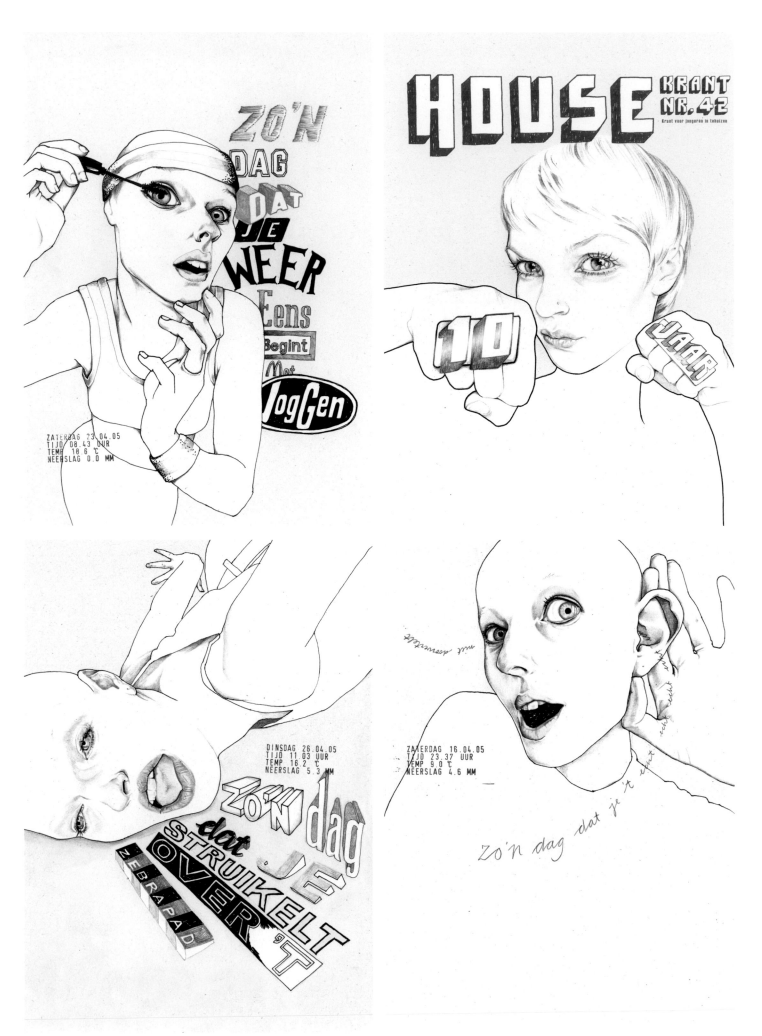

Denise van Leeuwen
(left)
Client: Dif
Technique: Hand-drawn,
Photoshop
2005

Denise van Leeuwen
(right)
Client: House Krant
Format: Editorial
Technique: Hand-drawn,
Photoshop
2007

Denise van Leeuwen
(left)
Client: Dif
Technique: Hand-drawn,
Photoshop
2005

Denise van Leeuwen
(right)
"Saturday 16.04.05"
Client: Dif
Technique: Hand-drawn,
Photoshop
2005

Marcus Oakley
Technique: Hand-drawn,
coloured on computer
2007

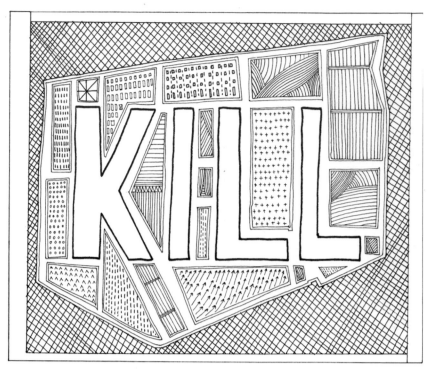
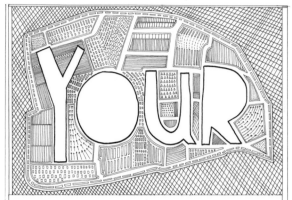
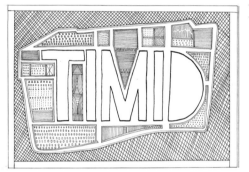
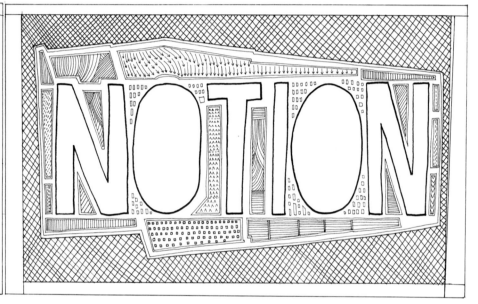

Nigel Peake
Client: Kill your Timid Notion
(arika / dca)
Artwork for the kytn music festival
2007

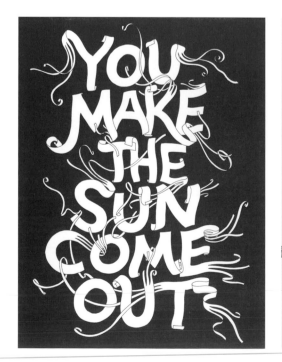
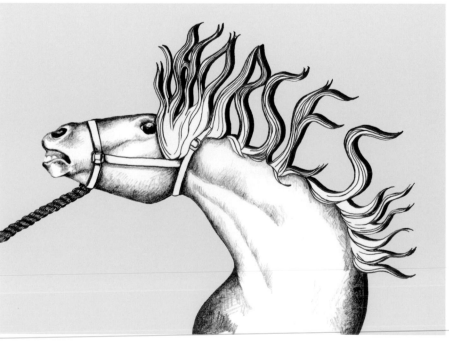

Adam Hayes
(left)
"You Make the Sun Come Out"
Format: Poster
Technique: Hand-drawn
2007

Noa Weintraub
(right)
"Horses"
Personal work
Technique: Hand-drawn and
Photoshop
2007

Adam Hayes
"Machines Dream Too"
Client: Beams
Format: T-shirt design
Technique: Hand-drawn
2006/07

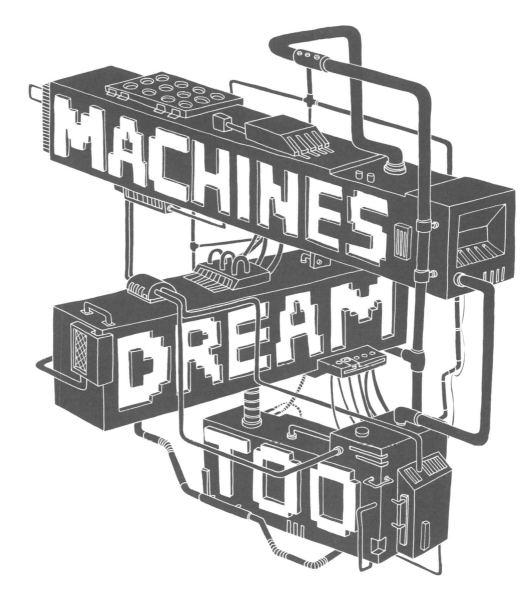

Adam Hayes
(left)
"Gonna Get Miles Away"
Format: Poster
Technique: Hand-drawn
2007

Björn Kowalski Hansen
(right)
Format: Book cover
Technique:
Illustrator and Photoshop
2007

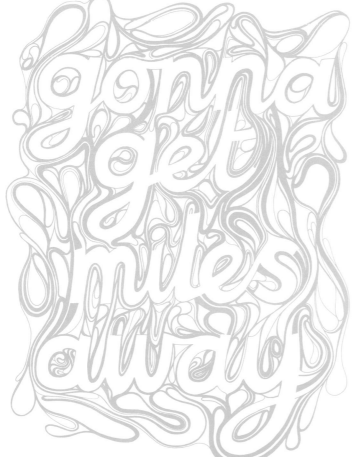

Fiodor Sumkin
"Brian Eno bookcase"
Client: Esquire Magazine
Technique: Hand-drawn
illustration in gel ink, Photoshop
2007

Fiodor Sumkin
"The Devil Hates Me!"
Client: eXtra wear
Format: T-shirt project
Technique: Hand-drawn
illustration in gel ink, Photoshop
2006

Fiodor Sumkin
"Glamour Sucks!"
Client: eXtra wear
Format: T-shirt project
Technique: Hand-drawn
illustration in gel ink, Photoshop
2006

Fiodor Sumkin
"Wash Your Pussy"
Client: eXtra wear
Format: T-shirt project
Technique: Hand-drawn
illustration in gel ink, Photoshop
2006

Seripop
"2006 Ann Arbor Film Fest Poster"
Designer:
Chloe Lum, Yannick Desranleau
Client: Ann Arbor Film Festival
Photo: Yannick Grandmont
Technique: 1-colour screenprint
2006

Seripop
"Bleh"
Designer:
Chloe Lum, Yannick Desranleau
Client: Dose Magazine
Technique: Offset litho
2005

Fiodor Sumkin
Seripop

MASA
"Kong"
Client: KONG Gallery and
Shop
Technique: Felt-tip markers
2006

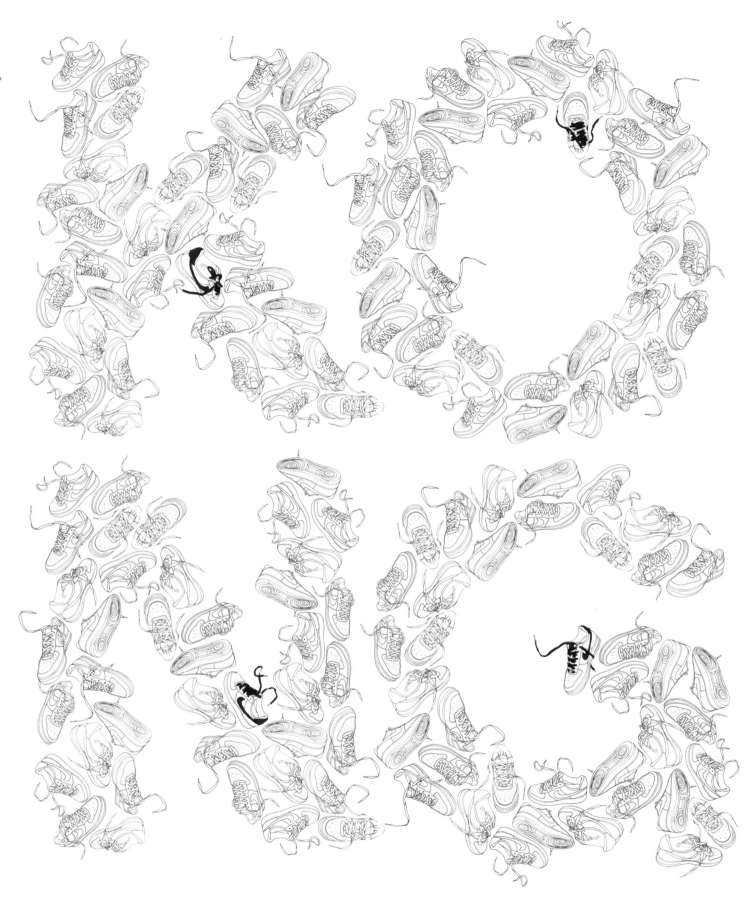

Mirage
(9 illustrations)
Designer: Yoshi Tajima
Private work
~Mirage A to Z~ Poster project
Technique: Ink, Illustrator,
Photoshop
2006

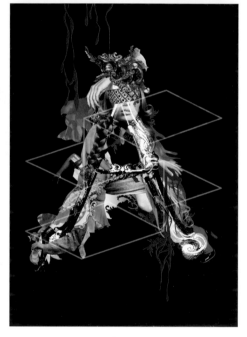

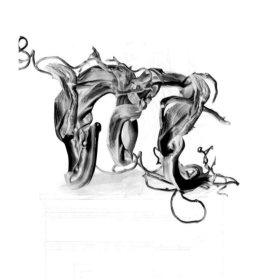
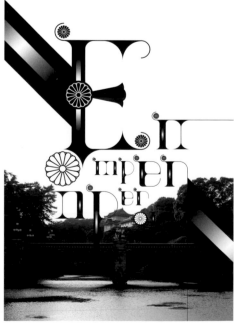
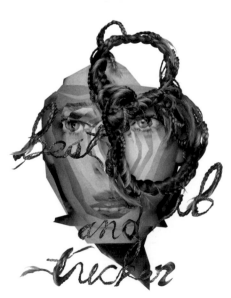

Sylvia Tournerie
(2 illustrations)
"Contested space"
Client: Kungl. Konsthögskolan
Credits: Program / poster for an
architecture class at the Kungl.
Konsthögskolan Arts School of
Stockholm, Sweden
2005

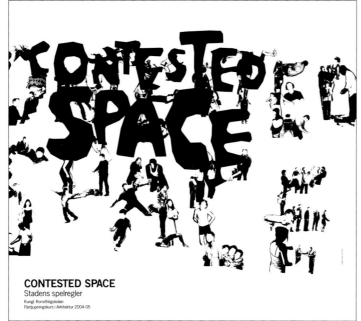 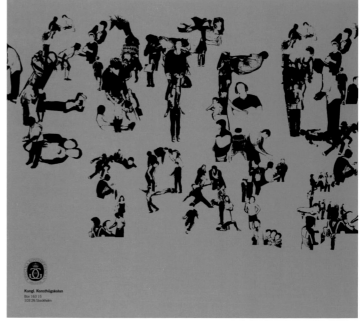

James Dawe
"Spook"
Client: The Ranch
bar / restaurant
Art Direction:
Village Green Studio
Format: Treatment for
Halloween branding, intended
to work in various media
Technique: Digital collage and
Photoshop
2006

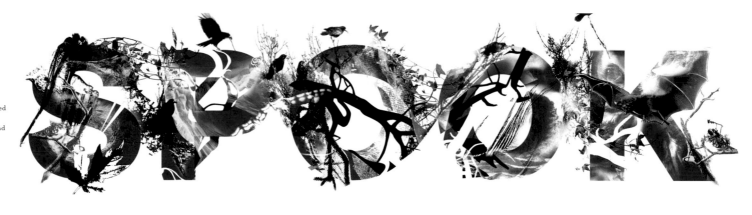

Laura Laine
Client: Wunder clothing store
Art Direction: Chris Vidal
Format: Logo
Technique: Hand-drawn
2006

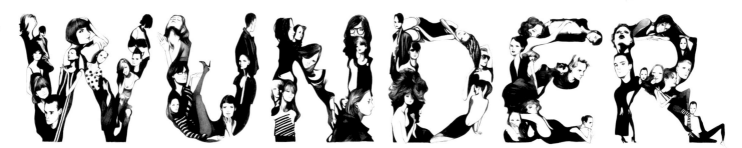

James Dawe
"The Ranch"
Client: The Ranch
bar / restaurant
Art Direction:
Village Green Studio
Format: Treatment for
branding, intended to work in
various media
Technique: Digital collage and
Photoshop
2006

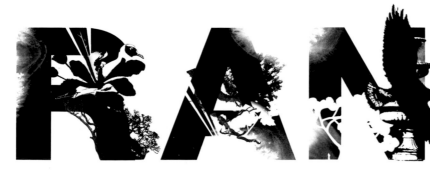 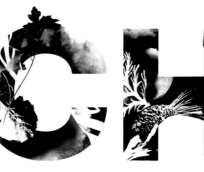

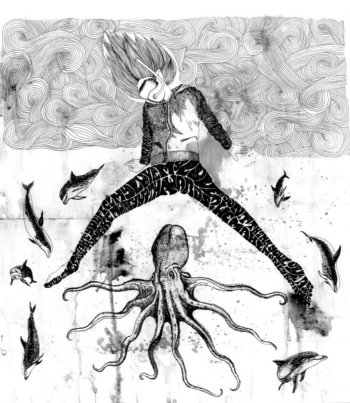

Fiodor Sumkin
Personal project
Technique: Hand-drawn
illustration in gel ink and
watercolour, Photoshop
2006

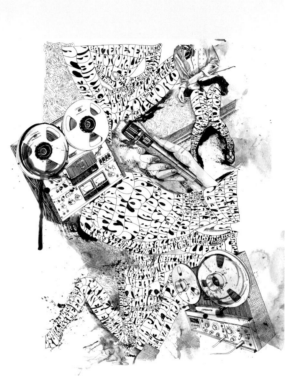

Fiodor Sumkin
"Frank Sinatra"
Personal project
Technique: Hand-drawn
illustration in gel ink and
watercolour, Photoshop
2006

Fiodor Sumkin
"Born (Octopus)"
Personal project
Technique: Hand-drawn
illustration in gel ink and
watercolour, Photoshop
2006

Fiodor Sumkin
"Saatchi & Saatchi"
Client: Saatchi & Saatchi, Moscow
Format: Website project
Technique: Hand-drawn
illustration in gel ink, Photoshop
2006

Fiodor Sumkin
"Imponderabilita"
Personal project
Technique: Hand-drawn
illustration in gel ink and
watercolour, Photoshop
2006

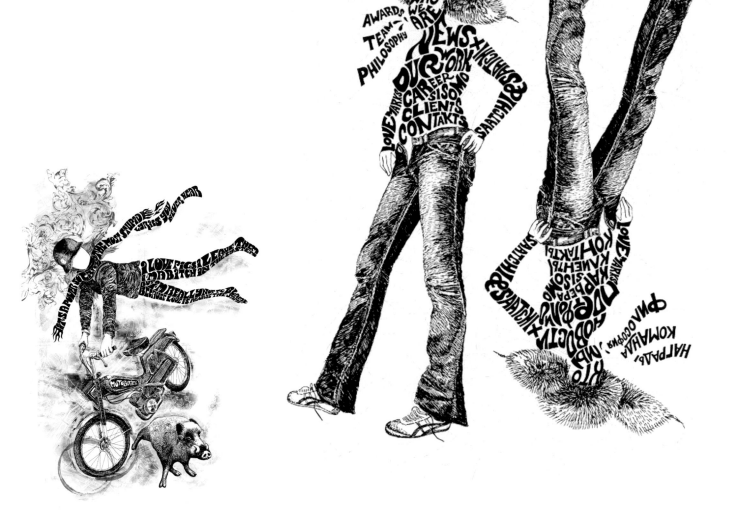

Fiodor Sumkin
"I've never been in Africa or
America"
Personal project
Technique: Hand-drawn
illustration in gel ink and
watercolour, Photoshop
2006

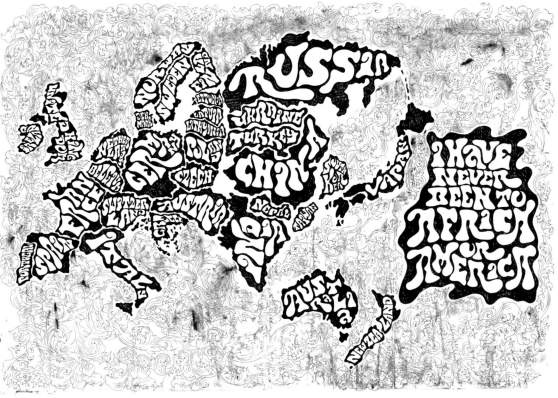

Interview Si Scott

Making waves—and whirls—with his elaborate, playful font creations, Si Scott's hand-inked gems come packed with their very own narrative. Blending pop and disco references with modern typography, the London-based designer's creations have made it into countless major ad campaigns, typography publications and reference tomes and take illustrated lettering to a new level.

Background

As far as I can remember, drawing has always been an important part of my life. Soon enough, this kindled my interest in design and, in particular, typography. It didn't take me long to realise that the north of England doesn't offer quite so many opportunities for budding designers. So after my graduation, I moved to London to work for a number of small design companies while continuing with my own work and freelance commissions.

Jon [Forss] and Kjell [Ekhorn] at Non-Format turned out to be really interested in my hand-drawn experiments and asked me to work with them on The Wire, a music magazine they were art directing and designing at the time. This in turn led to a commission for the new Casio campaign and a vast range of different clients over the last couple of years.

Skills and Techniques

My training was pretty straightforward. After school, I went from a foundation course at the Leeds College of Art and Design to a graphic design degree at Buckinghamshire Chilterns University. I didn't really receive any formal training in type design, but I spent endless hours drawing fonts and trying out new ways of creating type. This laborious trial and error approach really helped to shape my style. Everything I do starts with just pen and paper; I only use the computer to piece everything together at the end.

Inspiration and Influences

My current style is the product of my love for typography and drawing. I was always playing around with different methods of creating type by hand. I wanted to create something new that nobody else was doing, not copy somebody else's style. Music and type posters from the 1960s and 70s probably had the biggest impact.

Featured Works

The work featured here shows a mix of client commissions and exhibition pieces. Whatever I do, I just try to keep working as hard as I can and to create the best possible pieces of work. I'm constantly striving to push things forward and try new things, whether for exhibitions, collaborations or otherwise.

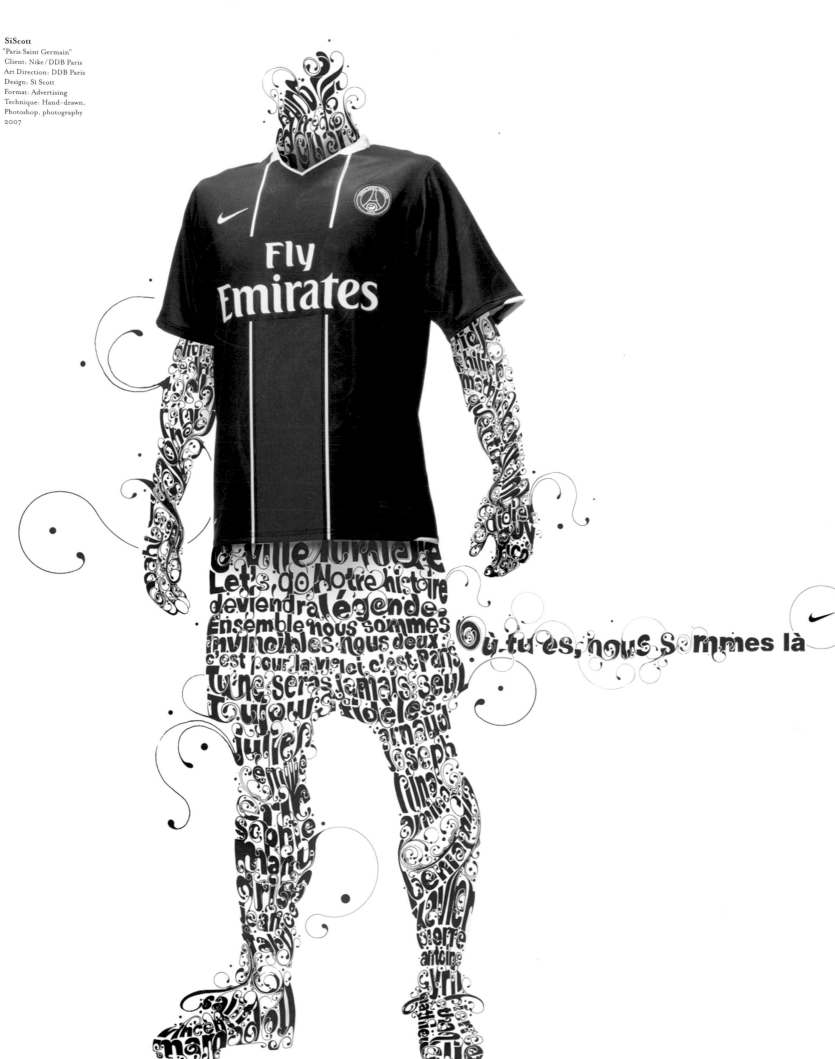

SiScott
"Paris Saint Germain"
Client: Nike / DDB Paris
Art Direction: DDB Paris
Design: Si Scott
Format: Advertising
Technique: Hand-drawn,
Photoshop, photography
2007

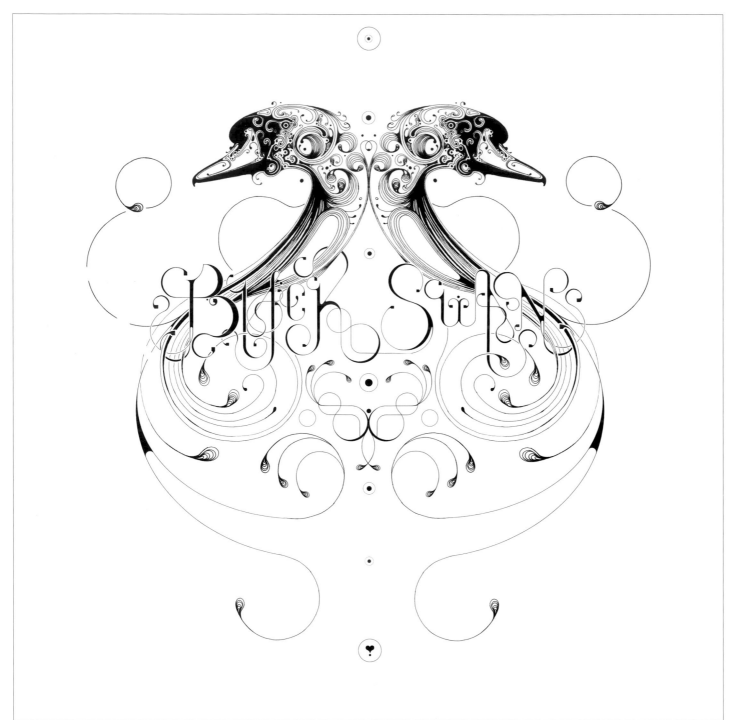

SiScott
Client: Ink & Lyrics Exhibition
Art Direction,
Design & Illustration: Si Scott
Format: Exhibition pieces
Technique: Hand-drawn
2007

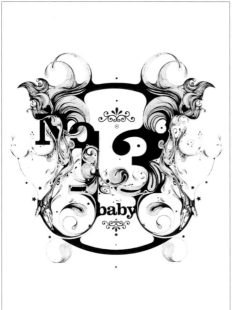

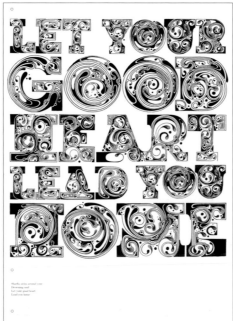

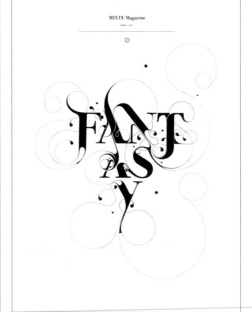

SiScott
(left)
Client: Ink & Lyrics Exhibition
Art Direction,
Design & Illustration: Si Scott
Format: Exhibition pieces
Technique: Hand-drawn
2007

SiScott
(middle)
"Let Your Good Heart
Lead You Home"
Client: The Playground
Art Direction,
Design & Illustration: Si Scott
Format: Book design
Technique: Hand-drawn,
Photoshop
2007

SiScott
(right)
"Fantasy"
Client: Mixte Magazine
Art Direction: Mixte Magazine
Format: Editorial
Technique: Hand-drawn
2007

Si Scott

SiScott
"Gris Gris"
Client: Tank Theory
Art Direction,
Design & Illustration: Si Scott
Format: T-shirt
Technique: Hand-drawn,
Photoshop
2007

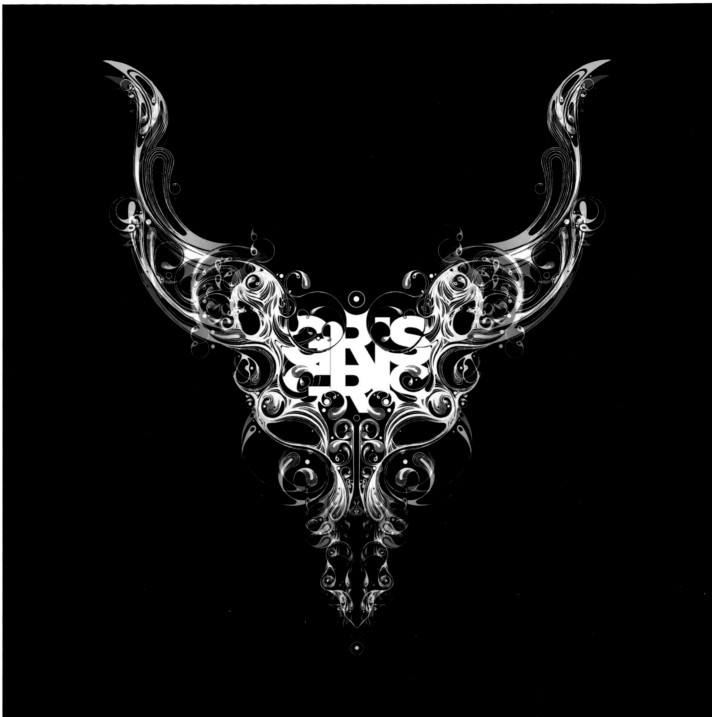

SiScott
(3 illustrations)
"Love Posters"
Client: Designers Block/
100% Design Tokyo
Art Direction: Hawaii Design
Format: Exhibition pieces
Technique: AI limited
edition
screened print in
phosphorescent ink
2006

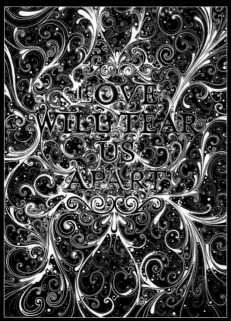
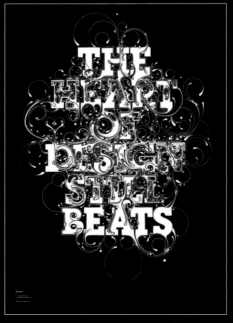
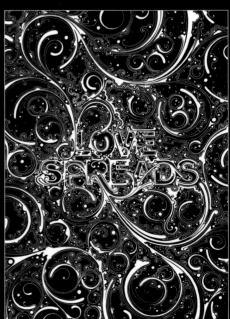

Zebby
Client: Boutique1
Credits: Elsa's new year's
resolution for 2007
Format: Editorial
Technique: Watercolour, ink,
coffee, Photoshop
2007

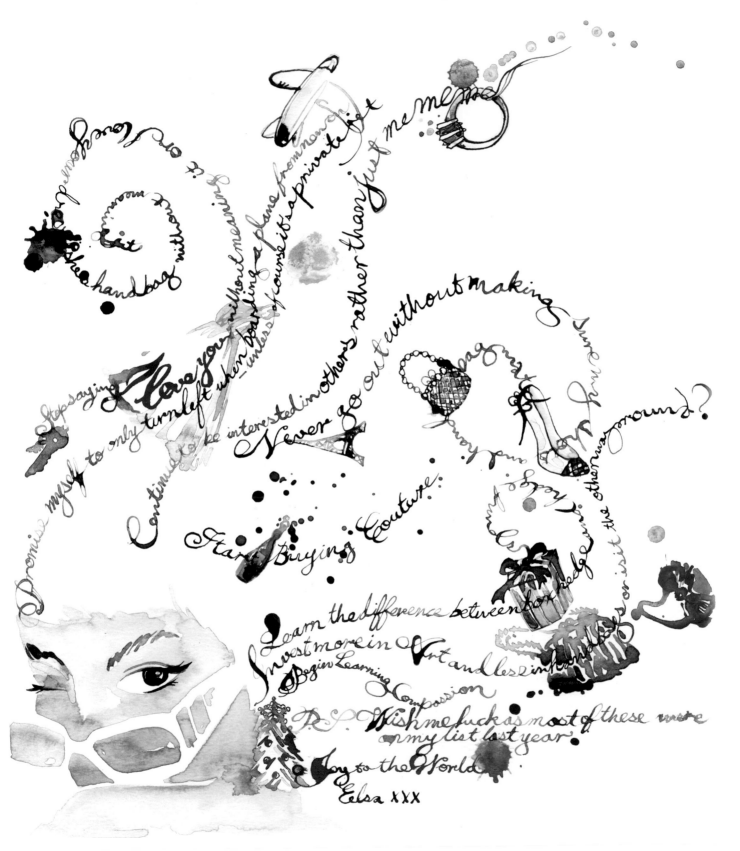

Elsa M H shares her New Year's Resolutions for 2007

Elsa xxx

Laura Varsky
Client: Marcelo Kertesz – Peri
Format: CD cover
Technique: Ink and digital
2007

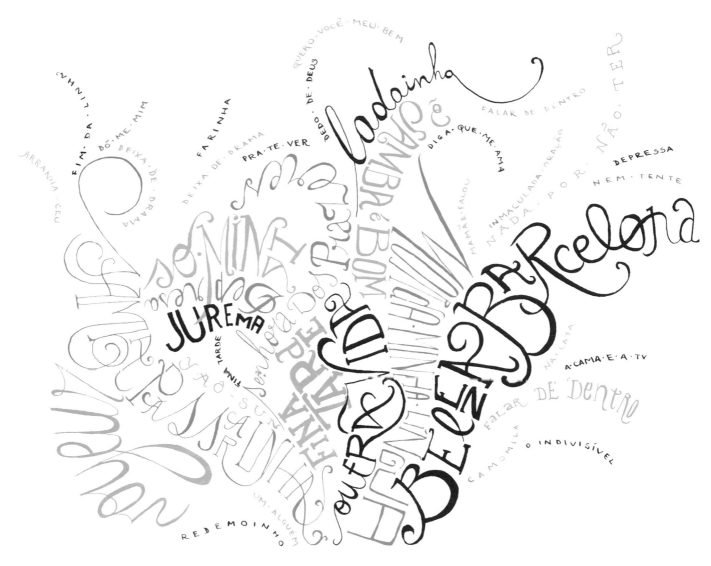

Laura Varsky
(left)
"I don't know why"
Client: Slash Magazine
Credits: Text by María Elena Walsh
Format: Editorial
Technique: Ink and digital
2005

Laura Varsky
(right)
"MRr"
Technique: Ink
2007

Laura Varsky
"Buscar"
Credits: Text by Alejandra Pizarnik
Technique: Ink
2007

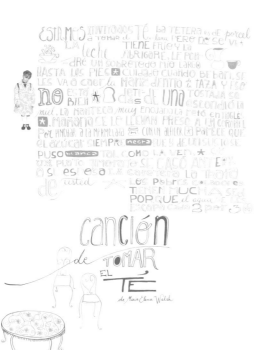

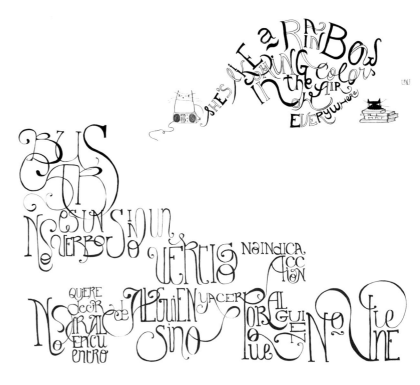

Hjärta Smärta
Client: Diego Magazine
Format: Editorial about Swedish
leadership
Technique: Paper collage
2006

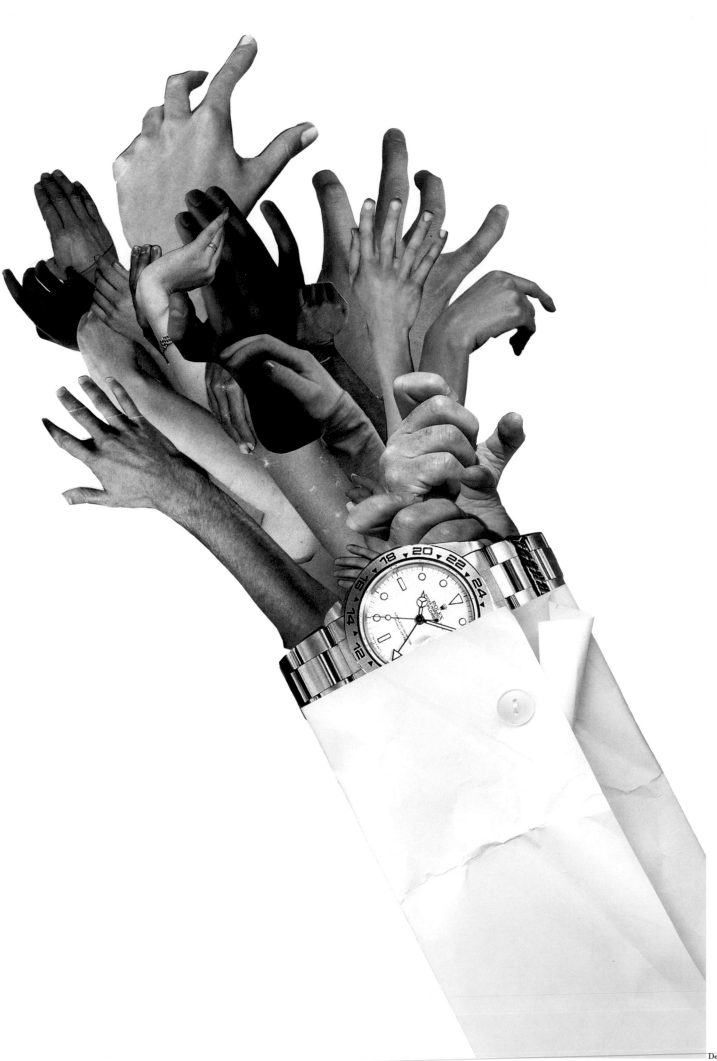

Maren Esdar
Client: W Korea
Technique: Collage and Photoshop
2007

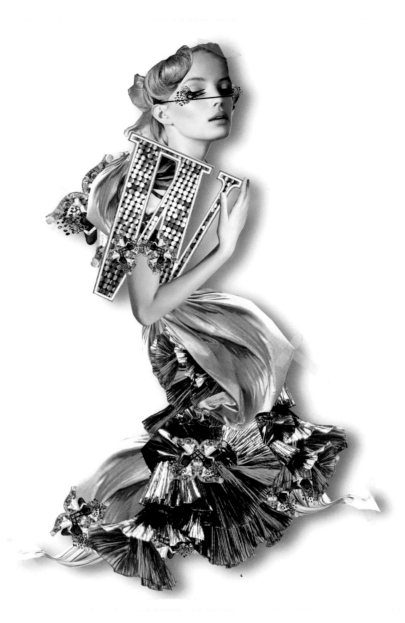

Maren Esdar
"Rue Faubourg St. Honoré"
Client: Kunert, D
CD: Reto Brunner
Technique: Collage and
Photoshop
2007

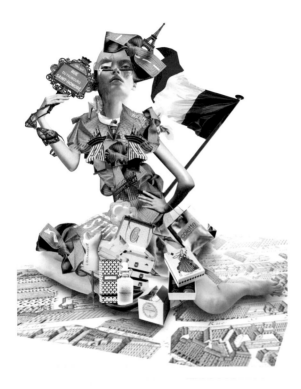

Maren Esdar
(left)
"Special beauty services"
Client: New York Times Magazine,
USA
Technique: Collage, Photoshop
2007

Maren Esdar
(right)
"Beauty-extensions"
Client: Avantgarde, NL
Technique: Collage, Photoshop
2006

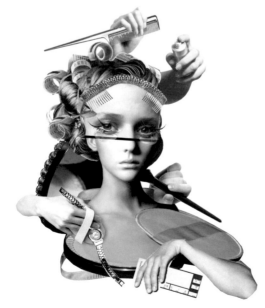

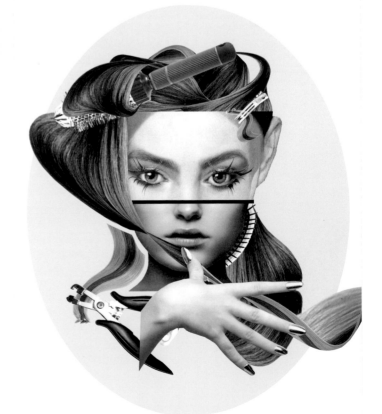

Interview Ingrid Baars

Award-winning Dutch painter, illustrator and Photoshop wizard Ingrid Baars takes the fabric of life and strips it of all anatomic constraints. Bypassing fashion's inherent vanity, her self-perpetuating collages and doctored multiple exposures explore the elusive realm of bizarre beauty, where body meets cloth meets machinery, and where seduction is contorted beyond human imagination.

Background

As a kid, I was equally passionate about drawing and ballet, and I found myself torn between these two vocations. The battle continued until I was 17, when a stint at the Academy of Ballet quickly revealed that I would make a very average ballerina. So I never took another step. Instead, I then transferred to the Academy of Arts, where I tried my hand at painting, but could not handle the autonomy involved. After switching to illustration and, for a second subject, photography, I soon started to mix things up. I chopped up my drawings and photos and then stuck them back together with copious amounts of spray glue; my apartment was always sticky!

After the academy, I started to juxtapose my own drawings and paintings with elements "borrowed" from pictures I had found in magazines. Later on, I decided to drop the drawing in favour of photography, and I haven't really looked back since.

Skills and Techniques

Thank God for Apple. For quite some time, I resisted the lure of computers because I thought I needed that hands-on, handcrafted feeling. But when I finally bought one, it turned out to be heaven. My Mac affords me the same spontaneity and "risk" as scissors, knife and glue. Working on a very large screen and an outsized Wacom tablet makes it a very immediate and physical experience.

The thing I've always liked—and still love—about collage is the inevitable element of surprise. It always gives me results I never could have planned in advance. I wouldn't be happy if my job stopped at mere photography. Sure, it's a nice medium, but too much of "what you see is what you get". In addition, I still do some painting and combine the results with my photography.

Inspiration and Influences

For as long as I remember, I have loved looking at faces and bodies. Their presence. Their intimacy. The flesh and blood, the tension between all those different body parts. The perfection, the imperfection, the sensuality and the sex. I enjoy reshaping and combining the most interesting parts of several people and turning them into a new human being, a person closer to my own idea of body and beauty. While I find the bodies and expression of dancers simply amazing and enormously inspiring, models — with their perfect proportions, skinny arms and stick-insect legs—tend to bore me. Most of the time, there is nothing edgy or disturbing about them, but I love to fuse them with dancers and "real" people.

When it comes to style, it's hard, but I try to think about my style as little as possible. Sometimes, I don't work for, let's say, a month and find that my style has changed and improved in the meantime. Usually, I start out with some music to get into the right mood. Music has always been my biggest source of inspiration. Without music, I just don't feel enough and everything around me appears too "real". I want to create images that come directly from the heart and music is a big help in that.

To keep me focussed, my studio is dominated by a huge mood board with all kinds of images. Some are my own, but it also features a lot of fashion-related pictures, images of cut-up sharks, my favourite sculptures and some Old Masters. It's a weird mix of all the things I like to combine in my images.

Featured Works

In an ideal world, I would like to produce a lot more personal images that would continue to surprise others and myself. However, I really love my assignments, too, exploring how far I can go within the confines of a job. It keeps me sharp. So, some of the pieces featured here were commissioned by an art director, who gave me a lot of leeway and trusted me enough to let me pursue my own direction, which turned the assignment into something more like a personal arts project. A stylist and make-up artist were involved in the production of the source material, although not much of the original make-up is left to see… Besides these commissions, every two years I produce an extensive series of strictly personal images for exhibition.

Ingrid Baars
Client: Bacardi B-life
Art Direction: Olaf van der Geld
Technique: Digital collage
2007

Ingrid Baars
(3 illustrations)
Client: Euro RSCG Life
Art Direction:
Maurice van Gijzelen
Technique: Digital collage
2007

Ingrid Baars
(2 illustrations)
Technique: Digital collage
2007

Ingrid Baars
Client: Euro RSCG Life
Art Direction:
Maurice van Gijzelen
Technique: Digital collage
2007

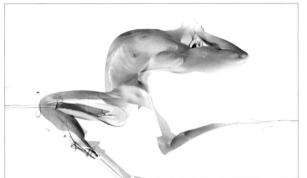

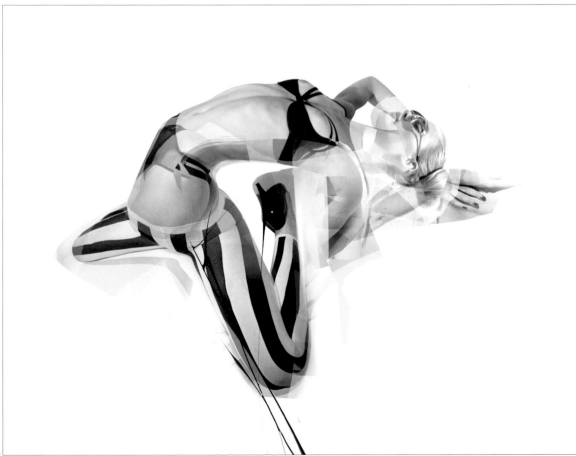

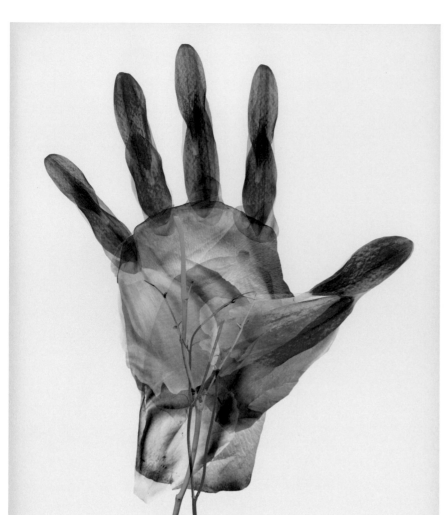

Hr. Müller
(3 illustrations)
Client: Walker Werbeagentur,
Fleurop
Art Direction: Mieke Haase
Format: Business report
illustrations
Technique: Blossom leaves,
twigs, roots, scanner
and Photoshop
2006

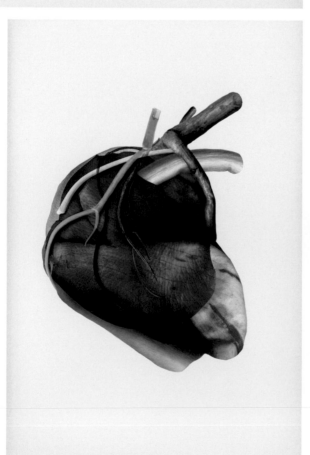

Sebastian Onufszak
(3 illustrations)
"Geometrical Chaos"
Format: Poster
Technique: Illustrator,
Photoshop
2006

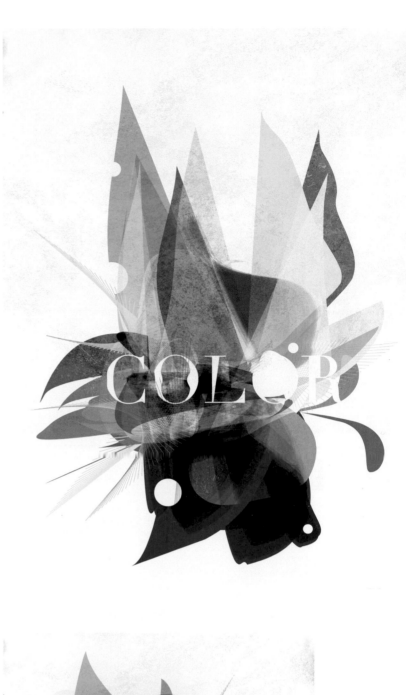

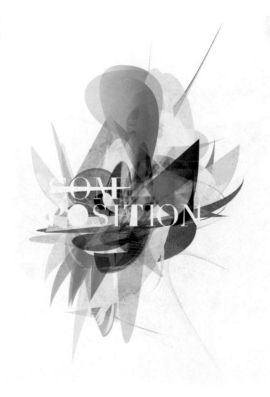

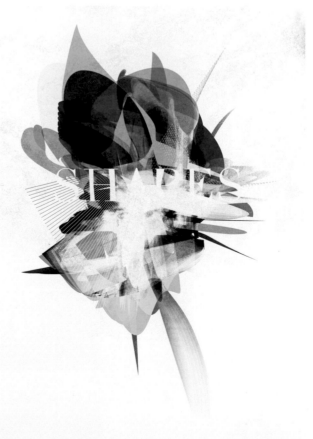

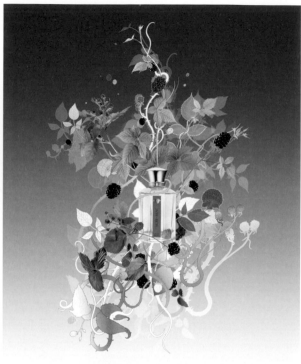

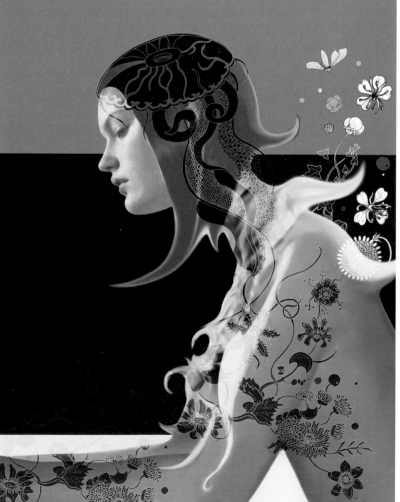

Lotie
Client: Etam
Format: Posters in the shops,
brochures, flyers
Technique: Hand-drawn, Pho-
toshop
2004

Lotie
"Mûre et Musc"
Client:
L'Artisan Parfumeur, Paris
Photos of blackberries, leaves:
Jacques de Marcillac
Format: Poster, flyer, kakemono
Technique: Hand-drawn, Pho-
toshop
2005

Lotie
(left)
Client: Ekens (Denmark)
Format: Brochure, website and
poster in the shops
Technique: Hand-drawn,
Photoshop
2007

Lotie
(right)
Client: Etapes Magazine
Format: Editorial
Technique: Hand-drawn,
Photoshop
2005

Benedita Feijó
(2 illustrations)
Client: Umbigo Magazine
Format: Magazine
Technique: Photoshop
2007

Benedita Feijó
(3 illustrations)
Designer: Michael Andersen
(InteractCreative)
Personal work
Technique: Photoshop
2007

Lisa Schibel
(5 illustrations)
Client: The Electronic Beats
Magazine / T-Mobile
Format: City guide / cover
Technique: Mixed media
2006

THE ELECTRONIC BEATS MAGAZINE
SPECIAL TRAVEL ISSUE PARIS 2006

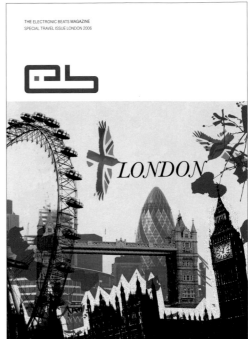

THE ELECTRONIC BEATS MAGAZINE
SPECIAL TRAVEL ISSUE LONDON 2006

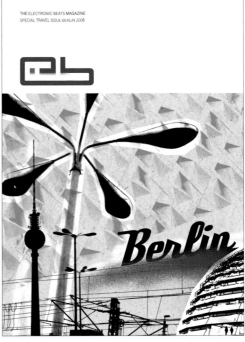

THE ELECTRONIC BEATS MAGAZINE
SPECIAL TRAVEL ISSUE BERLIN 2006

THE ELECTRONIC BEATS MAGAZINE
SPECIAL TRAVEL ISSUE BARCELONA 2006

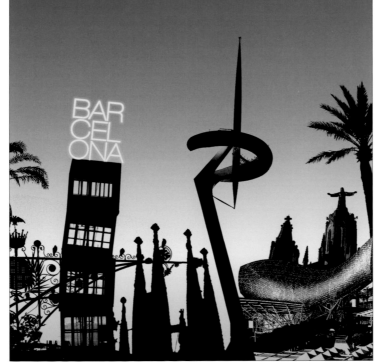

THE ELECTRONIC BEATS MAGAZINE
SPECIAL TRAVEL ISSUE PRAGUE 2006

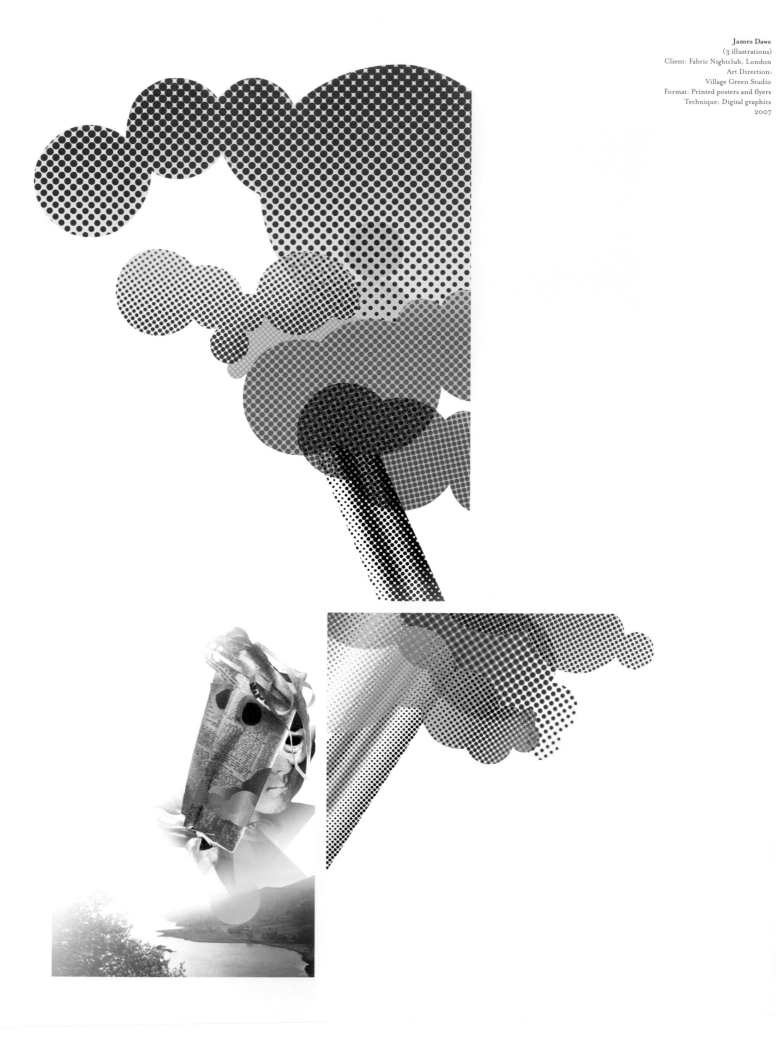

James Dawe
(3 illustrations)
Client: Fabric Nightclub, London
Art Direction:
Village Green Studio
Format: Printed posters and flyers
Technique: Digital graphics
2007

James Dawe

James Dawe
(3 illustrations)
Client: Fabric Nightclub, London
Art Direction:
Village Green Studio
Format: Printed posters and flyers
Technique: Digital collage
and graphics
2007

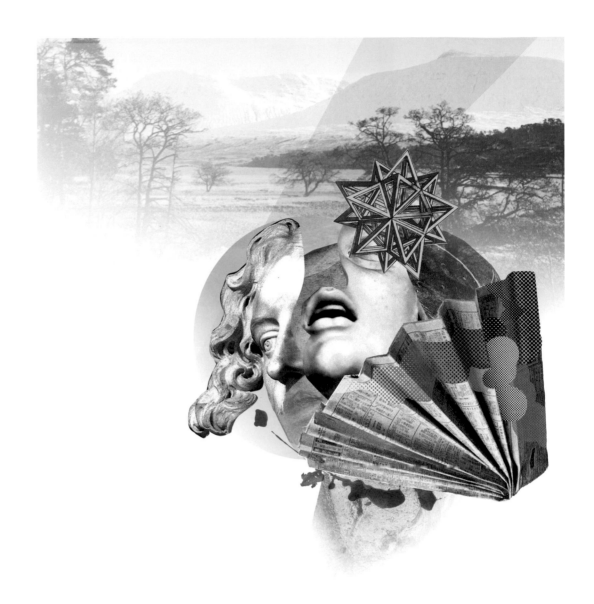

James Dawe

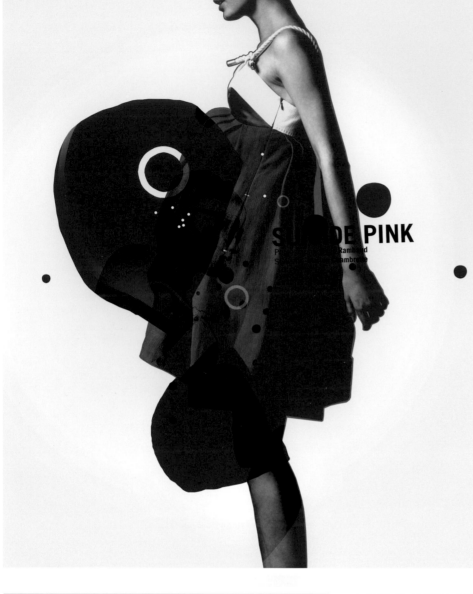

Benjamin Savignac
"Suicide Pink"
Client: DEdiCate Magazine
Photographer: Fred Rambaud
Technique: Photoshop
2007

Benjamin Savignac
"Elephant"
Personal work
Technique: Photoshop, drawings
2006

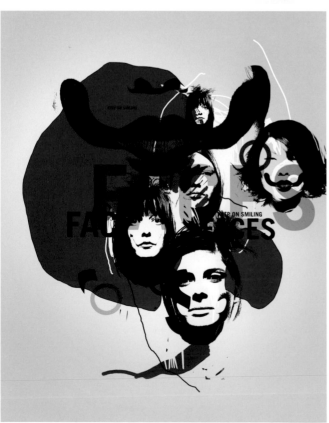

Benjamin Savignac
(left)
"Keep on Smiling"
Client: DEdiCate Magazine
Technique: Photoshop
2005

Benjamin Savignac
(right)
"Seven"
Client: DEdiCAte Magazine
Technique: Photoshop
2007

Beata Szczecinska | Cityabyss
"Camera"
Free project
Technique: Linocut print,
hand-drawings, photography,
Photoshop
2007

Beata Szczecinska | Cityabyss
"She"
Free project
Technique: Linocut print,
hand-drawings, photography,
Photoshop
2007

Beata Szczecinska | Cityabyss
(left)
"Book"
Client: Online Carpaltunnel
Magazine / 12
Format: Online publication
Technique: Hand-drawn,
fragment of linocut print,
Photoshop
2007

Beata Szczecinska | Cityabyss
(2 illustrations, right)
"City"
Client: Online Carpaltunnel
Magazine / 12
Format: Online publication
Technique: Hand-drawn,
Photoshop
2007

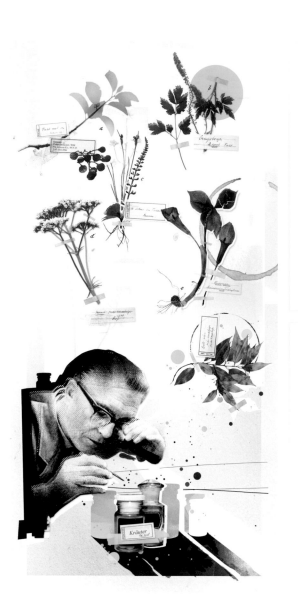

Skizzoma
(left
"Kräuter
Client: Brigitte Magazine
alternative medicines
Format: Editoria
Technique: Digital collage
2007

Marie Luise Emmermann
(right
"Exit02
Client: Noname Magazine
Format: Editoria
Technique: Digital collage
2006

Skizzoma
"Exit01
Client: Noname magazine
Format: Editoria
Technique: Digital collage
2006

Skizzoma
(left
"Pommes
Personal work
Technique: Digital collage
2007

Skizzoma
(right
"Runs in the family
Client: Kuenstlichst.de
issue "Family
Format: Editoria
Technique: Digital collage
2007

Forever Young
(left, 2 illustrations)
"Nostalgia"
Client: Frame Magazine
Credits: New Antiques by Marcel
Wanders for Cappellini Smoke,
clock by Maarten Baas 2579Bieder
y Emaf Progetti for Zanotta Eek,
dresser by Piet Hein for Moooi
Technique: Watercolour ink,
collage, Photoshop
2005

Forever Young
(right)
"Lustgarden #2"
Technique: Watercolour ink,
collage, Photoshop
2006

Martin Nicolausson
(left)
"Untitled (Think Outside The Box)"
Client:
Volvo / Forsman & Bodenfors
Format: T-shirt print
Technique: Illustrator
2006

Vicki Fong
(right, 2 illustrations)
Designer: Vicki Fong
Client: Modernist
Format: Commissioned print
for Modernist's Spring / Summer
2007 catwalk collection
Technique: Hand-drawn,
photography and Photoshop
2006

James Dawe
"Scoop Head"
Client: Meat Magazine
Format: Editorial
Technique: Hands-on collage
and mixed media
2006

Miles Cole
Client: University of Strathclyde
Format: Editorial
Technique: Photoshop
2006

James Dawe
(left)
"Material Progress"
Client: Rojo Magazine
Format: Editorial
Technique: Hands-on and digital
collage, 2007

Miles Cole
(right)
"Revolutions"
Client: Wall Street Journal
Format: Editorial
Technique: Photoshop
2005

Raum Mannheim
"Hybrid Optic"
Client: Exposition k+/Institut für
Raumfreiheit
Format: Digital print on canvas
Technique: Mixed media
2006

Raum Mannheim
"Hybrid Office"
Client: Exposition k+/Institut für
Raumfreiheit
Format: Digital print on canvas
Technique: Mixed media
2006

Benedita Feijó
(left)
"Crow"
Designer: Michael Andersen
(InteractCreative)
Client: Indie Lisbon Festival
Technique: Photoshop
2007

Raum Mannheim
(right)
"Hybrid Beauty"
Client: Exposition k+/Institut für
Raumfreiheit
Format: Digital print on canvas
Technique: Mixed media
2006

Raum Mannheim
Benedita Feijó

Marianna Rossi
"Glamorama"
Format: Poster
Technique: Collage
2007

Pandarosa
(2 illustrations)
Client: JR Duty Free
Credits: In-store illustrations
for duty free store
Technique: Collage
2006

Marianna Rossi
Pandarosa

Marianna Rossi
"Glamorama"
Format: Poster
Technique: Collage
2007

Pandarosa
(2 illustrations)
Client: JR Duty Free
Credits: In-store illustrations
for duty free store
Technique: Collage
2006

Marianna Rossi
Pandarosa

Yoshi Tajima
(2 illustrations)
"Gigolo girl 3 & 4"
Client: International Deejay
Gigolo Records
Format: Website
Technique: Drawing, ink, collage,
Illustrator, Photoshop
2006

Gi Myao
(left)
"Cinderella clock"
Personal project
Technique: Hand-drawn,
watercolour, graphics
2007

Gi Myao
(right)
"Chin chin"
Client: Shift Japan Magazinen
Format: Cover
Technique: Hand-drawn
watercolour, graphics
2007

Gi Myao
"Don't let the pirate in
Client
Nothing Lasts Forever Magazine
Format: Editorial
Technique: Hand-drawn
watercolour, graphics
2007

Sophie Toulouse
(left)
Client: Composite Magazine
Format: T-shirt
Technique: Illustrator
2006

Sophie Toulouse
(right)
"Face of 2006"
Client: Composite Magazine
Technique: Illustrator
2006

Sophie Toulouse
(left)
"In between worlds"
Personal work
Format: Nation of Angela –
Chapter05
Credits: Exhibit at FAT galerie,
in February 2006, Paris
Technique: Mixed
2006

Joel Lardner
(right)
"Absolut Rasperri"
Client: Absolut Reflections
Magazine, Sweden
Format: Editorial
Technique: Drawing
2005

Joel Lardner
Sophie Toulouse
163 | Deconstructive & Collage

The Secret Vine

...beyond the lake, past the vines, over the big hill to where the river flowed and make their way carefully over the bridge.

WHIRRRRRRR!!!

The Brown Kids would stay down there, eating those mysterious grapes from the Secret Vine and telling tales, until they heard Father Brown's truck heading back up the road. Then they would gather their things and rush back over the bridge, up the big hill, past the vines and by the lake back home.

Get a Grip

Pandarosa
(4 illustrations)
"The Secret Vine"
Client: KYN
Credits: Promotional children's storybook for KYN
Technique: Digital collage
2007

Deconstructive & Collage | 164

Pandarosa
(right)
"Religion"
Client: Fairfax
Credits: Illustrations for 365 calendar project
Technique: Vinyl collage
2006

Pandarosa
Deconstructive & Collage | 164

Pandarosa
(6 illustrations)
Interactivly choose your own
adventure book
Client: KYN
Credits: Animation by Kongzilla
CMS by bigfriendlyapes
Format: Online interactive
Technique: Digital collage
2007

To cellar To house

"Wow! Look at this house.
I wonder who lives here."

Would you like to go via the
forest or garden

What's this book? I wonder
what The Story is about."

Pandarosa
Promotional playing card set
Client: KYN
Technique : Digital collage
2007

Karolien Vanderstappen
Client: Weekend Knack
(magazine), Belgium
Format: Editorial
Technique: Collage
2007

Karolien Vanderstappen
(2 illustrations)
Client: Student work at EINA,
Escola Disseny i Art, Barcelona,
Spain
Format: Book
Technique: Collage
2006

Karolien Vanderstappen
"Sint"
Client: Cultural centre
"De Kern", Wilrijk
Format: Illustrations for a record
Technique: Collage
2005

Karolien Vanderstappen
(left)
Client: Student work, Sint Lucas
Antwerp, Belgium, final project
Format: Illustrations of the book
"Wolf" (unpublished)
Technique: Collage
2006

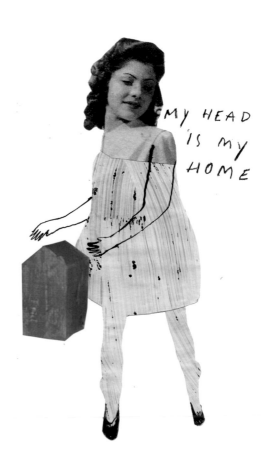

Karolien Vanderstappen
(right)
"My head is my home"
Personal work
Technique: Collage
2007

Karolien Vanderstappen
"La lune boit notre vin"
Client: Library Trivignano
Udinese, Italy
Format: Selected illustration for
"Imagine the Time" contest for
illustrations for a calendar
Technique: Collage
2006

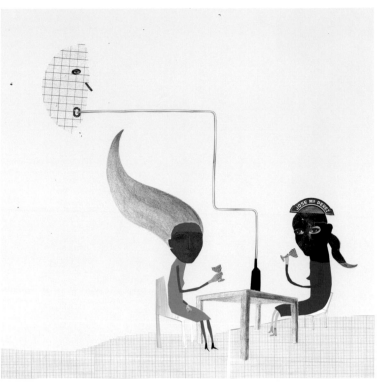

Karolien Vanderstappen
(left)
"Je pleut du vin pour vous"
Client: Library Trivignano
Udinese, Italy
Format: Selected illustration for
"Imagine the Time" contest for
illustrations for a calendar
Technique: Collage
2006

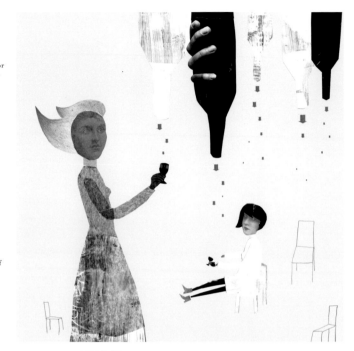

Karolien Vanderstappen
"Mama Tirannie"
Client: Medium, an imprint of
Luc Derycke & Co
Format: Book
Technique: Collage
2007

Karolien Vanderstappen
(left)
"Moederkoek"
Client: Medium, an imprint of
Luc Derycke & Co
Format: Book
Technique: Collage
2007

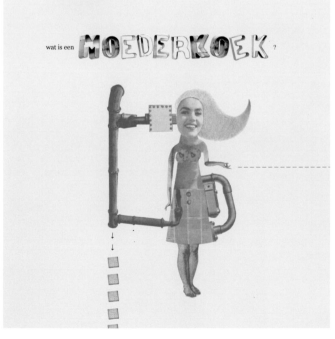

Karolien Vanderstappen
"Mamamania"
Designer: Karolien Vanderstappen
Client: Medium, an imprint of
Luc Derycke & Co
Format: Book
Technique: Collage
2007

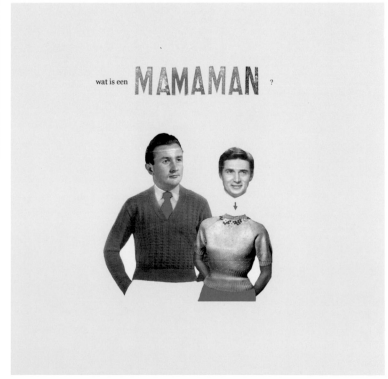

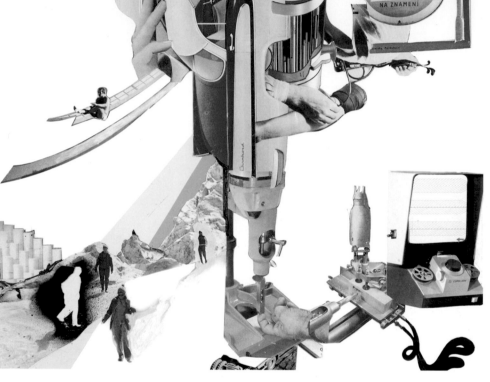

James Dawe
"Watch Tower"
Client: Rojo Magazine
Format: Editorial
Technique: Hands-on collage
2007

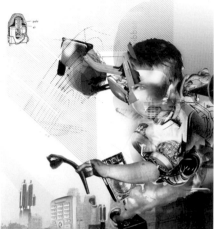

James Dawe
"Hearing, Oral argument"
Client:
YCN creative online agency
Format: Editorial
Technique: Hands-on and
digital collage
2007

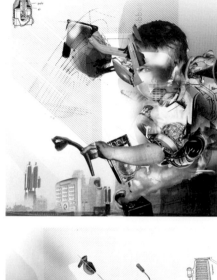

James Dawe
"Hearing, Manual
(sign language) argument"
Client:
YCN creative online agency
Format: Editorial
Technique: Hands-on and
digital collage
2007

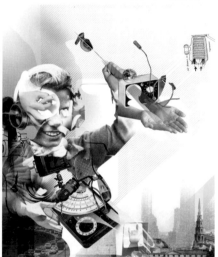

**Manchini |
Dermot McConaghy**
(left)
"For her benefit"
Format: Exhibition / display
Technique: Torn, photography,
scribbing, composition, spray
paint, stencil, tape, marks
2007

**Manchini |
Dermot McConaghy**
(right)
"Debbie does Craigavon"
Client: Managerial Material
Format: Album sleeve artwork
Technique: Barcodes, marker pen,
scribbles, photo, cut, typography,
Photoshop, scratches, dirty,
humour, numbers
2007

**Manchini |
Dermot McConaghy**
"Doctor's orders"
Format: Editorial
Technique: Scan, spray, dots,
photography, scrap, scribble, torn,
tape, cut
2007

**James Dawe
Manchini |
Dermot McConaghy**
Deconstructive & Collage | 168

MisprintedType |
Eduardo Recife
"Bright Side"
Personal work
Format: Poster / prints
Technique: Digital collage
2007

MisprintedType |
Eduardo Recife
"Assume the Position"
Client: HBO
(Commissioned by Raygun)
Format: Motion (still board)
Technique: Digital illustration
2006

MisprintedType |
Eduardo Recife
"Right Thoughts"
Personal work
(Misprinted Type)
Format: Poster / print
Technique: Digital collage,
drawings
2007

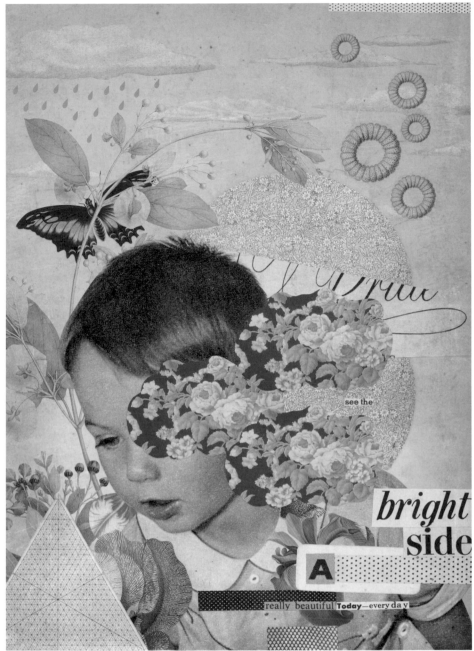

Jun | Ufho
Client: Ministry of Sound
Singapore
Format: Invitation
Technique: Digital collage
2006

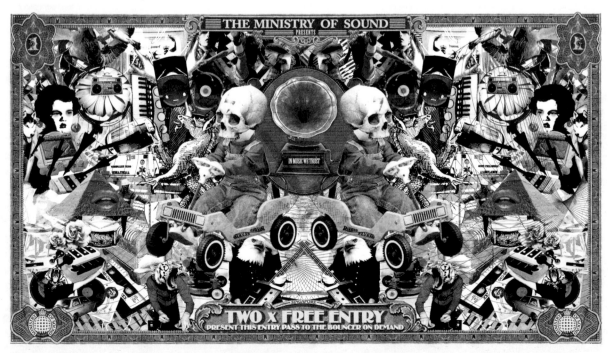

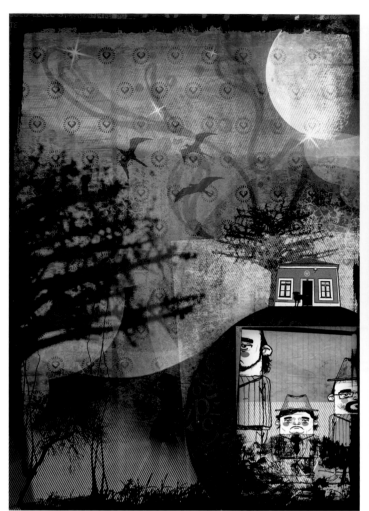

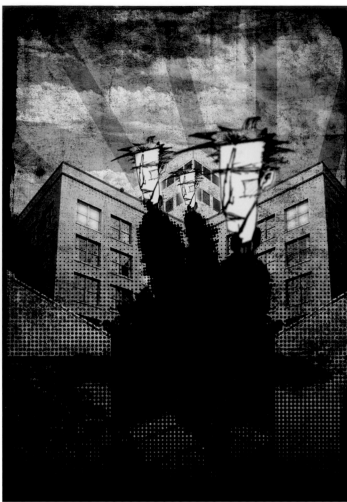

Purpura
(2 illustrations)
"Day and Night at Purpura's"
Designer: Luis Gomes, Nuno
Silva, Fernando Lopes
Client: Die Gestalten Verlag
Format: Image
Technique: Ink drawing,
Photoshop
2007

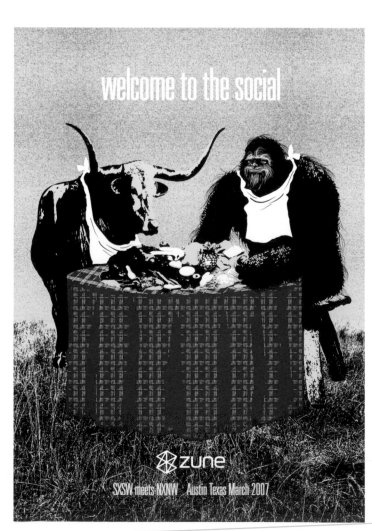

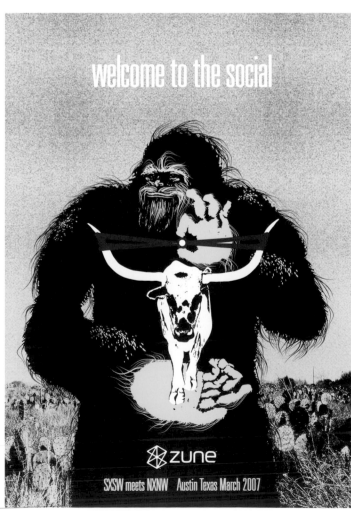

Andrio Abero | 33rpm
"Zune SXSW Poster"
Client: Microsoft
Format: Poster
Technique: Silkscreen print
2007

Matthias Gephart
(left)
"Ein wirklich nettes Mädchen"
Client: Vorn Magazine
Format: Editorial
Technique: Multiple collage,
digital
2006

Matthias Gephart
(right)
"Mellie sieht das anders"
Free work
Technique: Multiple collage
2007

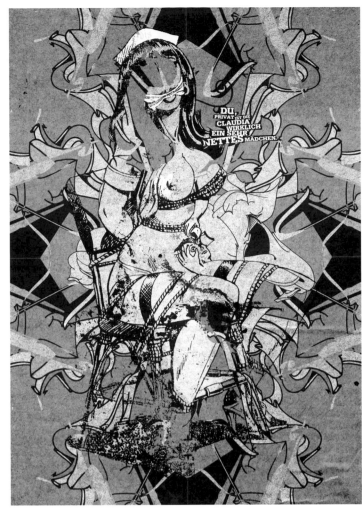

Kerry Roper
(2 illustrations)
"Snickers"
Client: BBDO NYC/Snickers
Format: Magazine advertisement
Technique: Digital and mixed
media
2005/06

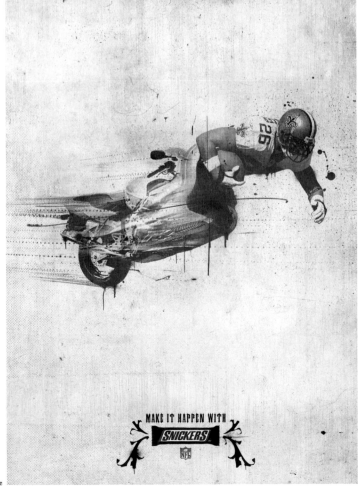
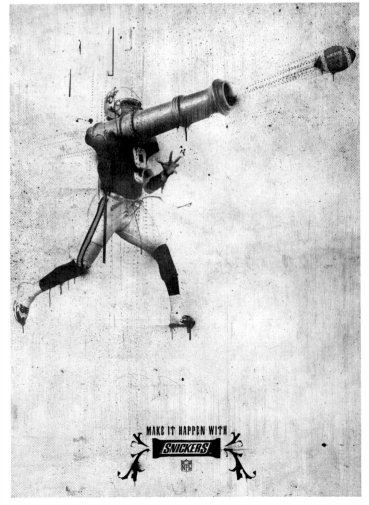

Matthias Gephart
Kerry Roper
171 | Deconstructive & Collage

Mone Maurer
"Michael Kors Glasses"
Client: Style & The Family Tunes
Format: Editorial
Technique: Acrylic, Indian ink,
sticker, Photoshop
2005

Mone Maurer
"Perspektive"
Client: brand eins
Format: Editorial
Technique: Acrylic, Indian ink,
sticker, Photoshop
2005

Mone Maurer
"Y-3 Sneaker"
Client: Style & The Family Tunes
Format: Editorial
Technique: Acrylic, Indian ink,
sticker, Photoshop
2005

Mone Maurer
"Perspektive"
Client: brand eins
Format: Editorial
Technique: Acrylic, Indian ink,
sticker, Photoshop
2005

Mone Maurer
(2 illustrations)
"Designing the Wave"
Client: Directions
(The Design Hotels Magazine)
Format: Editorial
Technique: Acrylic, Indian ink,
sticker, Photoshop
2007

Mone Maurer
(2 illustrations)
"Claudia Schiffer – Recover Beauty"
Client: Vorn Magazine
Format: Editorial
Technique: Acrylic, Indian ink,
sticker, Photoshop
2007

Mone Maurer

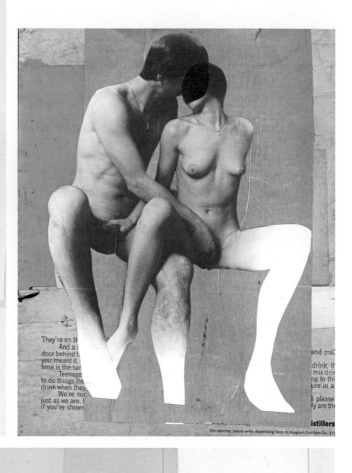

James Gallagher
"Swivel Step"
Technique: Collage
2007

James Gallagher
"Helping Hands"
Technique: Collage
2007

James Gallagher
(left)
"Another Reputation Ruined"
Technique: Collage
2007

James Gallagher
(middle)
"Conversation"
Technique: Collage
2006

James Gallagher
(right)
"Powerchair"
Technique: Collage
2007

James Gallagher
"To close"
Technique: Collage
2007

Mario Wagner
"1940s"
Client: The Globe
Technique: Paper collage, acrylic
and Letraset
2007

Via Grafik
Designer: André Nossek
Client: Afire
Format: Record sleeve
(not chosen)
Technique: Mixed – handmade,
Photoshop
2006

Mario Wagner
"Olympia"
Client: Booklet Magazine
Format: Editorial
Technique: Paper collage, acrylic
and Letraset
2006

Mario Wagner
(left)
"Scream"
Technique: Paper collage, acrylic
and Letraset
2006

Mario Wagner
(middle)
"Invader"
Format: Exhibition work
Technique: Paper collage, acrylic
and Letraset
2007

Mario Wagner
(right)
"Wolke"
Client: ROJO Magazine
Format: Editorial
Technique: Paper collage, acrylic
and Letraset
2006

Mario Wagner
"Buy"
Client: Matador Magazine
Format: Editorial
Technique: Paper collage, acrylic
and Letraset
2007

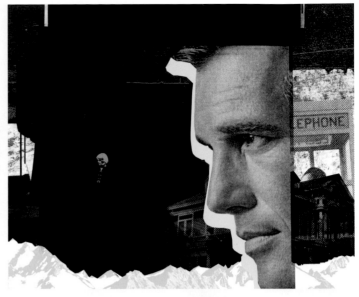

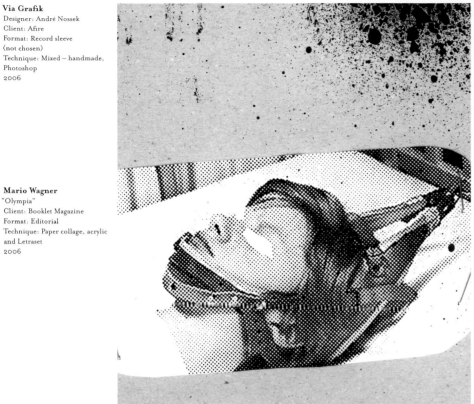

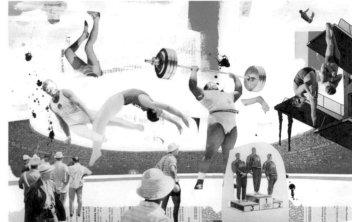

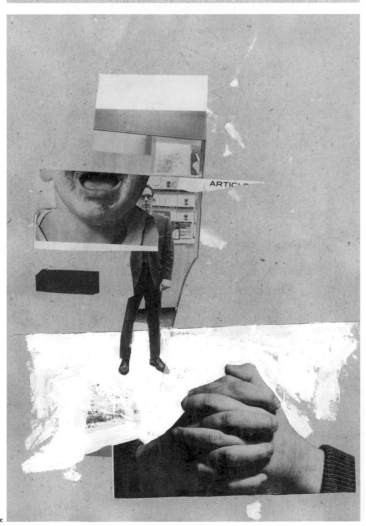

Mario Wagner

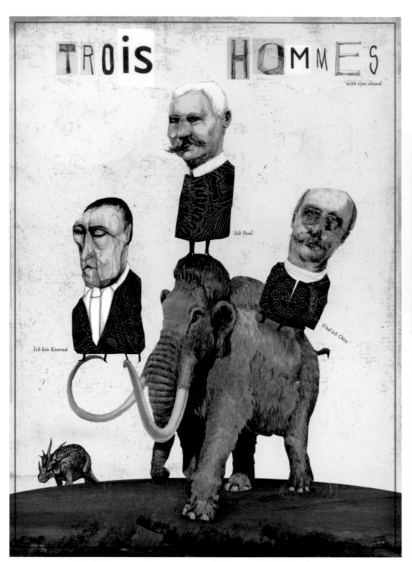

Marco Wagner
"Trois hommes"
Format: Poster
Technique: Hand-drawn,
Photoshop
2007

Marco Wagner
"Rotkäppchen"
Format: Book
Technique: Hand-drawn,
Photoshop
2007

Marco Wagner
"Alice in Wonderland"
Format: Book
Technique: Hand-drawn,
Photoshop
2006

Marco Wagner
(left, 2 illustrations)
"Rotkäppchen"
Format: Book
Technique: Hand-drawn,
Photoshop
2007

Marco Wagner
(right)
"Egon Schiele"
Technique: Hand-drawn,
Photoshop
2007

Marco Wagner

Marco Wagner
"Freischwimmer"
Format: Poster
Technique: Hand-drawn,
Photoshop
2007

Marco Wagner
"So wach warst du noch nie"
Client: Jung von Matt / Hamburg
Art Direction: Damjan Pita
Format: Print advertising
Technique: Hand-drawn,
Photoshop
2006

Marco Wagner
"Alice in Wonderland"
Format: Book
Technique: Hand-drawn,
Photoshop
2006

Marco Wagner
"Sein Auftrag"
Format: Cover
Technique: Hand-drawn,
Photoshop
2007

Marco Wagner
"Gustav Klimt"
Format: Portrait
Technique: Hand-drawn,
Photoshop
2007

Marco Wagner
"Thelonious Monk"
Format: Portrait
Technique: Hand-drawn,
Photoshop
2006

Marco Wagner

Lars Henkel | Reflektorium
"Pestilence"
"The Masquerade"
"The Red Death"
from POE
Client: Die Gestalten Verlag
Technique: Indian ink
2006

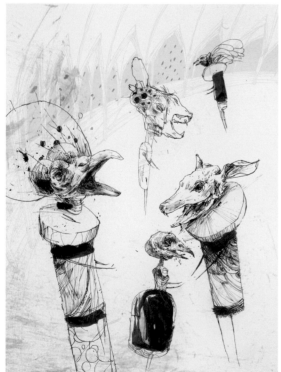

Lars Henkel | Reflektorium
(right)
Book fair supplement
Client: Hannoversche
Allgemeine Zeitung
Technique: Collage
2005

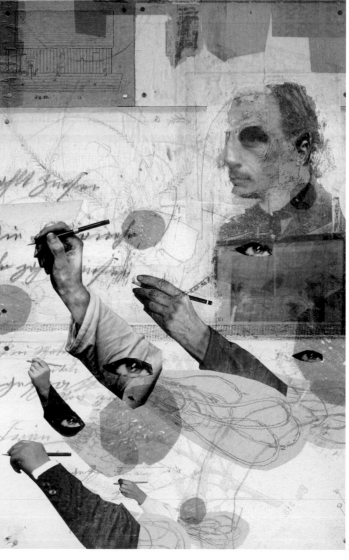

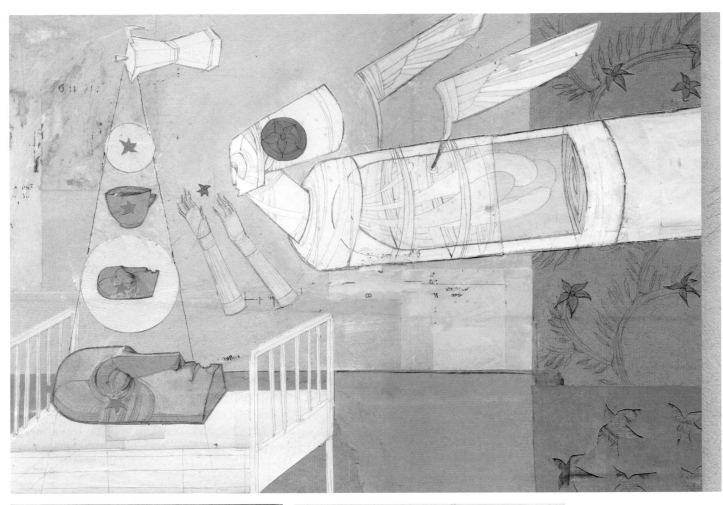

Lars Henkel | Reflektorium
"Tagnacht:Frühstück"
Client: StadtRevue Verlag
Technique: Pencil and tempera
on wooden boxes
2004

Lars Henkel | Reflektorium
(left)
Book fair supplement
Client: Hannoversche
Allgemeine Zeitung
Technique: Collage
2005

Lars Henkel | Reflektorium
(right)
"Tagnacht:Weinlokale"
Client: StadtRevue Verlag
Technique: Pencil and tempera
on wooden boxes
2004

Lars Henkel | Reflektorium
"Tagnacht:Vegetarisches Essen"
Client: StadtRevue Verlag
Technique: Pencil and tempera
on wooden boxes
2004

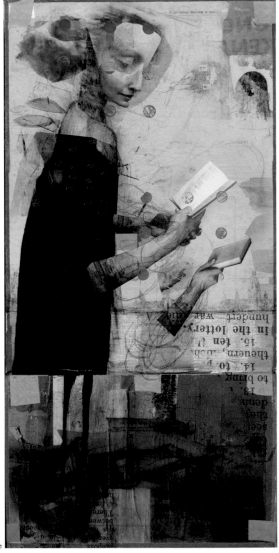

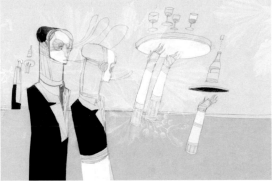

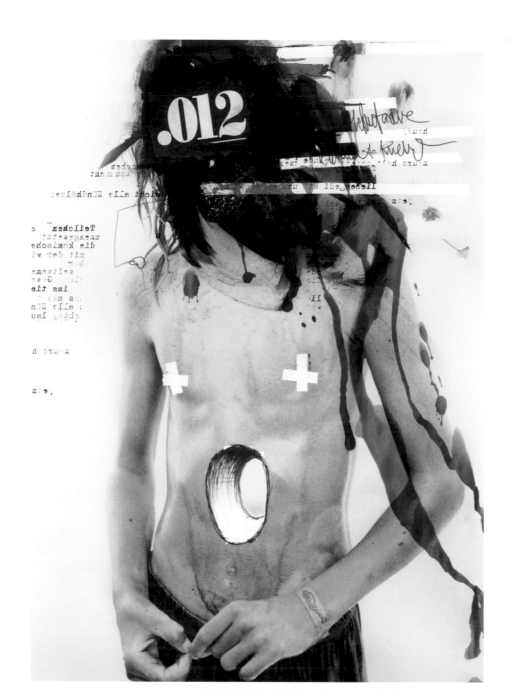

Uwe Eger
(2 illustrations)
Credits: Mnemonic Magazine
2004

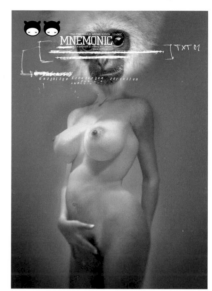

Uwe Eger
(2 illustrations)
Client: Die Krieger des Lichts
Brave communications
Credits: Feature for
Licht Magazine
2006

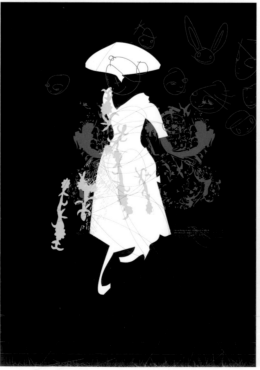

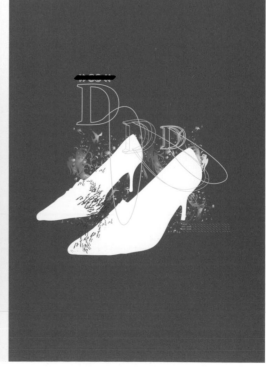

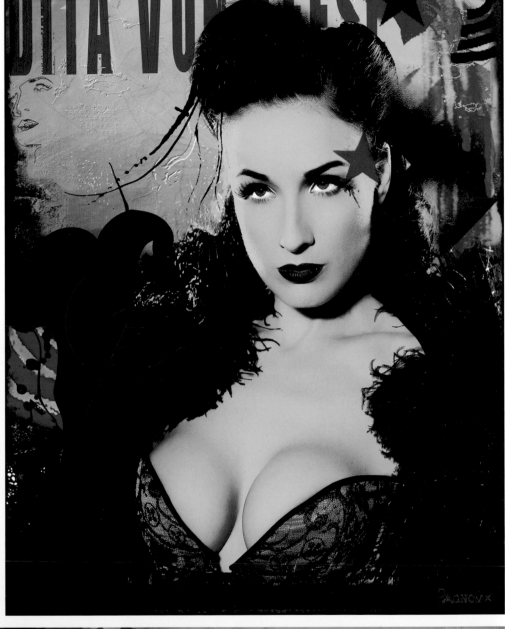

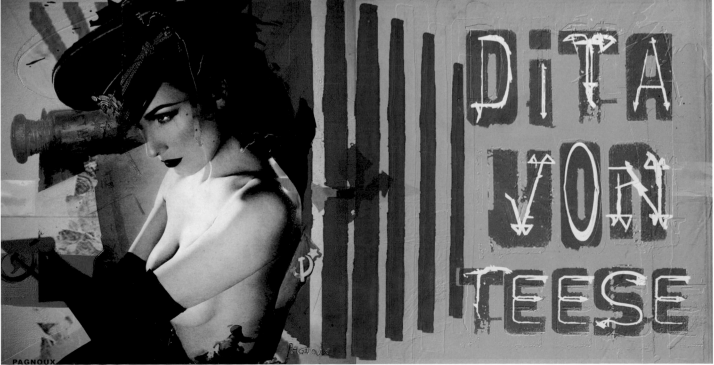

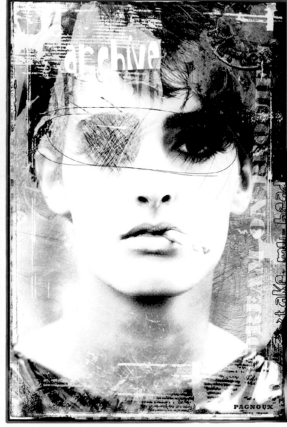

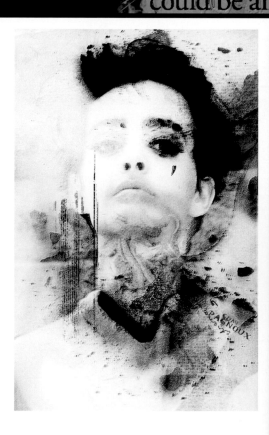

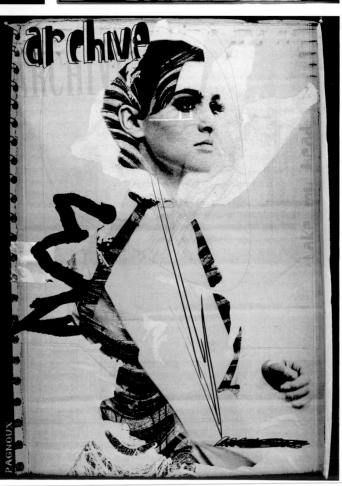

Sandrine Pagnoux
"Could be alive"
Client: Metallic Mayhem,
Bigbros Workshop (Singapore)
Photo: Sophie Etchart
Format: Editorial
Technique: Collage
2007

Sandrine Pagnoux
"Archive yeux"
Personal work
Photo: Sophie Etchart
Technique: Collage
2006

Sandrine Pagnoux
(left)
"Verre"
Personal work
Photo: Sophie Etchart
Technique: Collage
2005

Sandrine Pagnoux
(right)
"Archive (waiting for an angel)"
Personal work
Photo: Sophie Etchart
Technique: Collage
2006

Sandrine Pagnoux
"Carte postale"
Personal work
Photo: Sophie Etchart
Technique: Collage
2005

Sandrine Pagnoux
"Voluptes Noires"
Personal work
Technique: Collage
2006

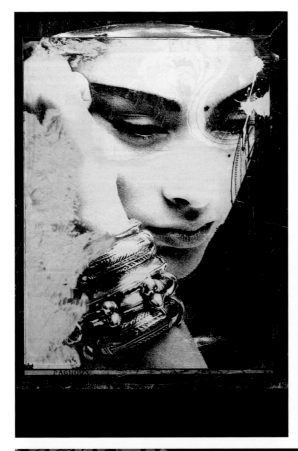

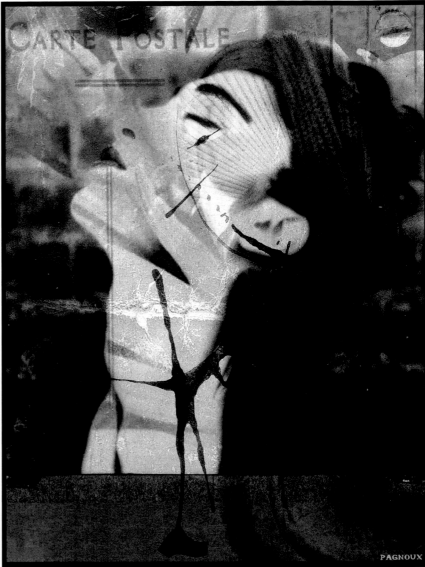

Sandrine Pagnoux
(left)
"Mes yeux dans ton âme"
Personal Work
Photo: Sophie Etchart
Technique: Collage
2007

Sandrine Pagnoux
(right)
"Tragic"
Personal work
Photo: Sophie Etchart
Technique: Collage
2006

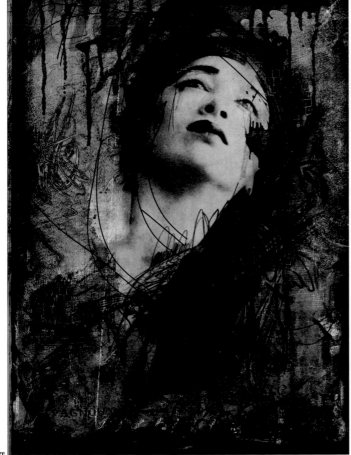

Sandrine Pagnoux
183 | Deconstructive & Collage

Vector

In the late 1990s, vectors were the new tool of choice for many designers. They offered an obvious antidote to graphic design's staid virtues of craft and diligence, its ruled margins and apprenticeship structures. Spurred on by the temptation of infinitely scaleable structures, perfect curves and finely-tuned colour schemes, vector graphics soon spawned a distinctive genre of their own making—a wealth of digital re-tracings of reality, coloured and processed into new shapes.

Now, an entire generation of artists and designers have explored—and OD'd on—this liberation from linear workmanship. Now that the hype has died away, the tides have turned once again.

In a gentle repudiation of the pre-millennial enthusiasm for all things digital (from electronic music to gadgets, networks and broadband applications), many have abandoned the cutesy simplicity of late 20th century vectorcises. Instead, many designers are now choosing to focus on stunning—and stunningly opulent—convolutes rooted in traditional illustration techniques. With a strong focus on detail and perfection, references to Art Nouveau might just join moments of inspired lightness.

Translated to the digital realm, these works no longer promote the hyper-real entities and über-perfection so seductive to early adopters. Instead, they explore idiosyncratic, mesmerising inner and outer realms that reach a level of complexity that renders realisation by non-digital means almost unthinkable. Here, vectors become less of an aesthetic statement and more of a tool and lever for the liberation of a wealth of stylistic diversity. Today, vectors are a means to an end for some truly staggering designs that take graphic sophistication and old-fashioned workmanship to new heights.

From blocky colours and filigree dreamscapes to mind-boggling references, repetitions and ramifications, vector graphics have finally severed their aesthetic leash. The well-tamed "ghost in the machine" allows their imagination to run riot—as controlled madness, reigned in by tight mastery.

Apfel Zet
"Chalkidiki 2005"
Client: International
Endohernia Society
Technique: Freehand
2005

Ella Tjader
"Japan"
Client: JEM Sportswear (USA)
Format: Fashion apparel
Technique: Illustrator
and Photoshop
2007

Ella Tjader
(left)
"Madame Zebra"
Client: JEM Sportswear (USA)
Format: Fashion apparel
Technique: Illustrator
and Photoshop
2007

Apfel Zet
(right)
"Wilde Schwäne"
Client: Mega Eins Verlag
Format: CD cover
Technique: Freehand
2006

Stephane Manel
"Shoe shine on"
Client: Le Coq Sportif, Japan
Credits: Illustration for the
Make You Imagine campaign
2006

Stephane Manel
"C'est mon histoire"
Client: Elle Magazine
Credits: In Elle France
Numero 3189
February 2007

Stephane Manel
"Roman Faces"
Client: "The Sound of Venus"
personal exhibition
held at the R. Pons galery, Paris
Technique: Pencil, ink
and gouache on paper
2007

Stephane Manel
"Frau Roma und Frau Napoli"
Client: Galeries Lafayette, Berlin
Credits: Store windows for the
Exhibition Traits Tres Mode
2005

Stephane Manel
Client: Mondial 2006
Credits: Cover and drawings
for a book about soccer for
Le Baron Perche editions,
Paris
2006

Stephane Manel
"Uschi Obermaier"
Credits: Series of people
for www.stephanemanel.com
2007

Uschi Obermaier
Actress, model 1946

Stephane Manel
Lucio Battisti
Credits: Series of people for
www.stephanemanel.com
2007

Lucio Battisti
Musician 1943-1998

Stephane Manel
"Sportivo"
Client: Printemps de l'Homme
Credits: Big Mural for
the Paris store Le Printemps
2005

Andy Potts
"NYC"
Personal work
Technique: Digital illustration
2007

Andy Potts
"Hastings Pier"
Personal work
Technique: Digital illustration
2007

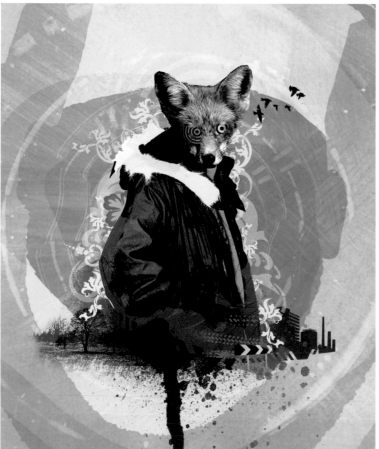

Andy Potts
(left)
"Love It When I Feel Like This"
Client: The Twang,
B-Unique Record Label
Commissioned by Stephen
Kennedy at Fury Art Direction
Format: Album cover design,
CD and 12"
Technique: Digital illustration
2007

Andy Potts
(right)
"Learning curve:
Finding Professional Training"
Client: Design Week
Commissioned
by Ivan Cottrell
Format: Magazine cover
Technique: Digital illustration
2007

Andy Potts
"20 Best Neighbourhoods"
Client: Portland Monthly
Commissioned by
Samantha Gardner
Format: Cover illustration
Technique: Digital illustration
2007

Andy Potts
"Cuba"
Personal work
Technique: Digital illustration
2007

Andy Potts
(left)
"Wide Awake"
Client: The Twang,
B-Unique Record Label
Commissioned by Stephen
Kennedy at Fury Art Direction
Format: Single cover design,
CD and 7"
Technique: Digital illustration
2007

Andy Potts
(right)
"The Free and Easy"
Client: Random House
Commissioned by Eleanor Crow
Format: Book cover
Technique: Digital illustration
2006

Adhemas
(5 illustrations)
"Havaianas Banner
Client: Havaianas / AlmapBBDO
Format: Print poster
Technique: Vector illustration
200

Adhemas
(3 illustrations)
"Havaianas Banners"
Client: Havaianas / AlmapBBDO
Format: Poster
Technique: Vector illustration
2006

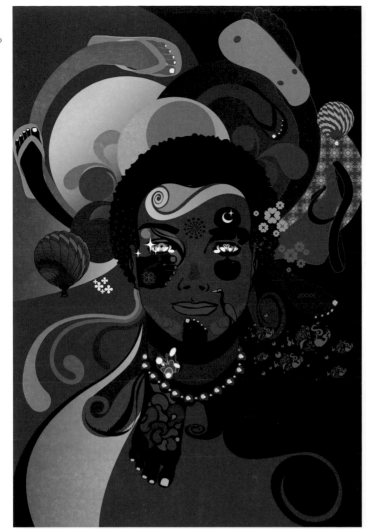

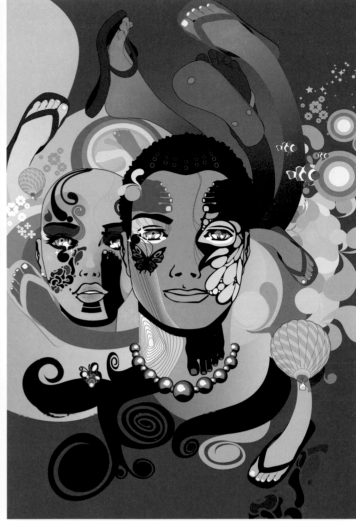

Adhemas
(left)
"30 Colors"
Client: Project 30
Format: Print
Technique: Vector illustration
2006

30 colors.
ABS Limited in thirty colors.

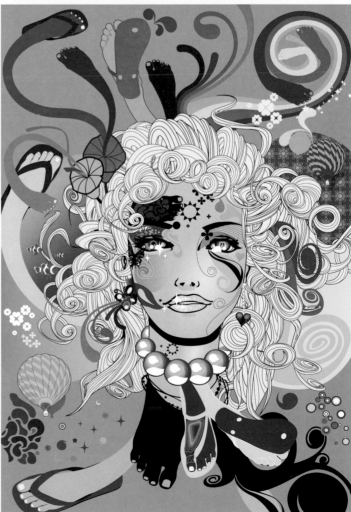

Marine
"The Trees"
Client: Amelia's Magazine
Format: Editorial
Technique: Hand-drawn,
Illustrator, Photoshop
2007

Marine
"Methuselah"
Client: Amelia's Magazine
Format: Editorial
Technique: Hand-drawn,
Illustrator, Photoshop
2007

Serge Seidlitz
"Our Network"
Client: Vodafone
Credits: Enterprise IG
Format: Poster
Technique: Vector
2007

Serge Seidlitz
"The Great Outdoors"
Client: Love Creative
Format: Editorial
Technique: Hand-drawn,
Photoshop
2007

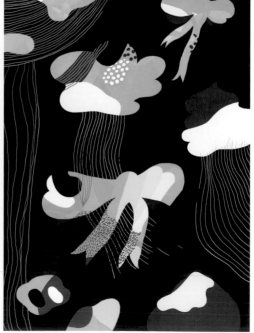

Nan Na Hvass
"Storm"
Client: Henrik Drescher
& Wu Wing Yee
Format: Book
Technique: Photoshop
2007

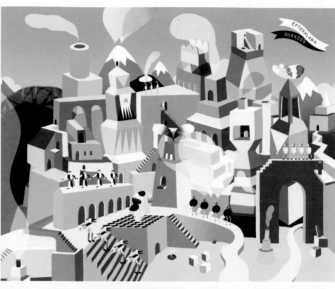

Nan Na Hvass
"Parades"
Designer: Nan Na Hvass and
Kasper Fjederholt
Client: Efterklang and
The Leaf Label
Format: Record sleeve
for CD, vinyl
Technique: Photoshop
and Illustrator
with painted elements
2007

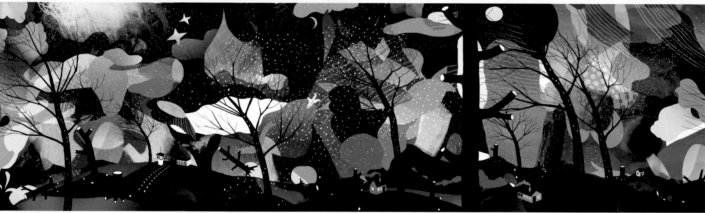

Nan Na Hvass
"Under Giant Trees"
Client: Efterklang and
The Leaf Label
Format: Record sleeve
for CD, vinyl
Technique: Completed in
Photoshop with hand-drawn
elements
2007

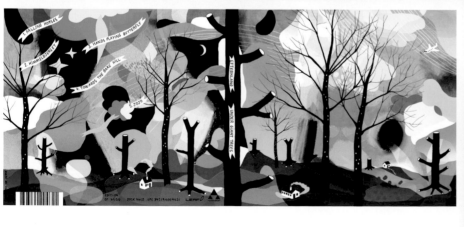

Nan Na Hvass
(left)
"Under Giant Trees"
Client: Efterklang and
The Leaf Label
Format: Record sleeve
for CD, vinyl
Technique: Completed in
Photoshop with hand-drawn
elements
2007

Nan Na Hvass
(right)
"Green Sea"
Format: Poster
Technique: Photoshop
and Illustrator
with painted elements
2006

Kustaa Saksi
(2 illustrations)
Client: Samsung
Format: Ad campaign
Technique: Mixed media
2007

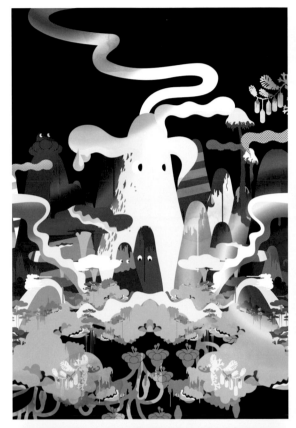

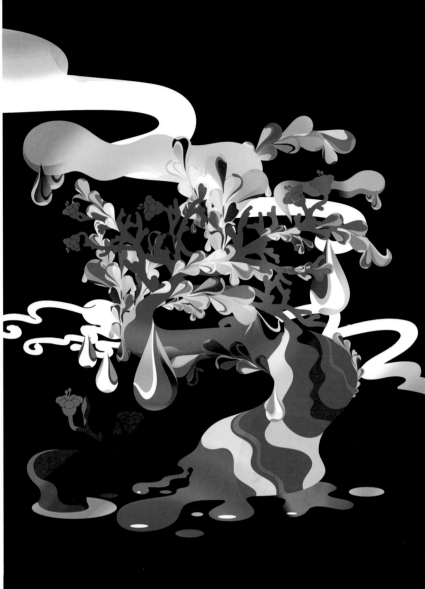

Kustaa Saksi
(left)
"Rollergirls"
Client: Sticky
Format: Promotional
Technique: Mixed media
2007

Kustaa Saksi
(right)
"Progressive"
Client: Swarovski
Format: Promotional
Technique: Mixed media
2007

Nan Na Hvass
(left)
"Blood"
Format: Poster
Technique: Photoshop
2006

Nan Na Hvass
(right)
"Green Sea"
Format: Poster
Technique: Photoshop and
Illustrator with painted elements
2006

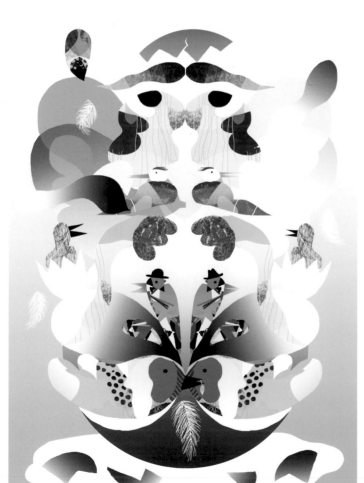

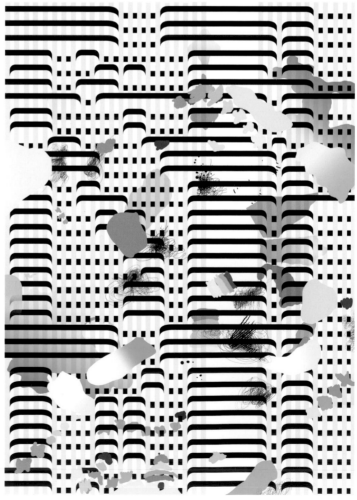

Nan Na Hvass
(left)
"Spring"
Format: Poster
Technique: Photoshop
2007

Nan Na Hvass
(right)
"Rain"
Format: Poster
Technique:
Photoshop and Weavepoint
2005

Katharina Leuzinger
"The Black Posters"
Client: Mielo
Format: Poster
Technique: Ink, Photoshop
2007

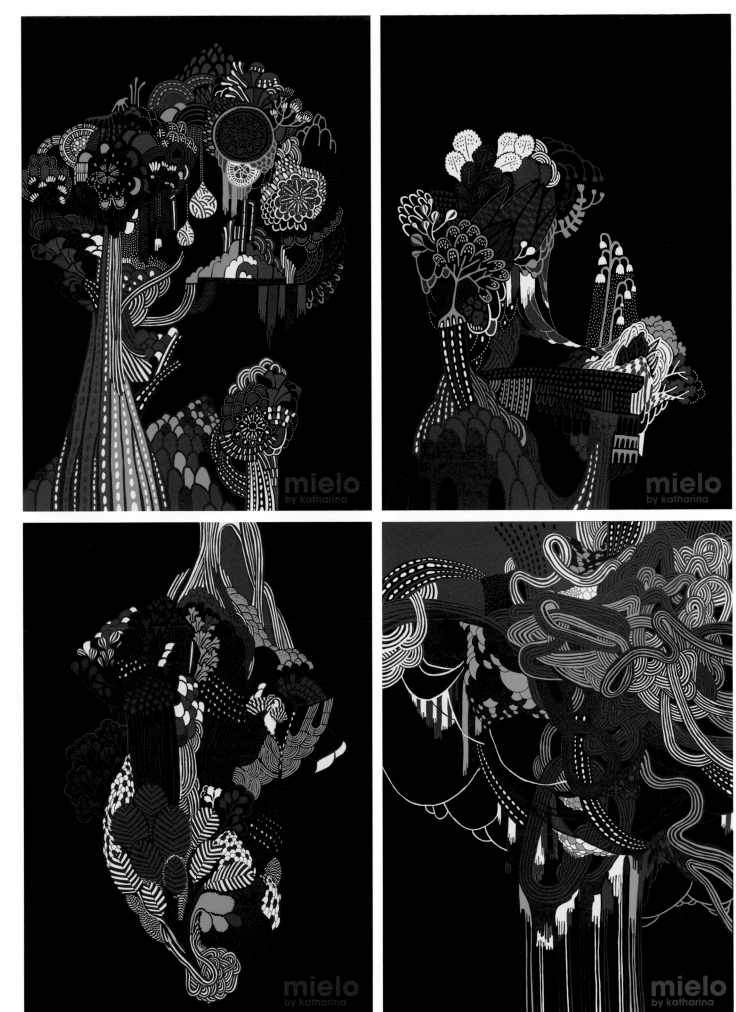

Margit Fellerer
(4 illustrations)
"Schauspiel" & "Musiktheater"
Client: Stadttheater Bern
Credits: In collaboration
with Achtung! Bern and
Michael Mischler
Technique: Collage,
Illustrator, Photoshop
2007

Kristian Olson
"Sticky Tanks"
Client: Sticky
Art Director: Don Pogany
Format: Poster, postcards,
advertisements
Technique: Photoshop and
Illustrator
2007

Kristian Olson
(left)
"The Queen"
Client: Financial Planning
Magazine
Art Director: James Jarnot
Format: Editorial
Technique: Photoshop and
Illustrator
2007

Kristian Olson
(right)
"Hedge Fund Control"
Client: Global Custodian
Art Director: SooJin Buzelli
Format: Editorial
Technique: Photoshop and
Illustrator
2006

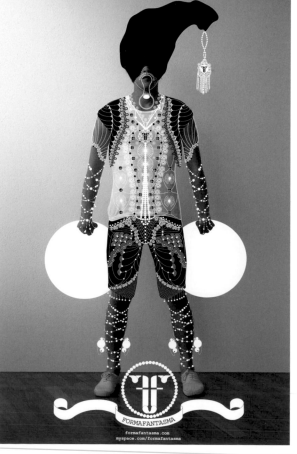

Formafantasma
formafantasma FRN
Designer: Andrea Trimarchi and
Simone Farresin
Technique: Digital photo and
digital illustration
2007

Formafantasma
"Le donne di notte"
Designer: Andrea Trimarchi and
Simone Farresin
Technique: Digital photo and
digital illustration
2007

Formafantasma
(left)
formafantasma MYS
Designer: Andrea Trimarchi and
Simone Farresin
Technique: Digital photo and
digital illustration
2007

Formafantasma
(right)
"my armour"
Designer: Andrea Trimarchi and
Simone Farresin
Technique: Digital photo and
digital illustration
2007

Seb Jarnot
"Train"
Client: ph. Pannetier Editions
Credits: (Janvier–Paris) Limited
edition of 3 signed and numbered
high quality photo prints
Technique: Graphic tablet
on Photoshop
2006

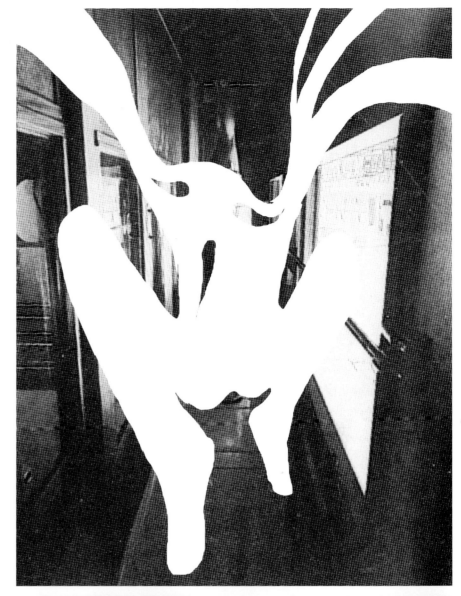

Seb Jarnot
Client: ph. Pannetier Editions
Credits: Published in "Seb
Jarnot – Bruxelles octnov 2005"
exhibition book
Technique: Graphic tablet
on Photoshop
2005

Seb Jarnot
(left)
"Living Room"
Client: ph. Pannetier editions
Credits: (Janvier–Paris) Limited
edition of 3 signed and numbered
high quality photo prints
Technique: Graphic tablet
on Photoshop
2005

Seb Jarnot
(right)
"Sofa"
Client: ph. Pannetier editions
Credits: (Janvier–Paris) Limited
edition of 3 signed and numbered
high quality photo prints
Technique: Graphic tablet
on Photoshop
2005

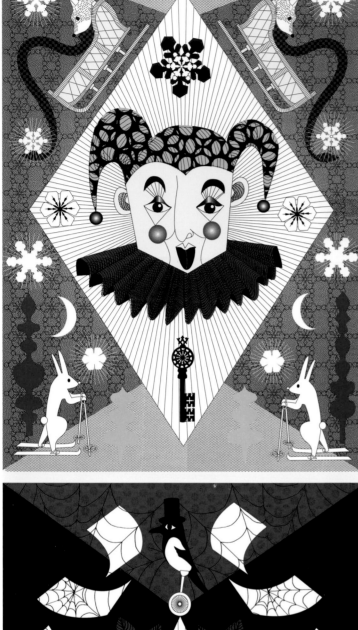

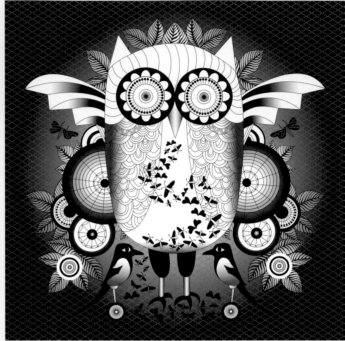

Maja Sten
"The Joker"
Personal project
Technique: Collage
2007

Maja Sten
"I Looked at You"
Client: Nordiska Kompaniet
Technique: Illustrator
2007

Maja Sten
(left)
"Fru Musica"
Personal project
Technique: Collage
2007

Maja Sten
(right)
"The Devil's Flower"
Personal project
Technique: Collage
2007

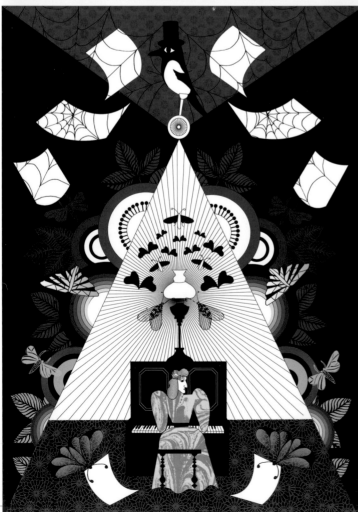

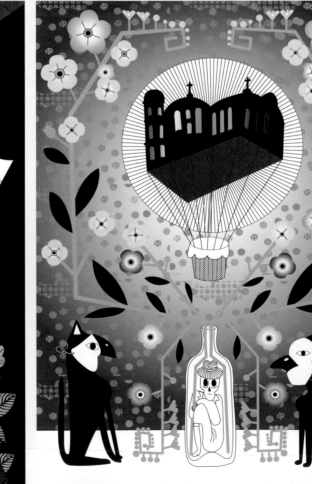

Sebastian Onufszak
(5 illustrations)
"Dos"
Client: Michael Fakesch
Format: Record packaging
Technique: Hand-drawn,
Photoshop
2007

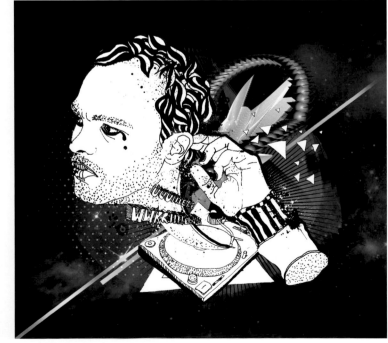

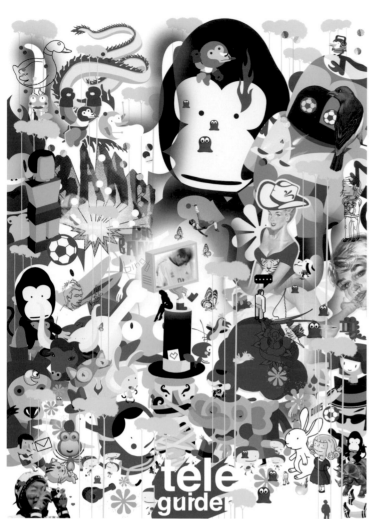

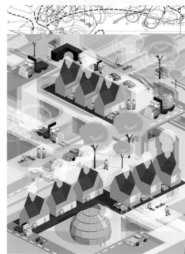

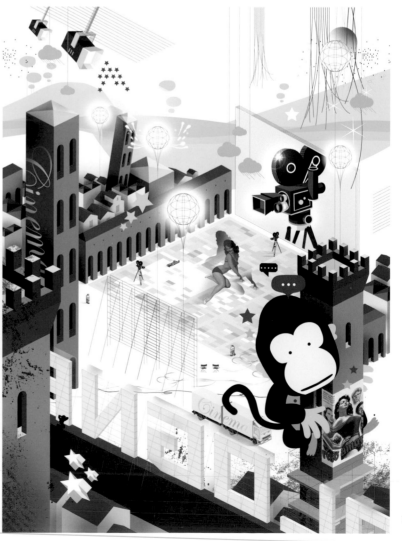

Famille K | Stephane Kiehl
(left)
Technique: Mixed media
2003

Famille K | Stephane Kiehl
(right)
"Camion 2"
Technique: Mixed media
2004

Famille K | Stephane Kiehl
(right 2)
"Camion 1"
Technique: Mixed media
2004

Famille K | Stephane Kiehl
(left)
"Camion 3"
Technique: Mixed media
2004

Famille K | Stephane Kiehl
(right)
"Ciné Bologna"
Client: Urban
Technique: Mixed media
2004

Famille K | Stephane Kiehl
(right)
"Pot 1"
Technique: Mixed media
2005

Famille K | Stephane Kiehl
(left)
"Steve Jobs Book"
Client: Ansol Book
Technique: Mixed media
2005

Famille K | Stephane Kiehl
"Steve Jobs Book"
Client: Ansol Book
Technique: Mixed media
2005

Famille K | Stephane Kiehl
(left)
Client: Redux
Technique: Mixed media
2006

Famille K | Stephane Kiehl
(right)
Technique: Mixed media
2003

Interview Katrin Olina

From snowboards to wallpaper, Katrin Petursdottir aka Katrin Olina's surreal realms and emotional, subconscious wanderings proudly display their computer-generated roots and translate to a huge variety of products, designs, interiors and editorials. The well-travelled Icelandic designer and artist completed stints at Philippe Starck's studio in Paris and Ross Lovegrove's studio in London before joining creative forces with husband Michael Young in 1998.

Since then, Olina has been responsible for a wide range of high-profile design projects, from large-scale commissions by the Kortrijk Design Biennale (2002) and Oslo National Gallery (2005) to exclusive designs for fashion house Fornarina, porcelain specialist Rosenthal and the latest poster campaign for the Montreux Jazz Festival.

Background

With its wild, deserted nature, my native Iceland is a place that calls for introspection and feeds the imagination. Here, it is easy to get lost in a dream state. So, really, you need to leave in order to get things done. My first trip took me to Paris, where I studied product design and spent my second adolescence, so to speak. Later on, I stopped for brief and extended stints in London, Japan, Germany, Spain and, for the past few years, in Taiwan and Hong Kong.

Skills and Techniques

After my studies I worked on product development for Philippe Starck and Ross Lovegrove, so my road to illustration has not been a straight one. Yet from a very early age I had a strong urge to make things. It could have been music, but I chose to work with materials and visual forms of expression instead. When I laid hands on my first computer in 1998, it felt as if I had finally found a space to experiment and develop my own visual language. And I have been at it ever since.

In visual terms, my creations fall into two distinct categories. One is dreamy, ethereal, organic and feminine. The other is more masculine and dominated by simple, black 2D illustrations that teem with all sorts of child/adult characters and deal with the fears, dreams, darkness and light of our emotional spectrum in a playful way.

Inspiration and Influences

I think people become artists because they have a need to embrace and learn about the many aspects of their existence; it is a path they choose to pursue. I have always tried to keep a very open mind, and thus, my diverse interests and influences encompass natural sciences, history and metaphysics as well as fashion and music. Years ago, I became very interested in studying plants and animals and I think this has also helped to sharpen my eye and style. After many years of observation and experimentation, I am putting these insights into practice.

In terms of visual culture, I truly admire the work of David Lynch, Norman McLaren, Duchamp, the Surrealists, Gustave Dore, Caspar David Friedrich and Goya as well as the ever-expanding realm of popular culture—Western and Asian... I could go on forever!

Featured Works

Many of my recent works are collaborations with Michael Young, mainly on interiors with high tech materials (Dupont Corian (R)), while other clients have applied my illustrations to table wear, fashion and fabrics.

Mixing illustration with painting techniques has resulted in some large-scale commissions and I have just launched a range of limited edition goods—from silk scarves to hand-painted porcelain—under my own label, Katrin Olina. Right now, I am working on sculpture and experimenting with animation, which is something I have dreamt of doing for many years.

Katrin Olina
"41st Montreux Jazz festival"
Client: Montreux Jazz Festival,
Switzerland 2007
Technique: Digital
2006

Katrin Olina
(3 illustrations)
"Smoke"
(There she goes my beautiful world)
Client: Teruo Kurasaki for JT
Technique: Print and mixed
media on canvas
2007

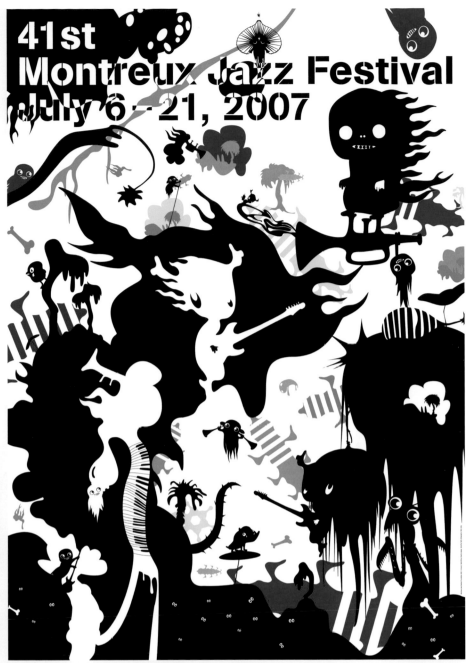

Katrin Olina
(2 illustrations)
Client: Iceland Review
Format: Cover
Technique: Digital
2006

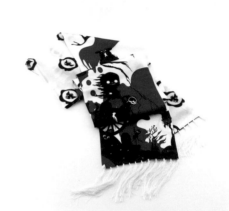

Katrin Olina
Client: Katrin Olina ltd.
Format: 100% silk scarf, with art
work featuring a crime riddle,
from a collection of limited
edition products
Technique: Digital
2007

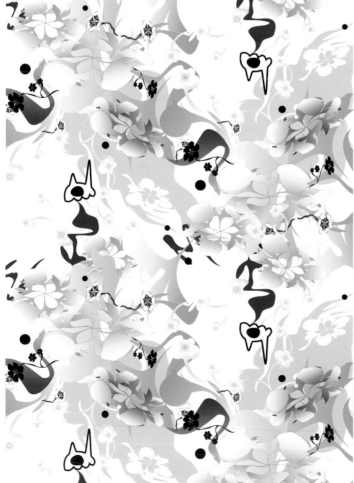
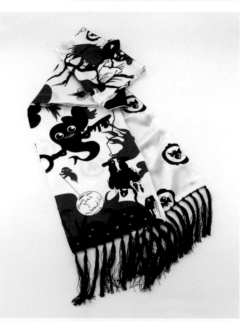

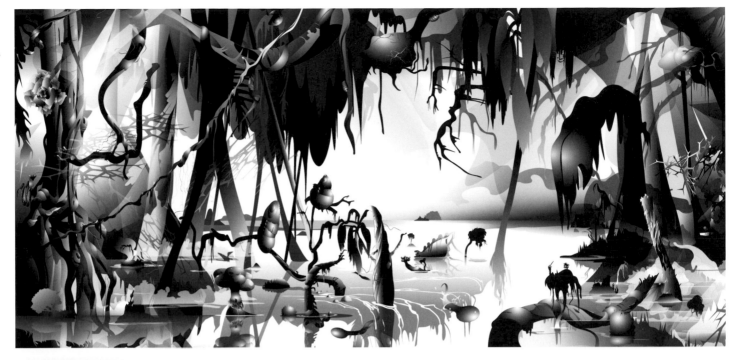

Katrin Olina
"Subplant5"
Client: National Gallery, Oslo
Format: computer-generated
drawing 1000 x 500 cm in size,
light jet print on pvc support
Technique: Digital
2005

Katrin Olina
(2 illustrations)
Client: Katrin Olina ltd.
Format: Porcelain dishes painted
by hand, featuring Noc, the
grinning ghost and trumpet head
Technique: Digital
2007

Katrin Olina
(right, 2 illustrations)
Client: Katrin Olina ltd.
Format: Snowboards and helmets,
limited edition
At Gallery i8, Reykjavik, Iceland
Technique: Digital
2006

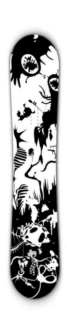

Katrin Olina
Client: Print Magazine
Designer: Michael Young
Format: Cover
Technique: Digital
2005

Katrin Olina
209 | Vector

Catalina Estrada Uribe
(left)
"Peace Please"
Personal work
Format: Editorial
Technique: Digital vector
2007

Catalina Estrada Uribe
(right)
"No More War"
Personal work
Format: Editorial
Technique: Digital vector
2007

Catalina Estrada Uribe
(2 illustrations)
"Nike Air2"
Client: Nike
Format: Editorial
Technique: Digital vector
2006

Catalina Estrada Uribe
(left)
"No Me Amenaces"
Client: Custo
Technique: Digital vector
2006

Catalina Estrada Uribe
(right)
"Little Red Hood"
Client: Custo
Technique: Digital vector
2006

Catalina Estrada Uribe
(left)
"More Love"
Personal work
Format: Editorial
Technique: Digital vector
2007

Catalina Estrada Uribe
(right)
"Don't Hate"
Personal work
Format: Editorial
Technique: Digital vector
2007

Catalina Estrada Uribe
(2 illustrations)
"Nike Air2"
Client: Nike
Format: Editorial
Technique: Digital vector
2006

Catalina Estrada Uribe
(2 illustrations)
"Animals in London Parks"
Client: Paul Smith
Technique: Digital vector
2007

Catalina Estrada Uribe
211 | Vector

Tim Lee
"Lucky charms"
Technique: Digital
2007

Tim Lee
"Lavolla"
Technique: Digital
2007

Tim Lee
"Yes victim"
Technique: Digital
2006

Tim Lee
"Howling bloodlust in ward 14"
Technique: Digital
2006

Erotic Dragon
Client: Kodansha Publishing
Company/Seiichi Suzuki Design
Format: Paperback cover art
Technique: Sketched by hand,
then illustrated details and assigned
colour using digital drawing
software
2007

Erotic Dragon
(2 illustrations)
Client: Shinsei Publishing
Company
Written by: Mahou
Design: Mizue Sugihara
Format: Tarot card deck design
Technique: Sketched by hand,
then illustrated details and assigned
colour using digital drawing
software
2007

Erotic Dragon

Fons Schiedon
"Modell"
Client: Park Avenue
Art Director: Alexander Aczél
Format: Editorial
Technique: Digital
2006

Edvard Scott
"Rhythm"
Client: Royal Festival Hall
Format: Print, web and digital
Technique: Illustrator
2006

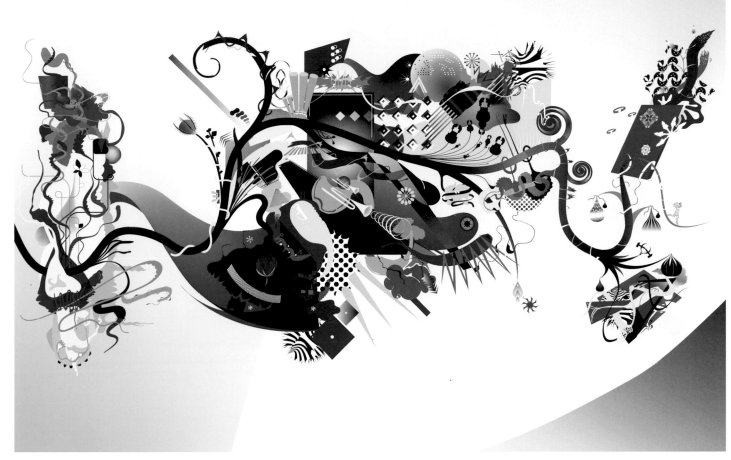

Edvard Scott
(left)
"It Works 3"
Client: Shift Japan
Credits: A poster illustration for
my solo exhibition "Everything
Works" at the SOSO Café in Japan
Format: Print
Technique: Illustrator
2006

Edvard Scott
(right)
Untitled
Client: Qompendium
Credits: Illustration for Qompen-
dium shown at Lee Store opening
in Berlin
Format: Projection
Technique: Illustrator
2006

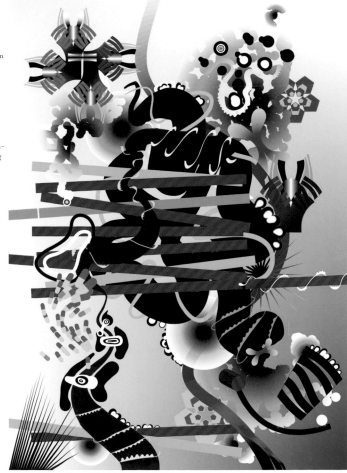

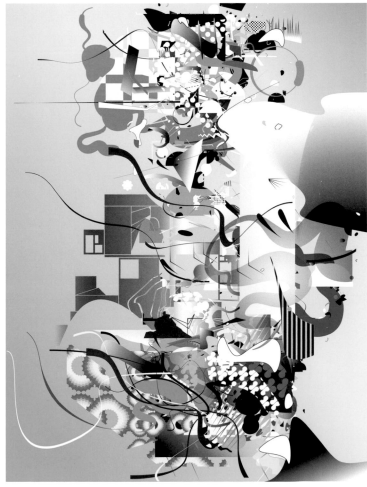

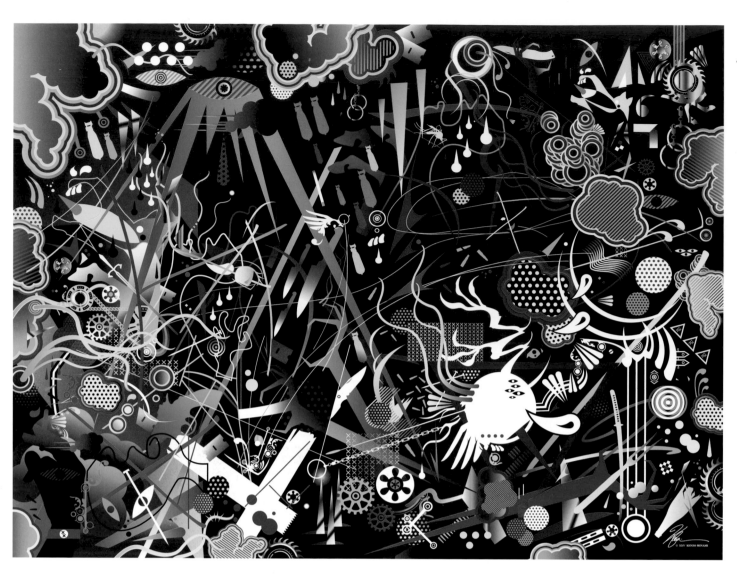

Kenzo Minami
"Guernica MMV"
Client: Remastered exhibition
curated by Sebastien Agneessens
Format: Print
Technique: Digital
2005

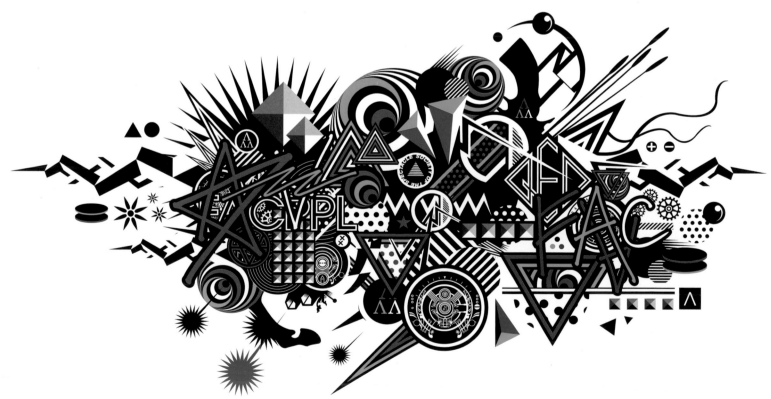

Kenzo Minami
"FAC"
Client: Factorypeople
Format: Mural painting
Technique: Mixed media
2006

Kenzo Minami
"What I Am"
Client: Reebok/Vacant
Format: Artwork for Reebok ad
campaign "I am what I am"
Technique: Digital
2005

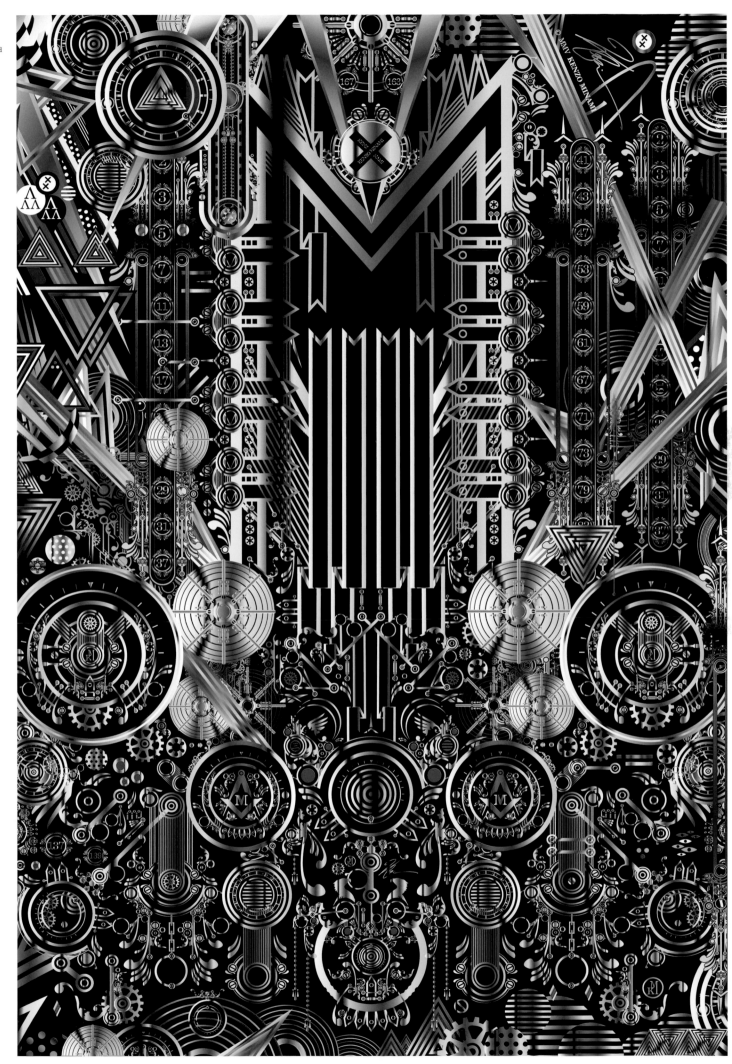

Pencileers & Ink

Masters of their respective crafts, the illustrators assembled in this chapter not only know how to wield the tools of their trade, but also flaunt a distinctive style anchored in visual realms of their own making. This encompassing atmosphere adds inspired and pointed flavour and focus to their creations. Rejecting the latest Adobe suite in favour of pen, pencil and paper, they relish the satisfyingly tangible restriction of indelible ink, of traces on paper, of a finality that counters the non-binding character of Photoshop layers, back buttons and 50 different versions of the same image.

Building on established techniques, they have found the means to archive, uphold and continue illustration's landmark techniques and traditions in their own way. By adding further layers and meaning beyond the distinction of solid "penmanship", these illustrators have aroused their own, inner art director. They invest their works with a convincing visual vigour that refuses to play by the rules of its genre. Contrasting traditional execution with modern themes and updated formats, they invite us to look beyond the framework of tool and style. They entice us to discover that these purportedly old-fashioned exercises rarely offer a mere depiction of their subject matter, but rather a very subjective, often surreal perspective on contemporary culture.

Ostensibly the products of seasoned draftsmen, rummaging around their pencil cases for those long-lost crayons, pencil stubs, water colours and felt tip pens, there is nothing improvised or ramshackle about the carefully crafted results. Mixing finely-honed skills with modern individualism, the work included here just might depict recent escapees from a zombie movie in copperplate engraving or take a stab at 1920s decadence, 1950s post-war prudence, stark Noir graphic novels, traditional Japanese fairytales, crazy collaged toonscapes and even painting by numbers. Slathered in plenty of faux patina, their "old-fashioned" narratives, cleverly frozen in time, take us on a rollercoaster ride to the past—and back to the future.

By mixing these seemingly incongruous styles and subject matters, by peeling back the skills to reveal what lies beneath, their subjective interpretations tickle and confuse our expectations. The work forces us to query our own perception. It's an unsettling experience and an enriching one at that.

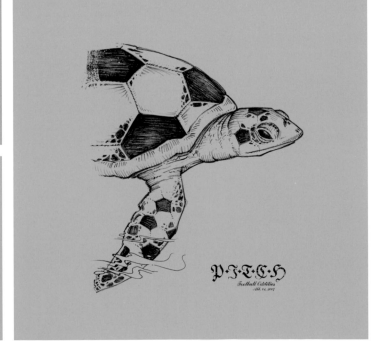

Stephane Tartelin
Typeholics

der bilder kommen nicht über die
augen in den kopf, sondern
über die haut

welche socken?

jemand sollte noch die wände bronzen.

Madeleine Stahel
(left)
"Kopfwelten Teil II: Gewelltes Fell"
Technique: Fine liner
2006/07

Madeleine Stahel
(middle)
"Manchmal"
Technique: Fine liner
2006

Madeleine Stahel
(right)
"Kopfwelten Teil II: Gewelltes Fell"
Technique: Fine liner
2006/07

Madeleine Stahel
(left)
"Kopfwelten Teil II: Gewelltes Fell"
Technique: Fine liner
2006/07

Madeleine Stahel
(middle 1)
"Kopfwelten Teil II: Gewelltes Fell"
Technique: Fine liner
2006/07

Madeleine Stahel
(right)
"Manchmal"
Technique: Ballpoint pen
2006

Madeleine Stahel
(left)
"Kopfwelten Teil II: Gewelltes Fell"
Technique: Ballpoint pen
2006/07

Madeleine Stahel
(middle 1)
"Kopfwelten Teil II: Gewelltes Fell"
Technique: Ink
2006/07

Madeleine Stahel
(middle 2)
"Kopfwelten Teil II: Gewelltes Fell"
Technique: Fineliner
2006/07

Madeleine Stahel
(right)
"Kopfwelten Teil II: Gewelltes Fell"
Technique: Fine liner
2006/07

Madeleine Stahel
(left)
"Kopfwelten Teil II: Gewelltes Fell"
Technique: Fine liner
2006/07

Madeleine Stahel
(middle left)
"Kopfwelten Teil I"
Technique: Ink
2006/07

Madeleine Stahel
(middle right)
"Kopfwelten Teil I"
Technique: Fine liner
2006/07

Madeleine Stahel
(right)
"Kopfwelten Teil II: Gewelltes Fell"
Technique: Fine liner
2006/07

Madeleine Stahel
Pencileers & Ink | 220

Maria Tackmann
(left)
"sideways"
Client: Clara Hill
Format: CD
Technique: Chinese ink, pen
2007

Maria Tackmann
(right)
"Das Ende der Geheimnisse"
Client: Die Zeit
Technique: Chinese ink,
photocopy
2007

Maria Tackmann
(left)
"Unterwerft Euch!"
Client: Zeit Geschichte
Technique: Chinese ink,
photocopy
2007

Maria Tackmann
(right 1)
"Wie der sexuellen Neugier
der Kinder zu begegnen ist"
Client: Zeit Geschichte
Technique: Chinese ink,
photocopy
2007

Maria Tackmann
(right 2)
"Lasst ihn schrein!"
Client: Zeit Geschichte
Technique: Chinese ink,
photocopy
2007

Maria Tackmann
(left)
"Wider die Affenliebe"
Client: Zeit Geschichte
Technique: Chinese ink,
photocopy
2007

Maria Tackmann
(middle)
"Über das Fratzenschneiden"
Client: Zeit Geschichte
Technique: Chinese ink,
photocopy
2007

Maria Tackmann
(right)
"O! na! nie!"
Client: Zeit Geschichte
Technique: Chinese ink,
photocopy
2007

Maria Tackmann

Redouane Oumahi
"500 Series"
Personal book project
Format: Editorial
Technique: Hand-drawn,
digitally reproduced and enhanced
with Illustrator
2006

Pencileers & Ink | 222

Matt Lee
(2 illustrations, left)
"Stay By Me"
Credits: From a series of
50 praying character drawings for
an exhibition in Osaka, Japan
Technique: Pen
2004

Matt Lee
(right)
"Only The Lonely"
Credits: Jeff Death series
Format: Book cover
Technique: Pen, Photoshop
2007

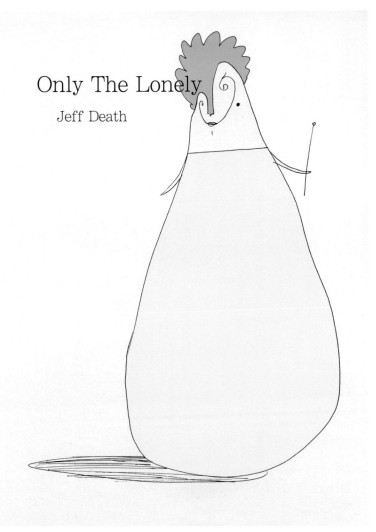

Only The Lonely

Jeff Death

Matt Lee
(2 illustrations, left)
"Stay By Me"
Credits: From a series of
50 praying character drawings for
an exhibition in Osaka, Japan
Technique: Pen
2004

Matt Lee
(right)
"Frankie & Johnny"
Credits: Jeff Death series
Format: Book cover
Technique: Pen, Photoshop
2007

Frankie & Johnny

Jeff Death

Julia Guther
"Einstein"
Client: Die Zeit – Geschichte
Format: Editorial
Technique: Oil pastels, pencil
2005

Julia Guther
"Jollenkreuzer"
Personal piece
Technique: Pencil, watercolour
2007

Julia Guther
(left)
"Fictional Interview
with Sigmund Freud"
Client: Emotion
Format: Editorial
Technique: Oil pastels, pencil
2006

Julia Guther
(middle)
Personal piece
Technique: Collage, pencil
2007

Julia Guther
(right)
Personal piece
Technique: Collage, pencil
2007

Julia Guther
(left)
"C.G. Jung's collective
shadow monster"
Client: Emotion
Format: Editorial
Technique: Oil pastels, pencil
2007

Julia Guther
(middle)
"Einstein 3"
Client: Die Zeit – Geschichte
Format: Editorial
Technique: Oil pastels, pencil
2005

Julia Guther
(right)
"Einstein 2"
Client: Die Zeit – Geschichte
Format: Editorial
Technique: Oil pastels, pencil
2005

Julia Guther
Format: Editorial
Technique: Vector, photo
2006

Julia Guther
"Liguster"
Client: Die Zeit
Format: Editorial
Technique: Vector, photo
2007

Julia Guther
(left)
"August"
Client: Die Zeit
Format: Editorial
Technique: Vector, photo
2004

Julia Guther
(right)
"Mourning Cloak"
Client: Die Zeit
Format: Editorial
Technique: Vector, photo
2006

Julia Guther
(left)
"The Hedge"
Client: Die Zeit
Format: Editorial
Technique: Vector
2005

Julia Guther
(right)
'Der Kleiber"
Client: Die Zeit
Format: Editorial
Technique: Vector
2005

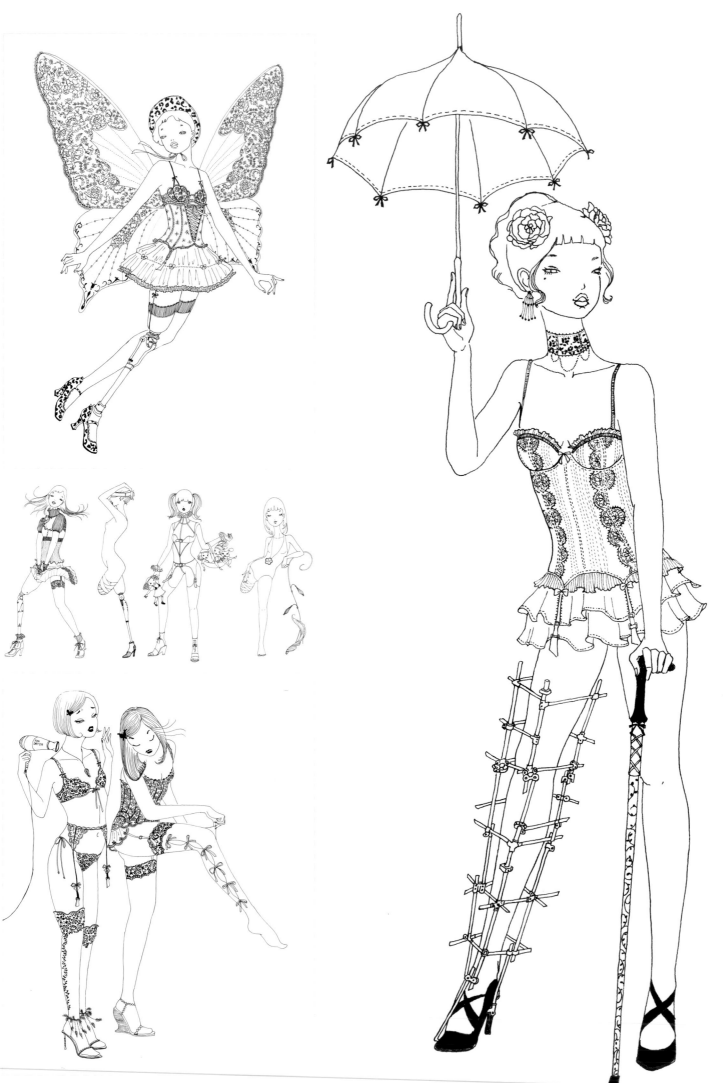

Makiko Sugawa
(left)
"Fairy"
Technique: Pen and ink drawing
2006

Makiko Sugawa
(right)
"Stick and parasol"
Technique: Pen and ink drawing
2006

Makiko Sugawa
(4 illustrations)
"Blows Hard"
"3r80"
"Lovely Children"
"Swimwear of Flower"
Technique: Pen and ink drawing
2006

Makiko Sugawa
"Get Dressed"
Technique: Pen and ink drawing
2006

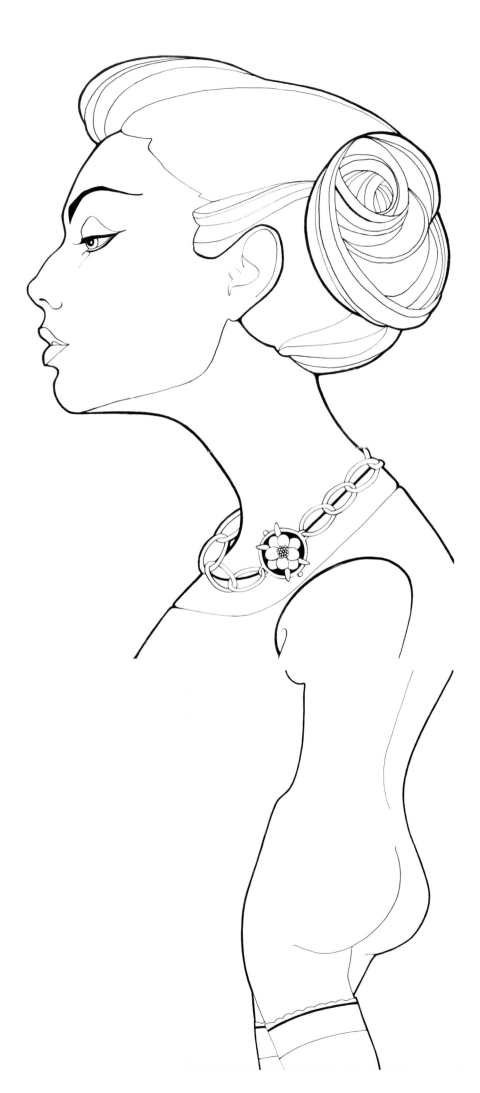

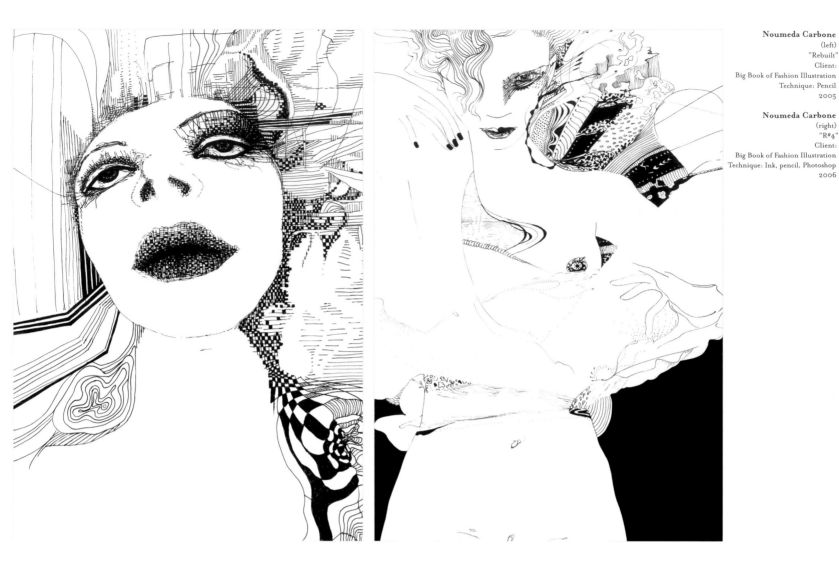

Noumeda Carbone
(left)
"Rebuilt"
Client:
Big Book of Fashion Illustration
Technique: Pencil
2005

Noumeda Carbone
(right)
"R#4"
Client:
Big Book of Fashion Illustration
Technique: Ink, pencil, Photoshop
2006

Marco Neves
(left)
"How naive you sound"
Personal project
Technique: Graphite hand-drawn,
Photoshop
2006

Marco Neves
(right)
"Any man with power"
Personal project
Technique: Graphite
hand-drawn, Photoshop
2006

Laura Weider
(4 illustrations)
Technique: Hand-drawn,
marker on paper
2006

Stephane Manel
(left)
"Constantinus Angela Venus"
Client: "The Sound Of Venus"
personal exhibition
held at the R. Pons gallery, Paris
Technique: Pencil on paper
2007

Stephane Manel
(right)
"Neron Venus Lisa"
Client: "The Sound Of Venus"
personal exhibition
held at the R. Pons gallery, Paris
Technique: Pencil on paper
2007

Constantinus Angela Venus

NERON VENUS LISA

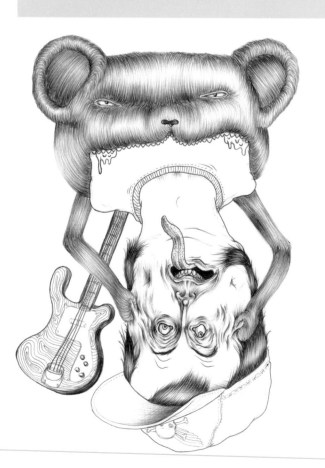
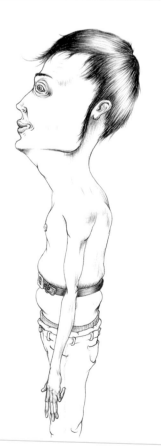
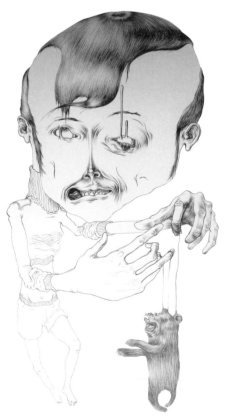

Tenko Ateliersérieux
"Girl"
Client: Arkitip Magazine,
Los Angeles
Credits: Sound in print,
illustration inspired by the song
"Girl" by the band Suicide
Technique: Stylo bille
and computer
2006

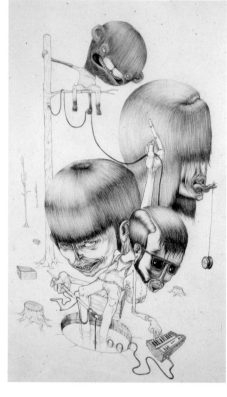
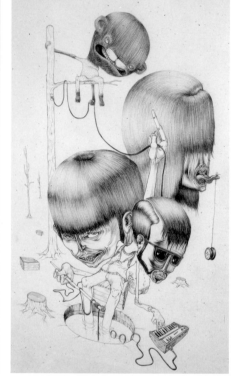

Tenko Ateliersérieux
Technique: Stylo bille
2006

Tenko Ateliersérieux
3 sketches
2005

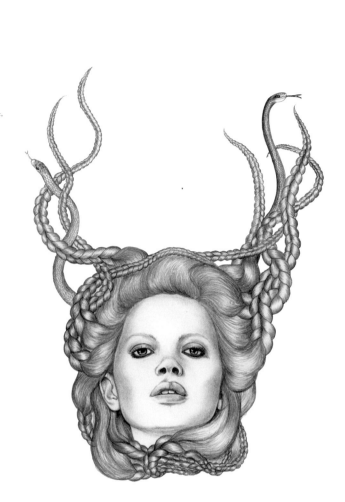

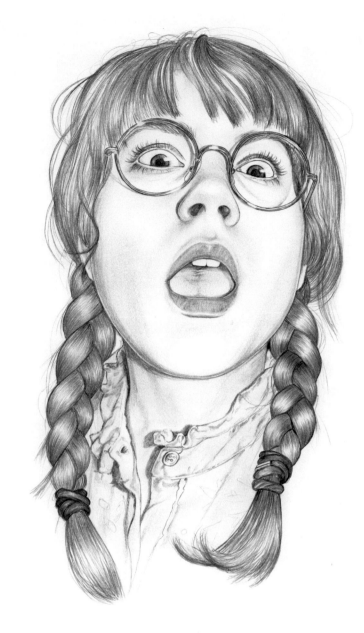

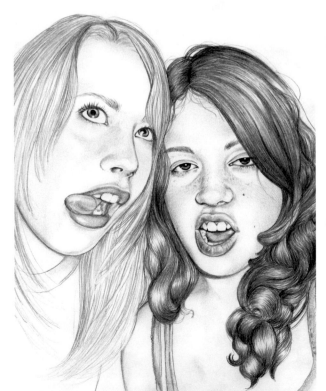

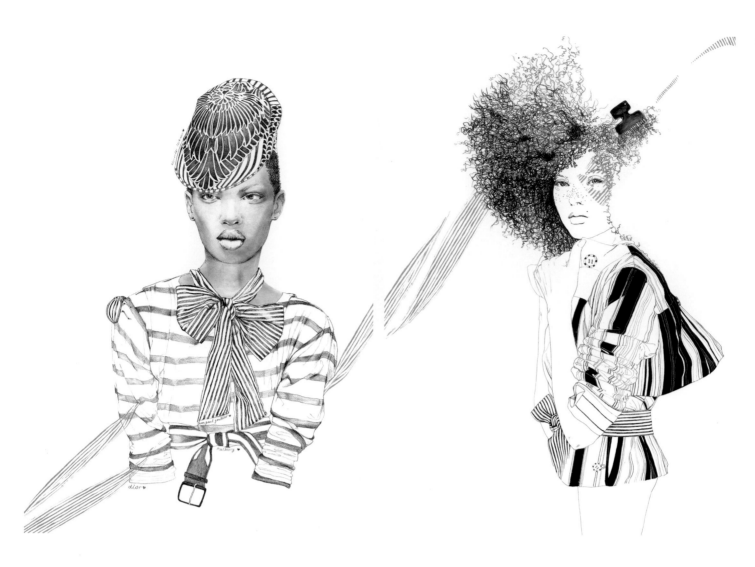

Christina Koutsospyrou
(2 illustrations)
"Black in White in Black"
Client: Orange Dot Gallery
Technique: Pencil
2007

Ina Keckeis
(3 illustrations)
"Speechballoon"
Client: Superstrings, BMG
Format: Booklet, leporello
Technique: Hand-drawn,
Photoshop
2007

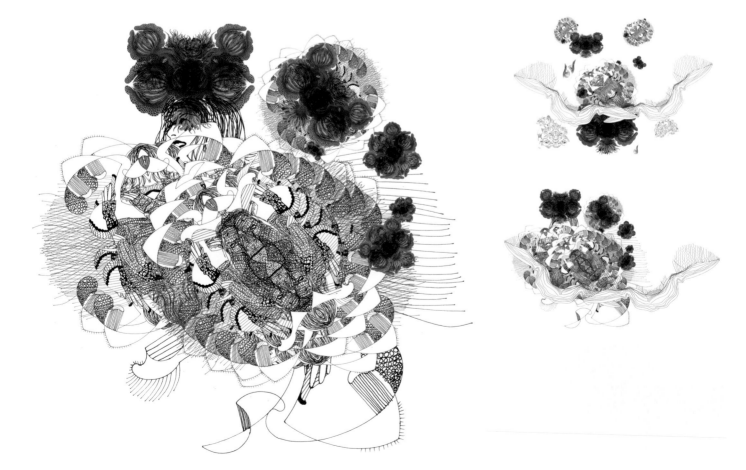

Christina Koutsospyrou
(2 illustrations)
"Black in White in Black"
Client: Orange Dot Gallery
Technique: Pencil
2007

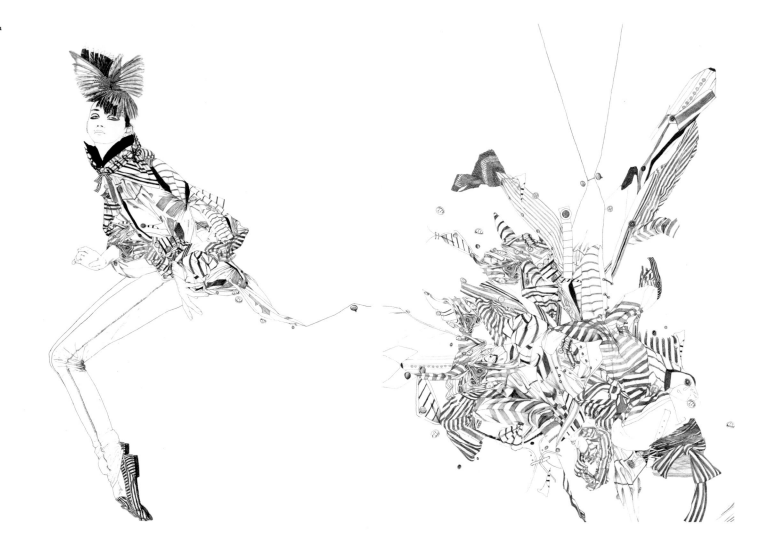

Ina Keckeis
(3 illustrations)
"Speechballoon"
Client: Superstrings, BMG
Format: Booklet, leporello
Technique: Hand-drawn,
Photoshop
2007

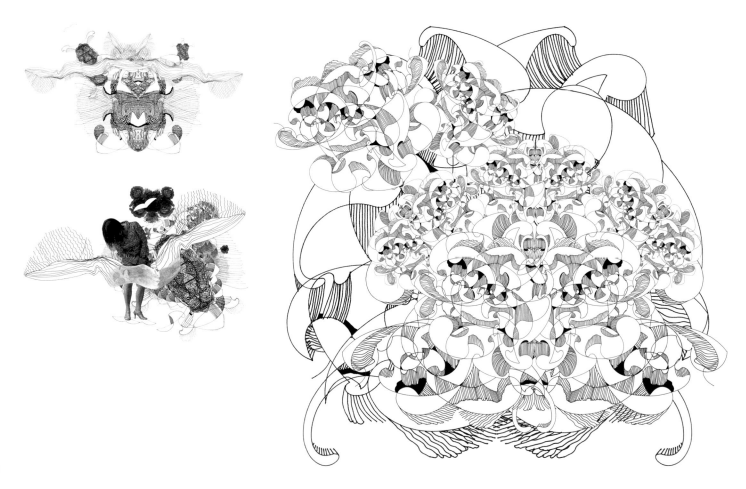

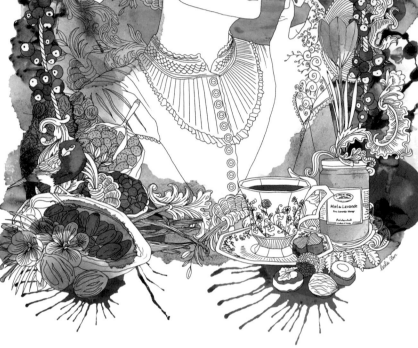

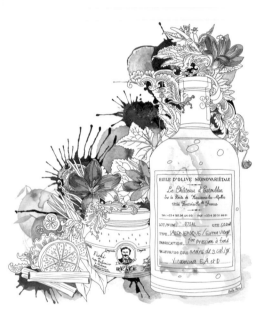

Forever Young
(2 illustrations)
"Ethical food"
Client:
Aéroports de Paris Magazine
Format: Editorial
Technique: Watercolour ink,
Photoshop
2006

Forever Young
(right)
"Stawberry Vodka"
Technique: Pencil, watercolour
ink, collage, Photoshop
2007

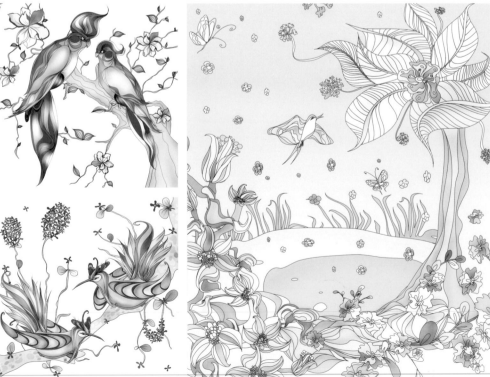

Ella Tjader
(left)
"Green Parrots"
Client: JEM Sportswear (USA)
Format: Fashion apparel
Technique: Illustrator
and Photoshop
2007

Ella Tjader
(right)
"Denim & Illustration Intro"
Client: NYLON (Japan)
Format: Editorial
Technique: Illustrator
and Photoshop
2006

Ella Tjader
"Pink Birds"
Client: JEM Sportswear (USA)
Format: Fashion apparel
Technique: Illustrator
and Photoshop
2007

Lapin
(left, 2 illustrations)
"Les calepins de Lapin
N°89 & N°89"
Technique: Hand-drawn,
photography, Photoshop
2007

Lapin
(right, 2 illustrations)
"For a fresher world"
Client: Publicis Paris for Heineken
Technique: Hand-drawn,
photography, Photoshop
2006

Silja Goetz
"Barcelona"
Client: Estrella Damm
Art Direction: Christian López /
Villar Rosas
Technique: Pen and Photoshop
2007

Lapin
Silja Goetz
235 | Pencileers & Ink

Noa Weintraub
"Pink Daydream"
Format:
Pen and watercolour on paper
Technique: Hand-drawn
2006

Noa Weintraub
"Bull"
Personal work
Format: Pen on paper
Technique: Hand-drawn
2006

Noa Weintraub
(left)
"Birdtree"
Personal work
Format:
Pencil and watercolour on paper
Technique: Hand-drawn
2006

Noa Weintraub
(right)
"Afrohead"
Personal work
Format:
Pencil and watercolour on paper
Technique: Hand-drawn
2006

Noa Weintraub
"Silhouette"
Client:
The Guardian Weekend Magazine
Format: Print
Technique:
Hand-drawn and Photoshop
2007

Noa Weintraub

Nanami Cowdroy
"Seven Seas"
Technique: Hand-drawn artwork,
illustration using pencil, pen,
watercolour and spray paint
2006

Nanami Cowdroy
"Kintoto Blot"
Technique: Hand-drawn artwork,
illustration using pencil, pen,
watercolour and spray paint
2007

Nanami Cowdroy
(left)
"DeepSea Sushi"
Technique: Hand-drawn artwork,
illustration using pencil, pen,
watercolour and spray paint
2006

Nanami Cowdroy
(right)
"Tampopo"
Technique: Hand-drawn artwork,
illustration using pencil, pen,
watercolour and spray paint
2007

Nanami Cowdroy
237 | Pencileers & Ink

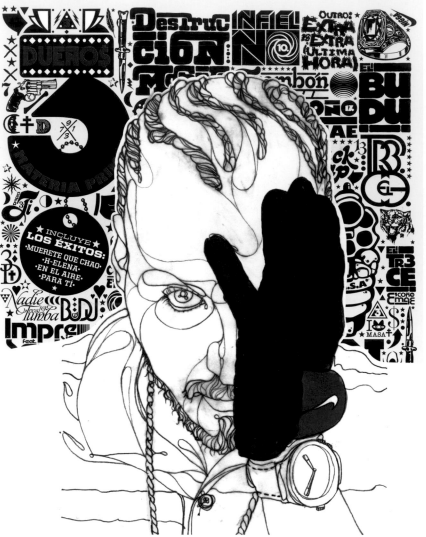

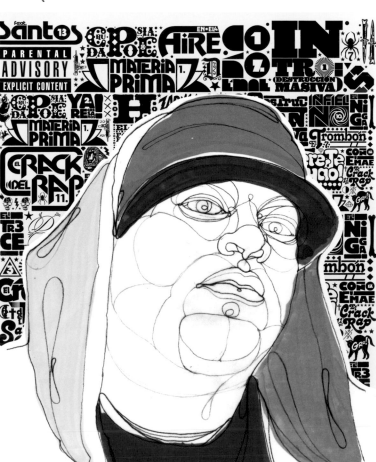

MASA
"3Dueños – DJ Trece"
Client: Subterraneo Records
Technique:
Pencil and felt-tip markers
2007

MASA
"Chusmita"
Client: Gozadera Records
Technique: Felt-tip markers
2006

MASA
(right)
"3Dueños – BUDU"
Client: Subterraneo Records
Technique: Pencil
and felt-tip markers
2007

MASA
(right)
"Pekos Kanvas"
Client: Gozadera Records
Technique: felt-tip markers
2006

Falk Klemm
Client: Burton, Raven-Boards
Technique: Pencil, ink, digital
2006

Falk Klemm
"Lode & Eric"
Client: S-W-H Amsterdam
Technique: Pencil, ink, digital
2007

Falk Klemm
Client: Lodown Magazine
Format: Editorial
Technique: Pencil, ink, digital
2004

Falk Klemm
Client: Burton, Raven-Boards
Technique: Pencil, ink, digital
2006

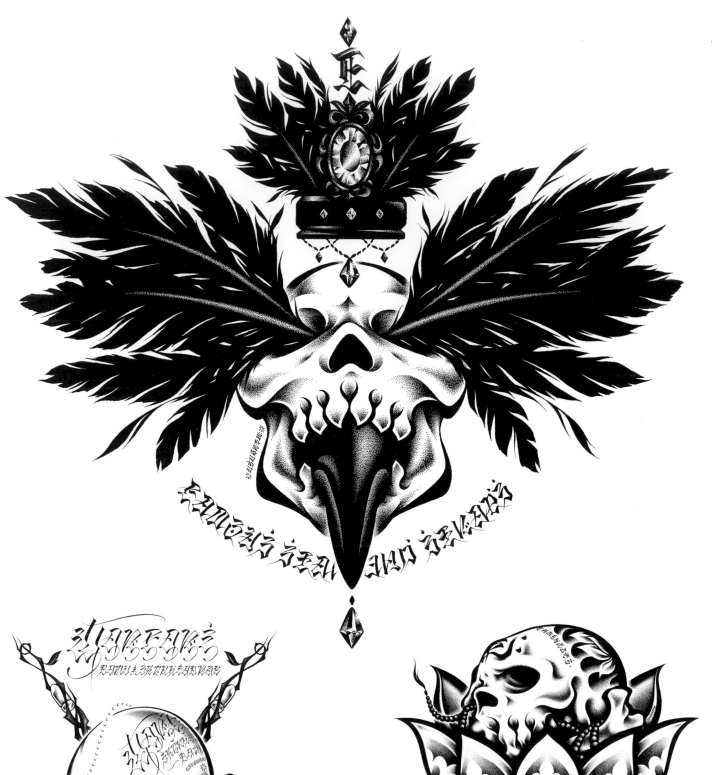

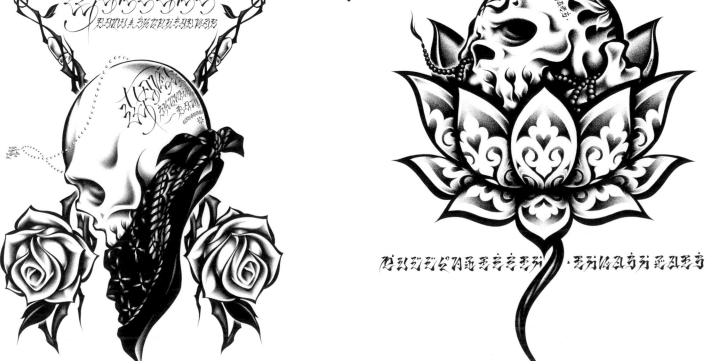

Usugrow
"Feather and Ice"
Client: Famous Staras and Straps
Technique: Ink on paper
2006

Usugrow
(left)
"Beautiful Thorn"
Client: Warfare
Technique: Ink on paper
2007

Usugrow
(right)
"LOD"
Client: Pulling Teeth
Technique: Ink on paper
2005

Fiodor Sumkin
"Cría Cuervos"
Client: Crocodile Magazine
Format: Editorial
Technique: Hand-drawn
illustration in gel ink, Photoshop
2007

Usugrow
(left)
"Ali Spituality"
Client: Adidas
Format: Painting
Technique: Acrylic on paper
2006

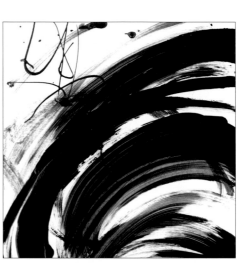

Usugrow
(right)
"Sou to Jaku"
Format: Painting
Technique: Acrylic on paper
2006

Usugrow
(left)
"Maebure"
Format: Painting
Technique: Acrylic on paper
2006

Usugrow
(right)
"Uzu"
Format: Painting
Technique: Acrylic on canvas
2007

Bene
"CQ"
Technique: Watercolour, marker,
spray on paper
2007

Bene
"Ginji"
Format: Mural
Technique: Water paint, marker,
spray on wall
2007

Bene
(left)
"Mitsume"
Technique: Water paint,
spray on wood board
2006

Bene
(right)
"Ita"
Format: Used skate deck
Technique: Water paint, marker,
spray on deck
2006

Bene

Interview Vania

A member of the extended Big Active empire, Vania Zouravliov's meticulous, yet romantic black and white tableaux add a generous dash of fairytale eroticism to the unchanging fundamentals of life—nature, growth, death and sex. Lost in reverie and tinged with the frozen nostalgia of early daguerreotypes, his spellbinding nymphets pair obvious symbolism and sexual connotations with a timeless, knowing innocence reminiscent of the paragons of late 19th/early 20th century Russian illustration.

Background

Back in Russia, my mother was employed as an art teacher; her paintings and books were my earliest encounters with the subject. Aged four, I had already appropriated her art supplies for my own paintings. By the time I was 12, my work was exhibited across Russia and, later, also internationally.

Skills and Techniques

I prefer to work with traditional tools and techniques: Pencil, ink, paint etc. I attended two art schools as well as an art college, yet my style has always encompassed a variety of elements from traditional art, illustration and early photography. Since my earliest childhood scribbles, it has evolved from pure lines to a more realistic style mixed with various other elements.
I simply love iconic, self-sufficient and beautifully executed images and that is what I try to achieve with my own artwork. People often comment on how detailed my images are, but to me, the amount of detail in the artwork is not important. I really enjoy and strive for simplicity.

Inspiration and Influences

Since I enjoy so many different things, it would be hard to single out one particular influence. For example, I adore the classics—especially from the Renaissance, Romanticism, Symbolism and Japanese Ukiyoe. Yet I also love a lot of classical illustrators, especially those from 19th century France and early 20th century Russia and Germany. If forced to pick some of the artists who had a long-lasting impact on my work, I would name Grunewald, Ingres, Khnopff, Bakst, Somov, Arcimboldo and Utamaro. Having said that, the people I draw hail from modern times and my inspirations also extend to a lot of contemporary music, photography, fashion and popular culture. There are certain contradictory elements in human nature that I find particularly interesting, and I often explore these in my images.

Featured Works

The images chosen here were inspired by different situations and real people, but they also contain some classical elements and historical references. One of the images is vaguely based on Pushkin's story; another carries a Hoffmannesque feel. While I would not call my work nostalgic, I incorporate elements and costumes from different styles and periods, akin to a couturier, who borrows from the past in order to create a new collection. Incidentally, I would love to try my hand at a collaboration with a fashion designer. Also, I would really like to illustrate a book of fairytales. I absolutely adore Italo Calvino's new take on old Italian folk tales.

Vania
"Toys"
Client: YaSo Magazine
Format: Editorial
Technique: Hand-drawn
2007

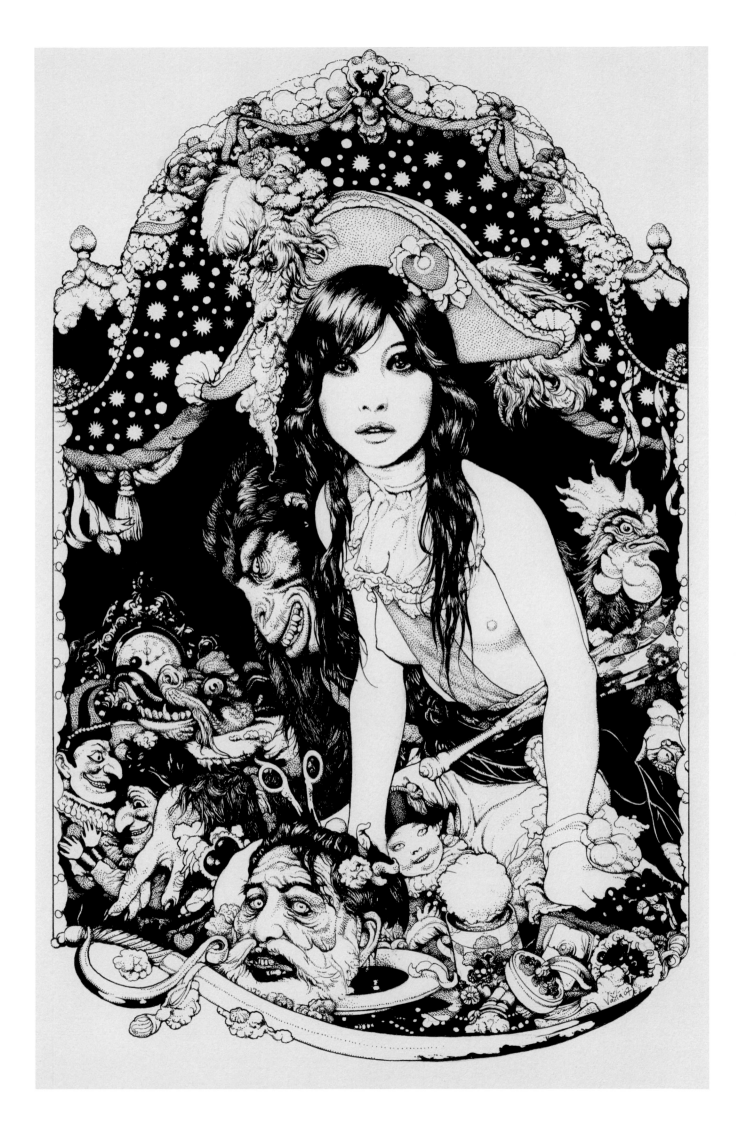

Vania
(left column, right
4 illustrations)
"Poe"
Client: Die Gestalten Verlag
Format: Book illustration
Technique: Hand-drawn
2007

Vania
(middle)
"Gift"
Client: YaSo Magazine
Client: Editorial
Technique: Hand-drawn
2006

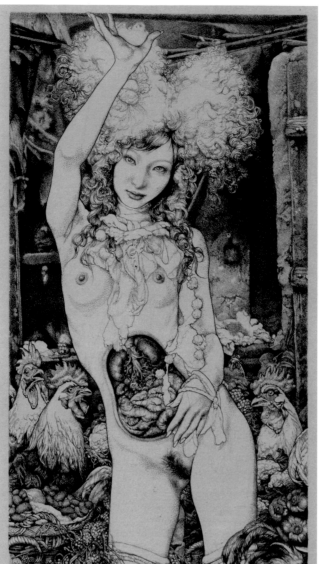

Vania
"Milky Pink"
Personal work
Technique: Hand-drawn
2007

Vania
"Puffy Peach"
Personal work
Technique: Hand-drawn
2007

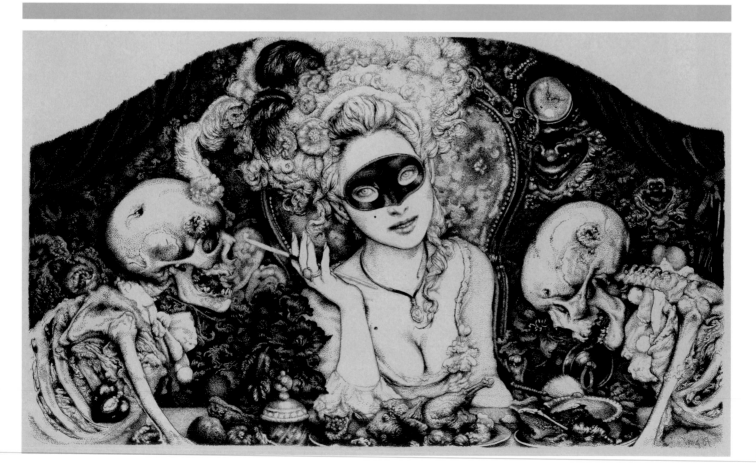

Vania
"Fate"
Client: YaSo Magazine
Client: Editorial
Technique: Hand-drawn
2007

Vania

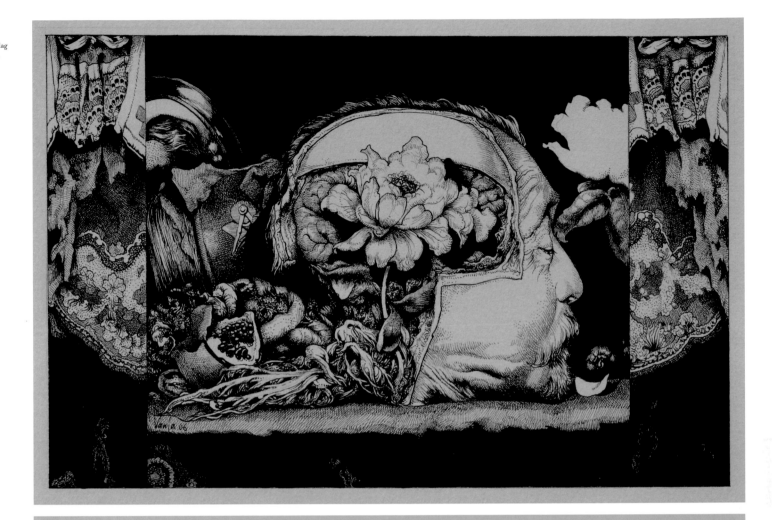

Vania
"Poe"
Client: Die Gestalten Verlag
Format: Book illustration
Technique: Hand-drawn
2007

Vania
(left)
"Fürstin der Finsternis"
Client: YaSo Magazine
Format: Editorial
Technique: Hand-drawn
2007

Vania
(right)
"Poe"
Client: Die Gestalten Verlag
Format: Book illustration
Technique: Hand-drawn
2007

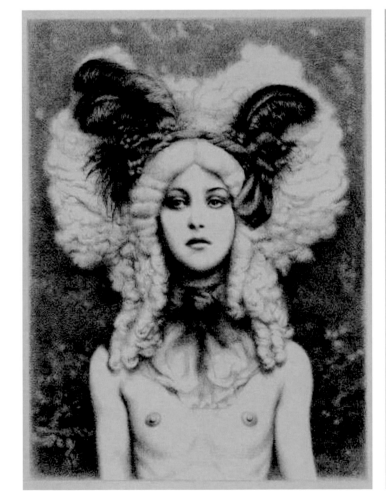

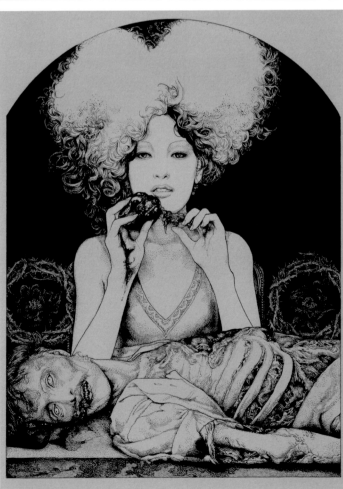

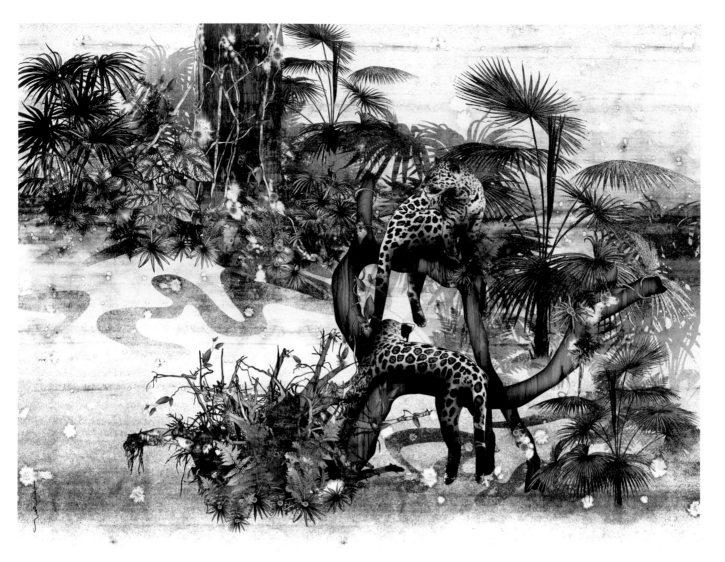

Tatiana Arocha
"Jaguares"
Technique: Mixed media
2007

Tatiana Arocha
"Tapir"
Technique: Mixed media
2007

Tatiana Arocha
"Amazonia"
Technique: Mixed media
2007

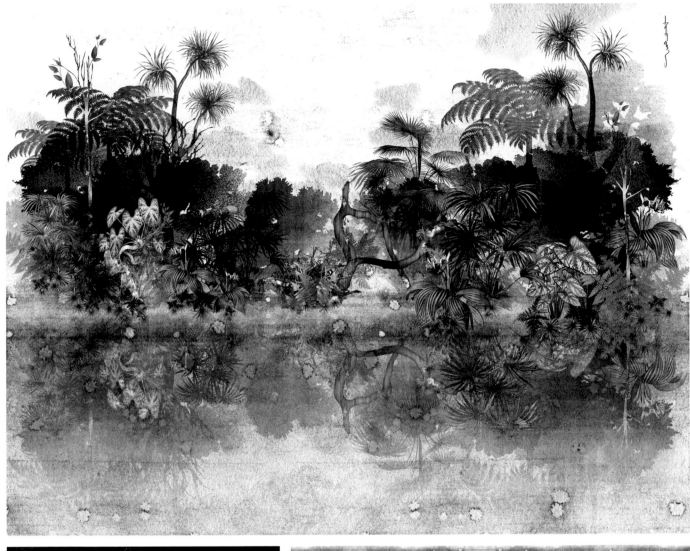

Tatiana Arocha
(left)
"En La Noche"
Technique: Mixed media
2006

Tatiana Arocha
(right)
"Colibri"
Technique: Mixed media
2006

Tatiana Arocha
249 | Pencileers & Ink

Nigel Peake
"Design for Billboard – pt 1–3"
Client: Six Cities
Design Festival – Scotland
Technique: Pen and paper
2007

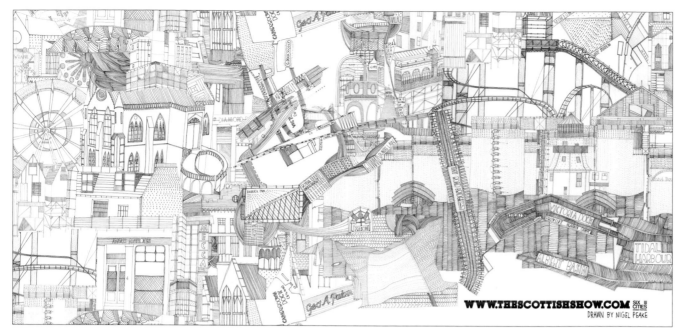

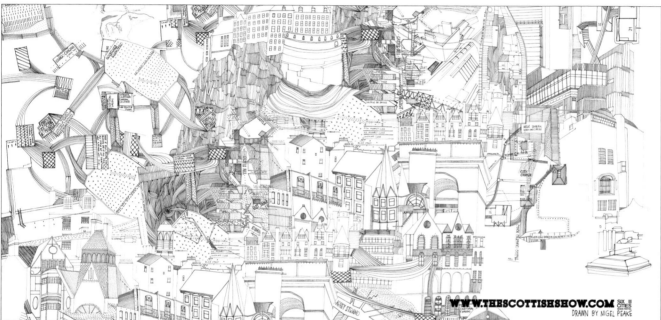

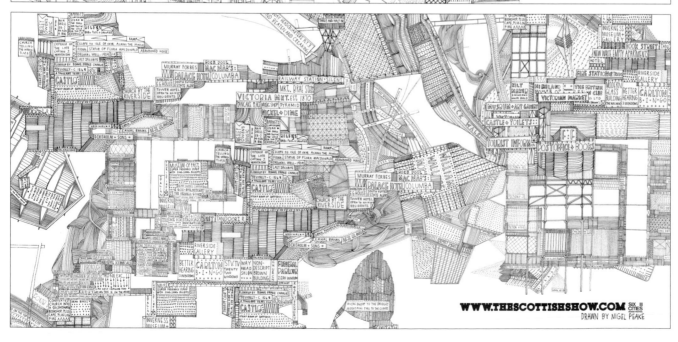

Nigel Peake
"Utopian City"
Client: Blueprint Magazine
Technique: Pen and collage
2006

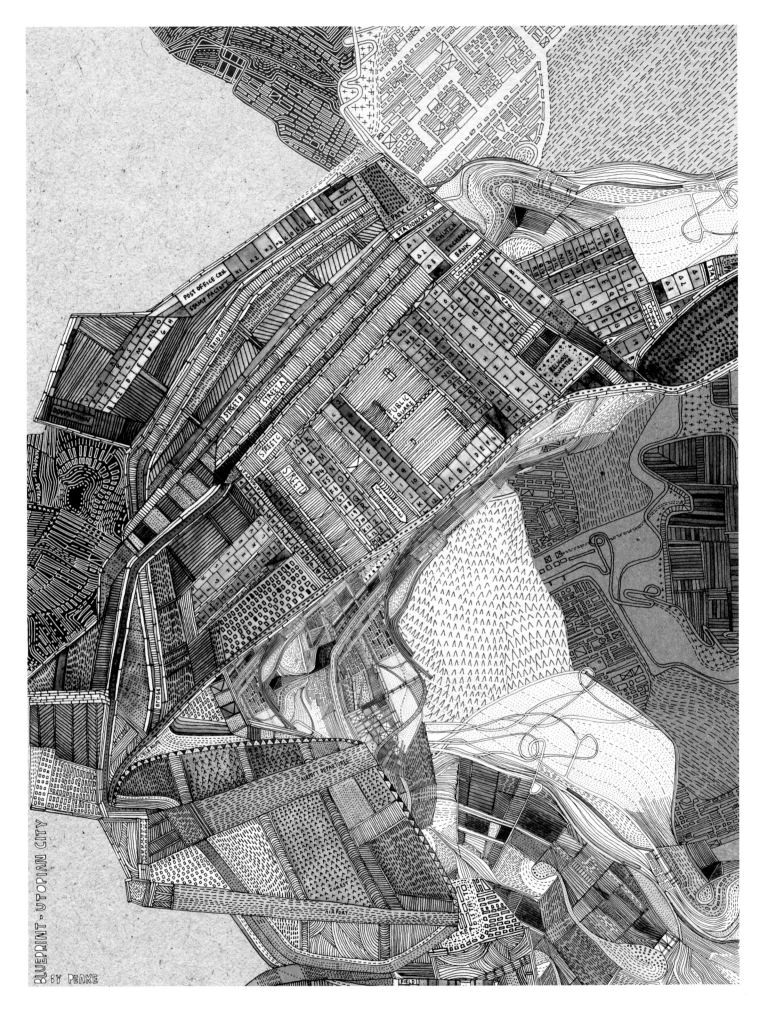

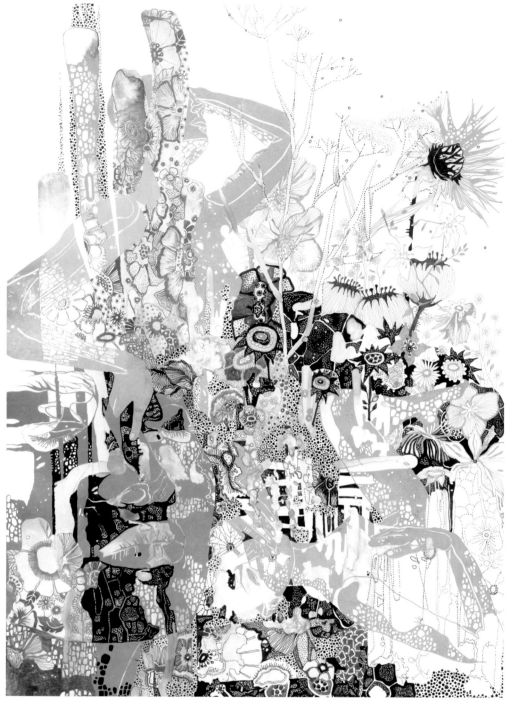

Sonya Suhariyan
"Laziness"
Technique: Hand-drawn
2005

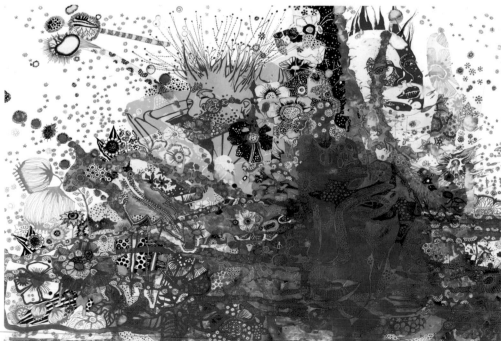

Sonya Suhariyan
"Red Mask"
Technique: Hand-drawn
2005

Sonya Suhariyan
"Melancholy"
Technique: Hand-drawn
2005

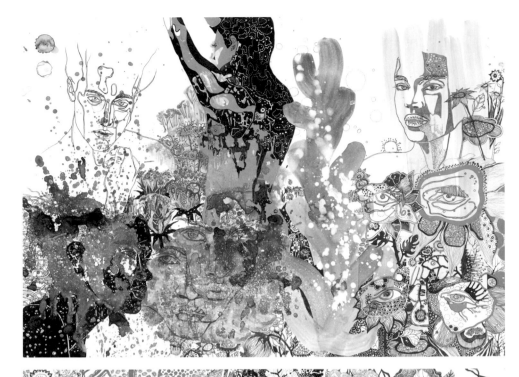

Sonya Suhariyan
"Pink"
Technique: Hand-drawn
2005

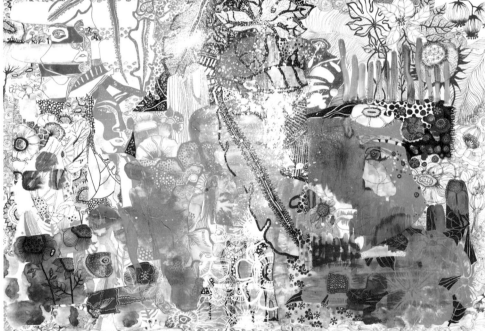

Sonya Suhariyan
"Blue Mask"
Technique: Hand-drawn
2005

Forever Young
"Animal Yeah! #4"
Client: VI DE
Animation: Marco Sauvebois
Format: DVD of
animated wallpapers
Technique: Watercolour ink,
Photoshop
2006

Forever Young
"Animal Yeah! #1"
Client: VI DE
Animation: Marco Sauvebois
Format: DVD of
animated wallpapers
Technique: Watercolour ink,
Photoshop
2006

Forever Young
"Animal Yeah! #3"
Client: VI DE
Animation: Marco Sauvebois
Format: DVD of
animated wallpapers
Technique: Watercolour ink,
Photoshop
2006

Forever Young
"Animal Yeah! #2"
Client: VI DE
Animation: Marco Sauvebois
Format: DVD of
animated wallpapers
Technique: Watercolour ink,
Photoshop
2006

Izumi Nogawa
"The Venus"
Client: Spirit and Destiny
Magazine
Technique: Illustrator
2007

Izumi Nogawa
"Flowers"
Client: WWD Beautybiz
Technique: Illustrator
2006

Izumi Nogawa
(left)
"Lotus Green"
Client: Lotus
Credits: Illustration for
package of toilet paper
Technique: Illustrator
2007

Izumi Nogawa
"Japanese Heaven"
Client: Shu Uemura
Credits: For exhibition
Technique: Illustrator
2007

Izumi Nogawa
"Perfume of Fruits"
Client: WWD Beautybiz
Technique: Illustrator
2006

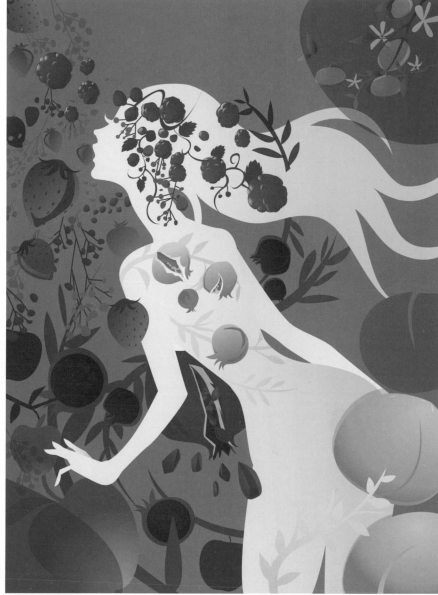

Izumi Nogawa
(left)
"Show Girl"
Client: Wire Design
Technique: Illustrator
2007

Izumi Nogawa
(right)
"The Jupiter"
Client: Spirit and Destiny
Magazine
Technique: Illustrator
2007

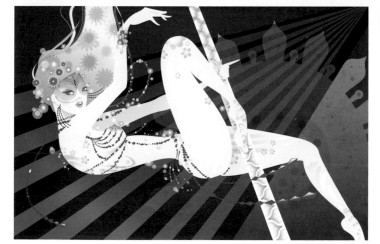

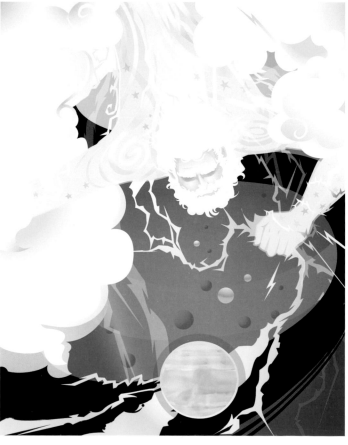

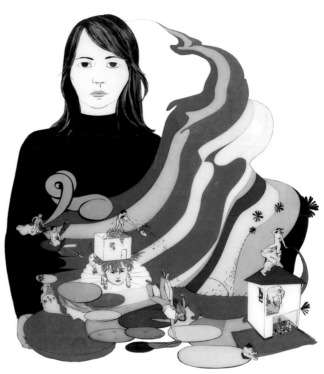

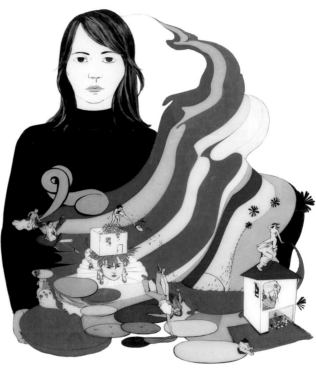

Katharina Gschwendtner
"Keramikschuh"
Technique: Acrylic on glass
2005

Katharina Gschwendtner
"Teppichkomet"
Technique: Acrylic on glass
2003

Katharina Gschwendtner
(left)
"Sitzgruppe / Engel"
Technique: Acrylic on glass
2005

Katharina Gschwendtner
(right)
"Kuss der Ente"
Technique: Acrylic on glass
2005

Katharina Gschwendtner
"Schneewittchen"
Technique: Acrylic on glass
2006

Katharina Gschwendtner
"Der Seher"
Technique: Acrylic on glass
2006

Katharina Gschwendtner
"Sensorkeule"
Technique: Acrylic on glass
2006

Katharina Gschwendtner
"Himmel / Abgefrühstückt"
Technique: Acrylic on glass
2006

Katharina Gschwendtner
"WG Küche"
Technique: Acrylic on glass
2006

Katharina Gschwendtner

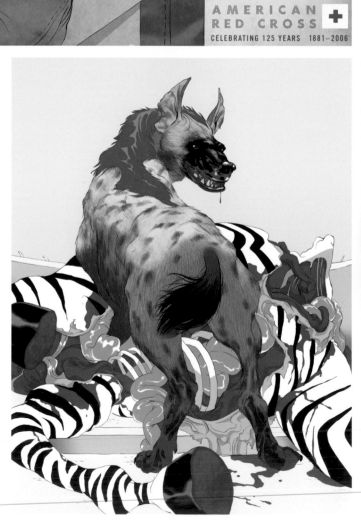

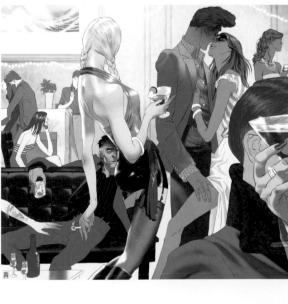

Tomer Hanuka
"Hope"
Client: American Red Cross
Format: Poster
Technique: Mixed
2006

Tomer Hanuka
"Main Land"
Client: Harcourt
Format: Book (proposal)
Technique: Mixed
2006

Tomer Hanuka
(left)
"Food chain"
Client: Harcourt
Format: Book (proposal)
Technique: Mixed
2006

Tomer Hanuka
(right)
"The Possibility of an Island"
Designer: Rob Willson
Client: Playboy Magazine
Format: Editorial
Technique: Mixed
2006

Tomer Hanuka
"Cholera"
Client: Harvard Medical Review
Format: Editorial
Technique: Mixed
2007

Tomer Hanuka
"Life of Pi"
Client: Harcourt
Format: Book (proposal)
Technique: Mixed
2006

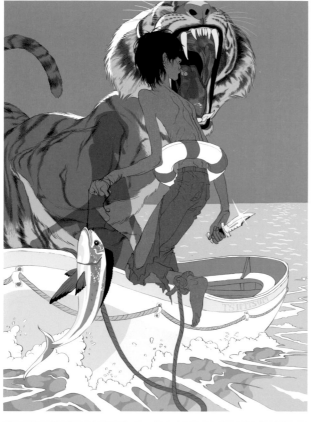

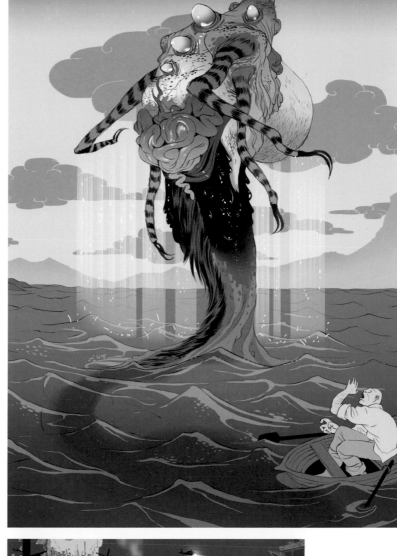

Tomer Hanuka
(left)
"Cell"
Client: Entertainment Weekly
Magazine
Format: Editorial
Technique: Mixed
2006

Tomer Hanuka
(right)
"No Fare, No Well"
Client: Playboy Magazine
Format: Editorial
Technique: Mixed
2006

Tomer Hanuka
"Night Probe"
Designer: Mark Heflin
Client: American Illustration
Format: Book
Technique: Mixed
2006

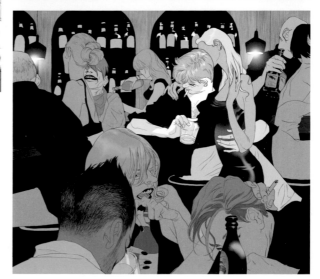

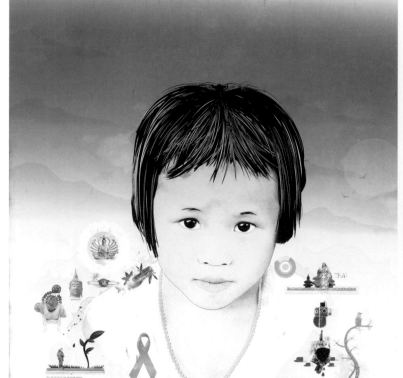

Doug Alves
"Unite for children"
Unite Against Aids campaign
Client: Unicef
Format: Editorial
Technique: Photoshop,
collages and vector
2007

Doug Alves
(2 illustrations)
Client: MTV Brasil
Format: Editorial
Technique: Photoshop and vector
2007

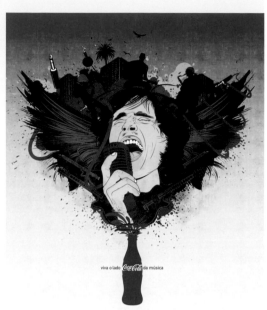

Doug Alves
"Mari"
Personal work
Format: Poster
Technique: Photoshop and vector
2006

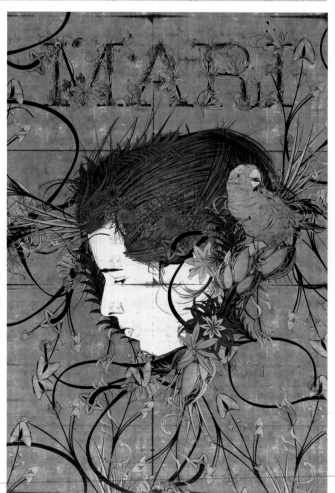

Marcos Chin
(right 2)
"Love Me, Love Me Not"
Designer: Charles Hively
Client: 3 x 3: The Magazine of
Contemporary Illustration
Publisher: Charles Hively
Format: Magazine cover
Technique: Digital
2006

Marcos Chin
Client: Dellas Graphics
Art Director: Jim Burke
Format: Calendar
Technique: Digital
2007

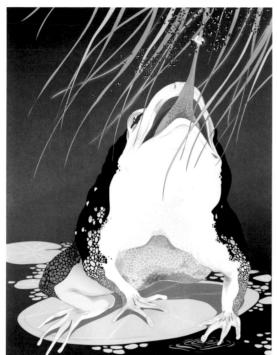

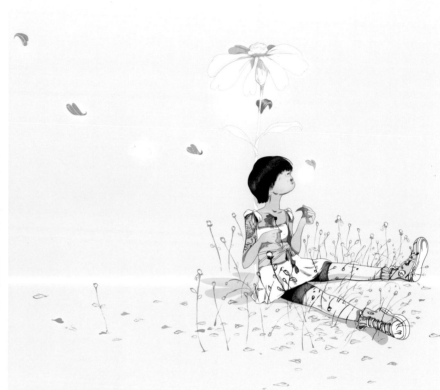

Marcos Chin
(left)
"Divorce"
Designer: Soojin Buzelli
Client: Plansponsor
Format: Editorial
Technique: Digital
2007

Marcos Chin
(right)
"Deer in Marc Jacobs"
Personal work
Technique: Digital
2005

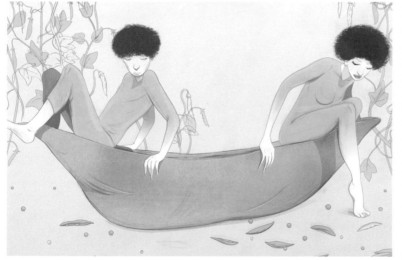

Marcos Chin
"My Pain, My Brain"
Designer: Jeff Glendenning
Client: New York Times Magazine
Format: Editorial
Technique:
2006

Marcos Chin
"Emotional Infidelity"
Designer: Jaspal Riyait
Client: Dose
Format: Editorial
Technique: Digital
2005

Marcos Chin
"Yoko Ono: Yes, I'm a Witch"
Designer: José Reyes
Client: Paste
Format: Editorial
Technique: Digital
2007

Marcos Chin
(left)
"Falling Off The Workout Wagon"
Designer: Heidi Volpe
Client: Hers, Muscle & Fitness
Format: Editorial
Technique: Digital
2005

Marcos Chin
(right)
"Good Fortune"
Designer: Mark Murphy
Client: The Directory
of Illustration
Format: Illustration source book
Technique: Digital
2005

Yuko Shimizu
"Band Garbage"
Designer: Christine Bower
Client: Rolling Stone Magazine
Format: Editorial illustration
Technique: Ink drawing with
Photoshop
2005

Yuko Shimizu
(right)
Designer: Maynard Kay
Client: Planadviser
Magazine (USA)
Format: Editorial
Technique: Ink drawing
with Photoshop
2006

Yuko Shimizu
(left)
"Golden Mushrooms"
Designer: André Mora
Client: Nylon Magazine (USA)
Format: Editorial
Technique: Ink drawing
with Photoshop
2005

Yuko Shimizu
(right)
Client: Dellas Graphics
Art Director: Jim Burke
Format: Calendar illustration
Technique: Ink drawing
with Photoshop
2007

Yuko Shimizu
Designer: Kate Elazegui
Client: New York Magazine (USA)
Format: Editorial illustration
Technique: Ink drawing
with Photoshop
2006

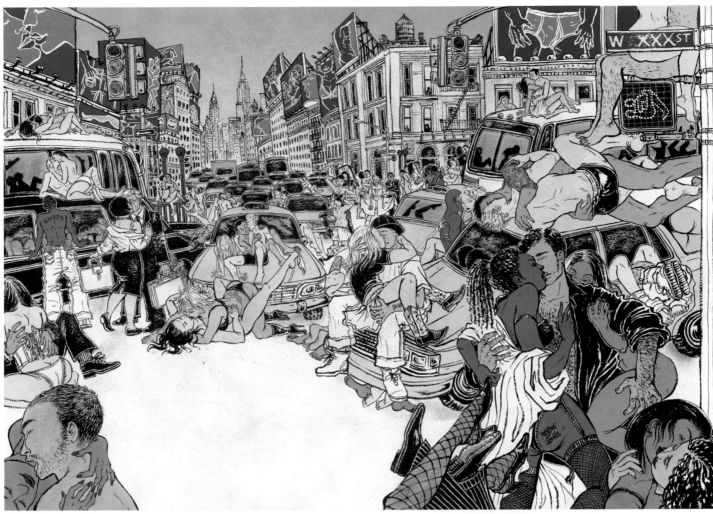

Yuko Shimizu
(left)
"P Trees"
Personal work
Technique: Ink drawing with
Photoshop
2003

Yuko Shimizu
(right)
Designer: Tom Staebler
and Rob Wilson
Client: Playboy Magazine (USA)
Format: Editorial illustration
Technique: Ink drawing
with Photoshop
2005

Kelly Ording
"Cape Agulhas"
Technique: Coffee, ink and
acrylic on paper
2006

Kelly Ording
(left)
"Kusama"
Technique: Coffee, ink and
acrylic on paper
2006

Kelly Ording
(right)
"Diamond Cutters"
Technique: Coffee and
acrylic on paper
2006

Kelly Ording
"St. Exupery"
Technique: Acrylic on paper
2006

Amy Sol
"Garden of Dormant Giants"
Technique: Acrylic on wood
2007

Amy Sol
(left)
"A Change of Wind"
Technique: Acrylic on wood
2007

Amy Sol
(right)
"Hello Sea Pony"
Technique: Acrylic on wood
2006

Amy Sol
"Dream of a Distant Cousin"
Technique: Acrylic on wood
2007

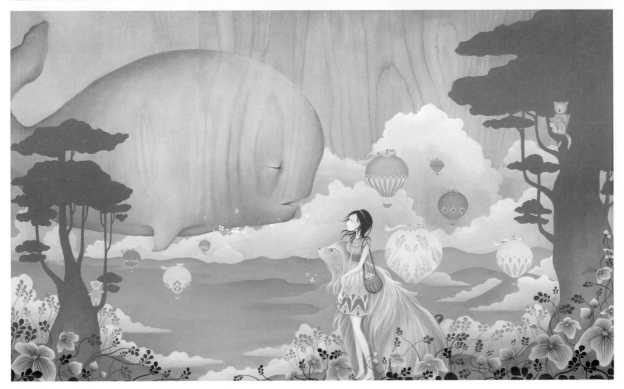

Amy Sol

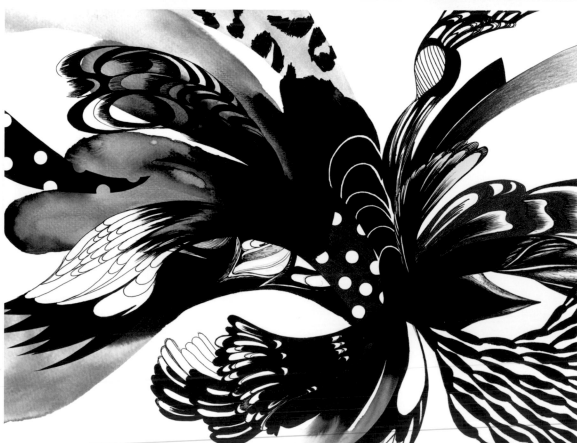

Laura Laine
Client: Make-Up Club
Concept and Design: Chris Bolton
Format: Website illustration
Technique: Hand-drawn
2006

Etsu Meusy
Technique: Computer programs
2006

Etsu Meusy
Credits: Neomu Magazine
Technique: Computer programs
2005

Etsu Meusy
Credits: Neomu Magazine
Technique: Computer programs
2003

Laura Laine
Client: Make-Up Club
Concept and Design: Chris Bolton
Format: Invitation
Technique: Hand-drawn
2006

Fuyuki
"Dragon Swing"
Client: anotherr
Credits: tezomeya X fuyuki
Technique: Analogue drawing
2007

Fuyuki
"Onigawara"
Technique: Analogue drawing
2006

Fuyuki
Client: Osaka Dining Bar
(Oidenka)
Credits: Gold Byoubu
Technique: Analogue drawing
2006

Jens Harder
(6 illustrations)
"Kamera"
Client: Illustrative 06 /
Gallery Johanssen
Credits: "Kryptozoo" —
a range of triptychs
Technique: Pen, brush, Photoshop
2006

Jens Harder
(top)
Client: Die Gestalten Verlag
Credits: Story "M.S. Found in a
Bottle" from the book POE:
Illustrated Tales of Mystery and
Imagination
Technique: Pen, brush, Photoshop
2006

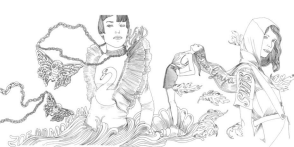

Silja Goetz
"1001 nights"
Personal piece
Technique: Pen, Photoshop
2007

Silja Goetz
"Fashion 1 & 2"
Client: WAD Magazine, France
Art Direction: Mari Pietarinen
Format: Magazine spread
Technique: Pen, Photoshop
2007

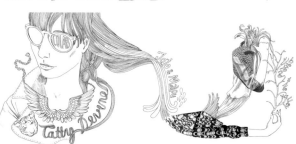

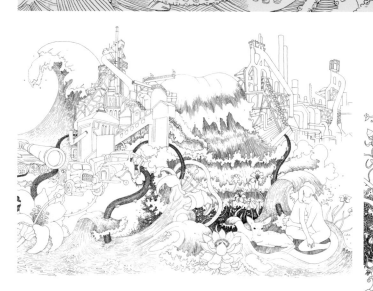

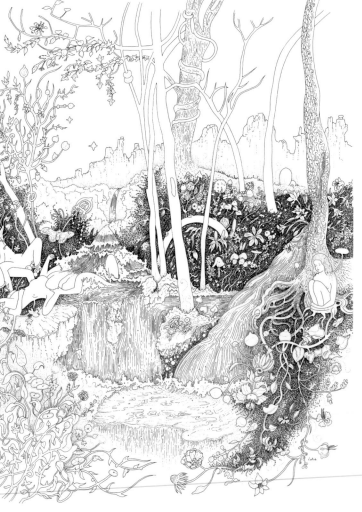

Lotie
(left)
"Refuge"
Client:
Magda Danysz Gallery, Paris
Technique: Hand-drawn,
Indian ink
2005

Lotie
(right)
"L'attente"
Personal work
Technique: Hand-drawn,
Indian ink
2005

David Bray
'Golden morning"
Client: La Perla
Format: Poster
Technique: Pen, pencil on paper
2005

David Bray
'"Good mountain 1 & 2"
Client: Gallery show at stolenspace
Technique: Pen, pencil on paper
2006

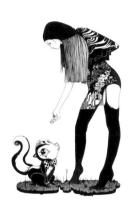 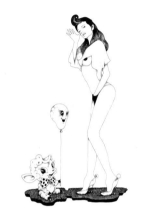

David Bray
(left)
"Limbs/phortune"
Client: Various productions
Format: 7 inch record sleeve
wraparound vars0015
Technique: Pen, pencil on paper
2007

David Bray
(right)
Personal work
Technique: Pen, pencil on paper
2007

Jen Ray
Client: Sleek Magazine
Format: Editorial
Courtesy of Jan Wentrup Galerie
Technique: Pen and ink
2006

Jen Ray
Client: Die Gestalten Verlag
Format: Illustrated story in
"POE: Illustrated Tales of Mystery
and Imagination
Technique: Pen and ink
2006

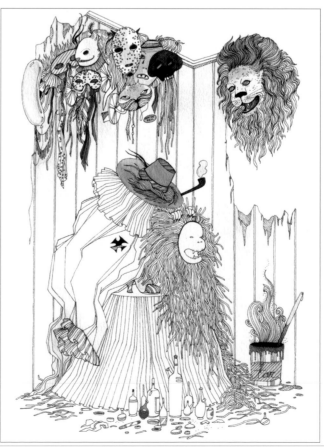

Jen Ray
(2 illustrations)
Client: Sleek Magazine
Format: Editorial
Courtesy of Jan Wentrup Galerie
Technique: Pen and ink
2006

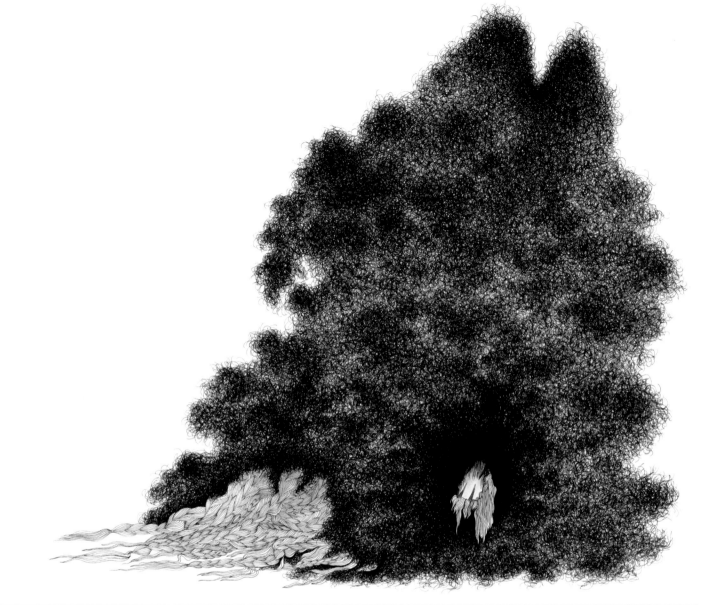

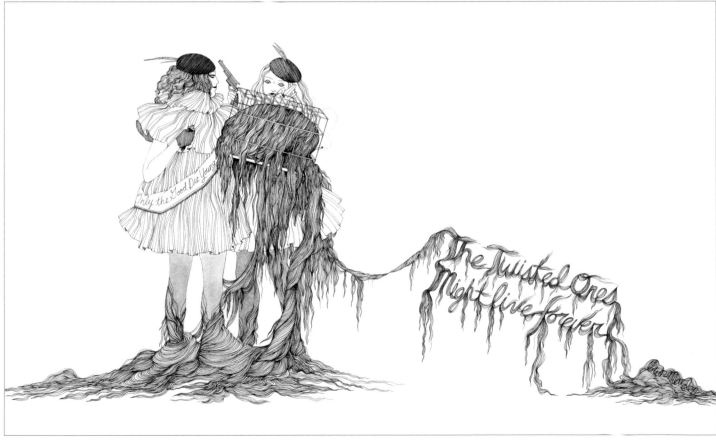

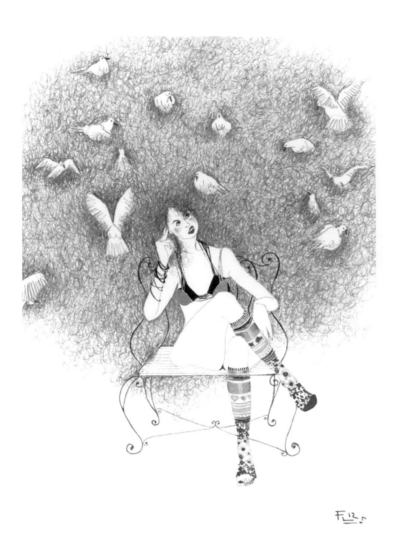

Fernanda Cohen
(left)
"Fashion Ruined My Life"
Client: Pupu Magazine
Technique: Ink and gouache
2005

Fernanda Cohen
(right)
"Rupert Everett"
Technique: Ink and gouache
2007

Fernanda Cohen
(left)
"Pasta and I"
Client: Gallery Taste of Art
Technique: Ink and gouache
2004

Fernanda Cohen
(right)
"Geo Oval"
Client: Wussmann
Technique: Ink and gouache
2005

Fernanda Cohen
(2 illustrations)
"Listen!"
Client: Gallery Dabbah Torrejon,
Buenos Aires
Technique: Ink and gouache
2007

Daniel Egneus
"Woman and deers"
Client: Heckler Associates, US
Technique: Ink, pencil, watercolour,
collage, Photoshop
2007

Daniel Egneus
(right)
"Nesting the city I"
Client: Visual research with Also
Available Architecture
Technique: Ink, watercolour,
collage, Photoshop
2006

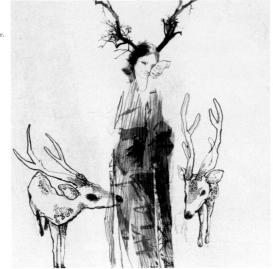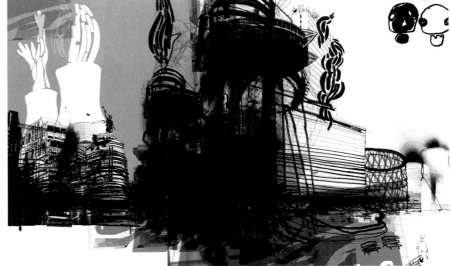

Daniel Egneus
(left)
"Safari I"
Client: Visual reserach with Also
Available Architecture
Technique: Ink, pencil, watercolour
2006

Daniel Egneus
(right)
"WSC Showroom, Tokyo"
Client: Visual research with Also
Available Architecture.
Rome, Italy
Credits: Luca Diffuse, Mariella Tesse
Technique: Ink, pencil, watercolour,
Photoshop
2006

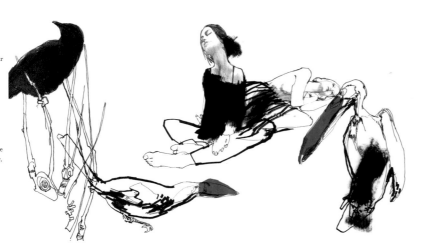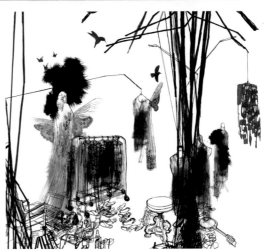

Daniel Egneus
"Women in the woods"
Technique: Pencil, ink,
Photoshop
2006

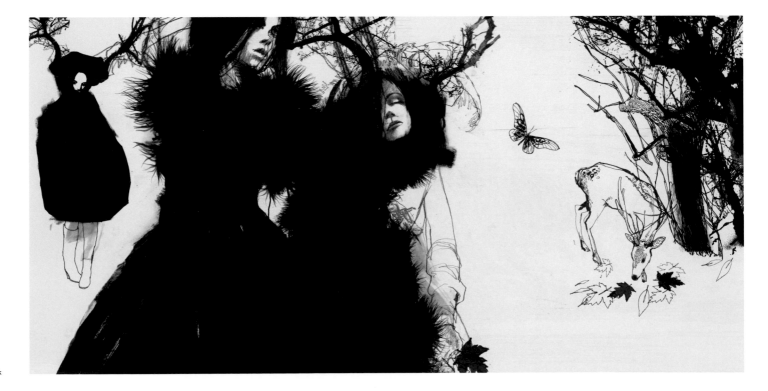

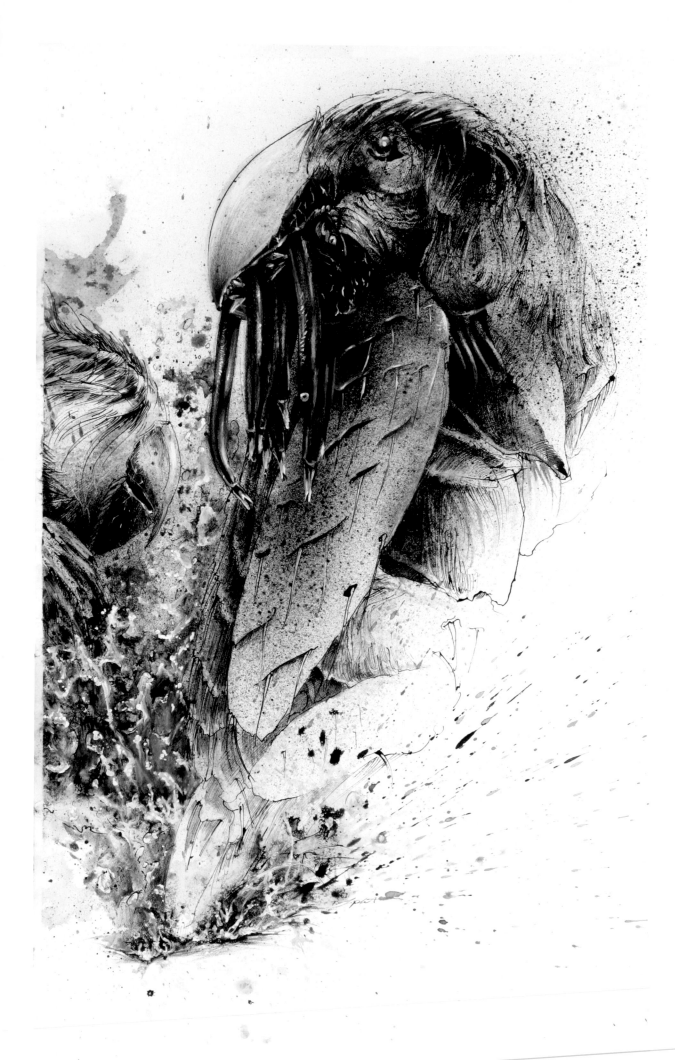

Felix Gephart
"Prey"
Series: "Bestiary"
Technique: Ink on paper
2007

Felix Gephart
"Metamorphosis"
"Vulture"
"Treasure Island"
Series: "Bestiary"
Technique: Ink on paper
2007

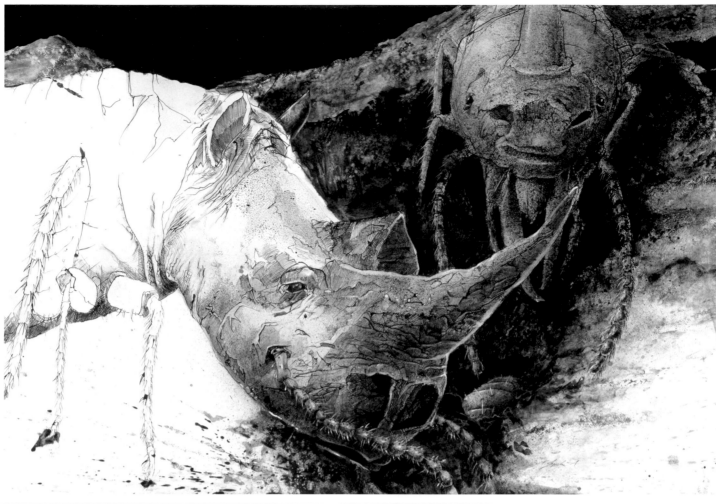

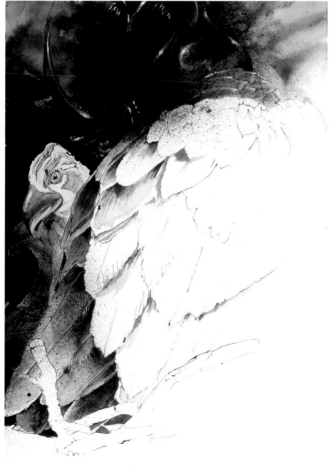

Nicholas Di Genova
"Greater Turkey-Hydra"
Format: Piece for art installation
Technique: Ink and animation
paint on mylar
2006

Nicholas Di Genova
"Bi-Faced Amphibious Fowl
with Ectoplasm"
Format: Piece for art installation
Technique: Ink and animation
paint on mylar
2006

Nicholas Di Genova
(left)
"Siamese Chicken Dogs"
Format: Piece for art installation
Technique: Ink and animation
paint on mylar
2006

Nicholas Di Genova
(right)
"Bi-Necked Amphibious Climber"
Piloted by Member
of the Series 7 Militia
Format: Piece for art installation
Technique: Ink and animation
paint on mylar
2006

Nicholas Di Genova
"Upright Shephard-Waddler"
Format: Piece for art installation
Technique: Ink and animation
paint on mylar
2006

Nicholas Di Genova
"Bi-Necked Amphobious Sentry"
Technique: Ink and animation
paint on mylar
2006

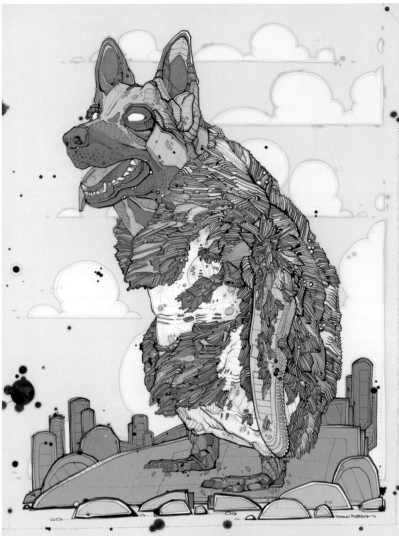

Nicholas Di Genova
(left)
"Upright Chicken Strutter"
Format: Piece for art installation
Technique: Ink and animation
paint on mylar
2006

Nicholas Di Genova
(right)
"Bi-Faced Amphibious Bull-Cock"
Format: Piece for art installation
Technique: Ink and animation
paint on mylar
2006

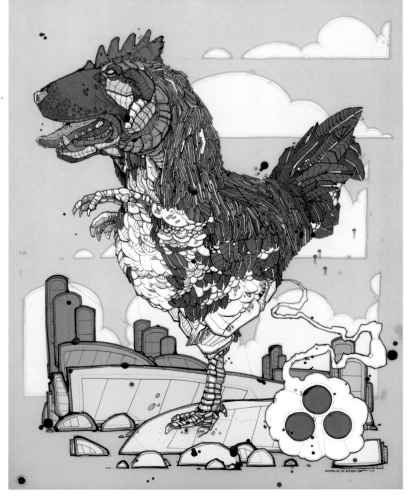

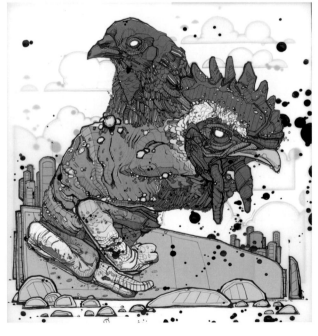

Nicholas Di Genova

Nicholas Di Genova
"The 88 Fiercest Invertebrates
in the Animal Kingdom"
Format: Image for limited
edition print
Technique: Ink on paper
2007

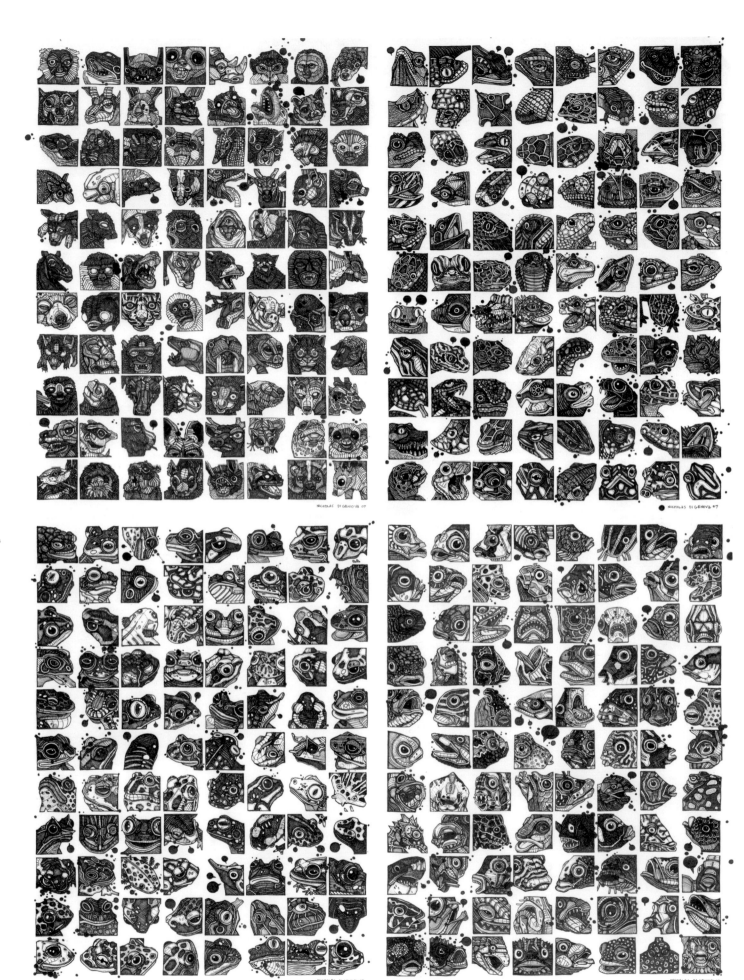

Nicholas Di Genova
(left)
"The 88 Fiercest Mammals
in the Animal Kingdom"
Format: Image for limited
edition print
Technique: Ink on paper
2007

Nicholas Di Genova
(right)
"The 88 Fiercest Reptiles
in the Animal Kingdom"
Format: Image for limited
edition print
Technique: Ink on paper
2007

Nicholas Di Genova
(left)
"The 88 Fiercest Amphibians
in the Animal Kingdom"
Format: Image for limited
edition print
Technique: Ink on paper
2007

Nicholas Di Genova
(right)
"The 88 Fiercest Fish
in the Animal Kingdom"
Format: Image for limited
edition print
Technique: Ink on paper
2007

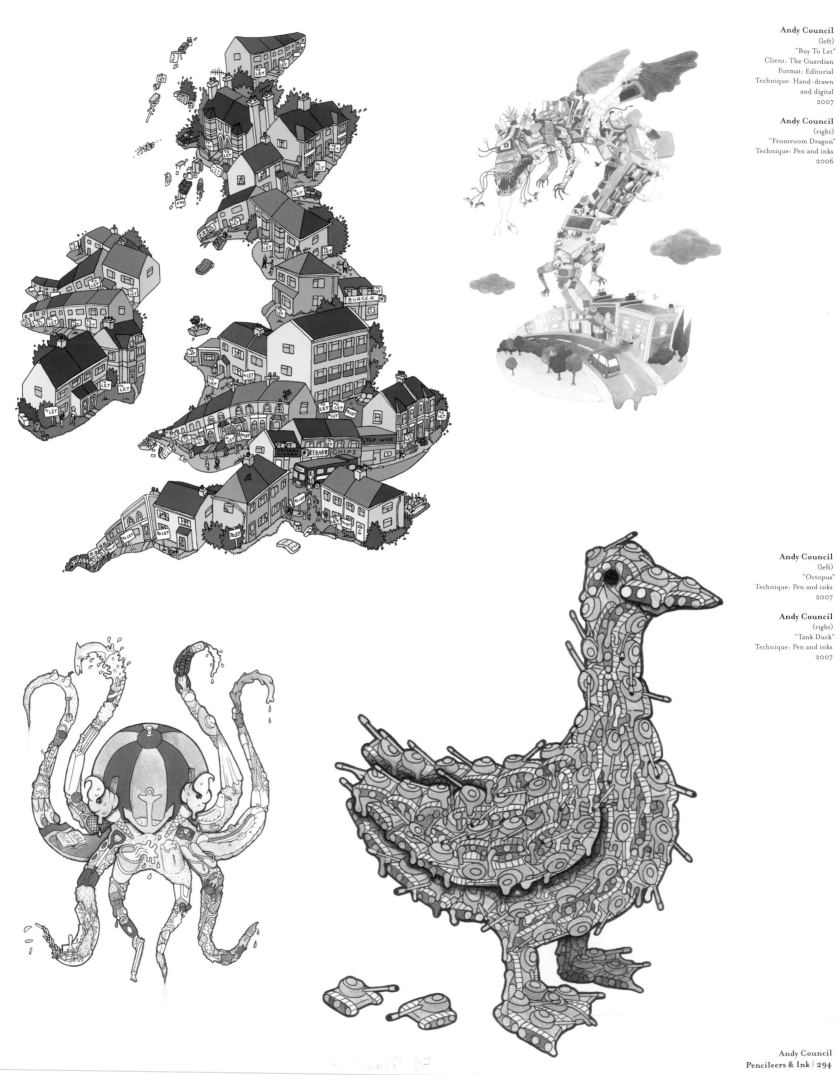

Andy Council
(left)
"Buy To Let"
Client: The Guardian
Format: Editorial
Technique: Hand-drawn
and digital
2007

Andy Council
(right)
"Frontroom Dragon"
Technique: Pen and inks
2006

Andy Council
(left)
"Octopus"
Technique: Pen and inks
2007

Andy Council
(right)
"Tank Duck"
Technique: Pen and inks
2007

Andy Council
"City Rooster"
Technique: Pen and inks
2006

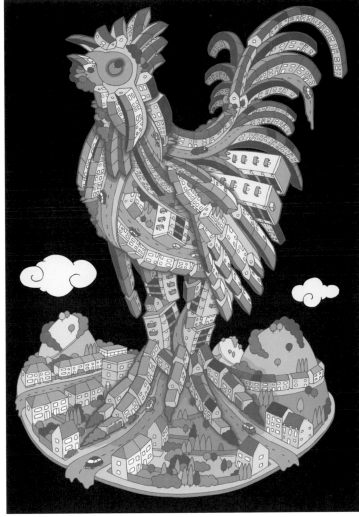

Andy Council
"Rail Rooster"
Client: Amelias Magazine
Format: Editorial
Technique: Hand-drawn
and digital
2007

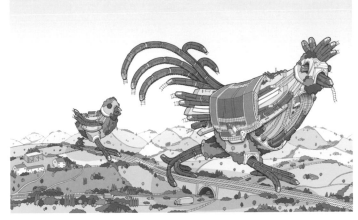

Andy Council
(left)
"Cwmbranasaurus"
Technique: Hand-drawn
and digital
2006

Andy Council
(right)
"Feversaurus"
Client: Fever Zine
Format: Editorial
Technique: Hand-drawn
and digital
2007

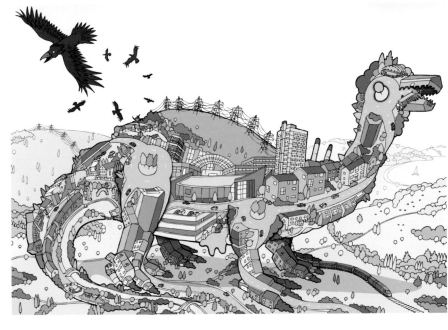

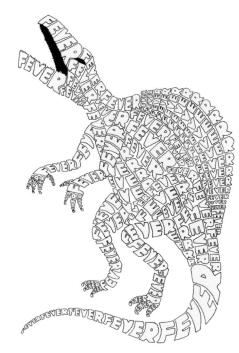

Andy Council
"Bristol Dinosaur"
Client: Decode Magazine
Format: Editorial
Technique: Hand-drawn
and digital
2004

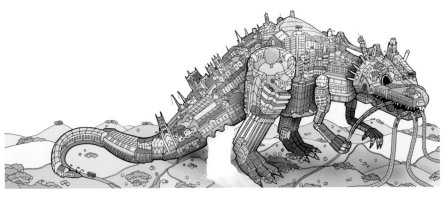

Jan Oksböl Callesen
"Networking"
Client: DJØF
Format: Editorial
Technique: Mixed media,
Photoshop
2006

Jan Oksböl Callesen
"English Studies"
Client: RUC
Technique: Mixed media,
Photoshop
2006

Jan Oksböl Callesen
A series of animal illustrations
2006

Jan Oksböl Callesen
"Astronaut"
Client: Graf Magazine
Technique: Mixed media,
Photoshop
2006

Jan Oksböl Callesen
"Paris"
Client: Graf Magazine
Technique: Mixed media,
Photoshop
2006

Jan Oksböl Callesen
A series of animal illustrations
2006

Fernando Leal
Client: V.ROM
Format: Calendar
Technique: Hand-drawn, collage,
Photoshop
2005

Fernando Leal
"Panic Syndrome"
Client: Diálogo Médico Magazine
Format: Editorial
Technique: Hand-drawn, collage,
Photoshop
2005

Fernando Leal
(left)
"Superimmune"
Client: New Scientist (UK)
Format: Editorial
Technique: Hand-drawn, collage,
Photoshop
2007

Fernando Leal
(right)
Client: V.ROM
Format: Editorial
Technique: Hand-drawn, Collage,
Photoshop
2005

Eva Mastrogiulio
"Trojan horse"
Client: Tinta Fresca – Clarin
Format: Editorial, educational book
Technique: Handmade collage and
Photoshop
2006

Eva Mastrogiulio
"Bird"
Client: Tinta Fresca – Clarin
Format: Editorial, educational book
Technique: Handmade collage and
Photoshop
2006

Eva Mastrogiulio
(left)
"The prince"
Self-promotion
Technique: Handmade collage
2005

Eva Mastrogiulio
(right)
"Spring rain"
Client: Tinta Fresca – Clarin
Format: Editorial, educational book
Technique: Handmade collage and
Photoshop
2006

Eva Mastrogiulio

Hans Baltzer
Double-page spread
from the book "Hans im Glück"
Technique: Pen, ink,
collage and Photoshop
2002

Hans Baltzer
"Mustang"
Format: Illustration from the
book "Hans im Glück"
Technique: Pen, ink and
Photoshop
2002

Hans Baltzer
(left)
"Jondear"
Free work
Technique: Pen, brush,
ink and Photoshop
2007

Hans Baltzer
(right)
"Milk & Wodka"
Client: Milk & Wodka Magazine
Technique: Pen, brush,
ink and Photoshop
2007

Tim Dinter
(left)
"Kod"
Client: Illustrative 06
Format: Exhibition piece
Technique: Screenprint
2006

Tim Dinter
(right)
"Kunststoffe"
Client: Illustrative 06
Format: Exhibition piece
Technique: Screenprint
2006

Tim Dinter
"Rosa-Luxemburg-Platz"
Client: Illustrative 06
Format: Exhibition piece
Technique: Screenprint
2006

Tim Dinter
(2 illustrations)
Client: OCÉ
Technique: Fine liner
2006

Tim Dinter
301 | Pencileers & Ink

Apfel Zet
"Overhead Trafficways"
Designer: Roman Bittner
Client: Illustrative 06
Technique: Freehand
2006

Apfel Zet
"B-2"
Designer: Roman Bittner
Client: Illustrative 06
Technique: Freehand
2007

Apfel Zet
"Fresh Up"
Designer: Roman Bittner
Client: Illustrative 06
Format: Poster
Technique: Freehand
2007

Espira
(left)
"Svaghet"
Format: Art print
Technique: Photoshop
2007

Espira
"Pressed precious"
Format: Art print
Technique: Photoshop
2007

Espira
"Undvika"
Format: Art print
Technique: Photoshop
2007

Espira
(right)
"1939"
Format: Art print
Technique: Photoshop
2006

Espira
"Crucifixion (the hunter gets
captured by the game)"
Format: Art print
Technique: Photoshop
2006

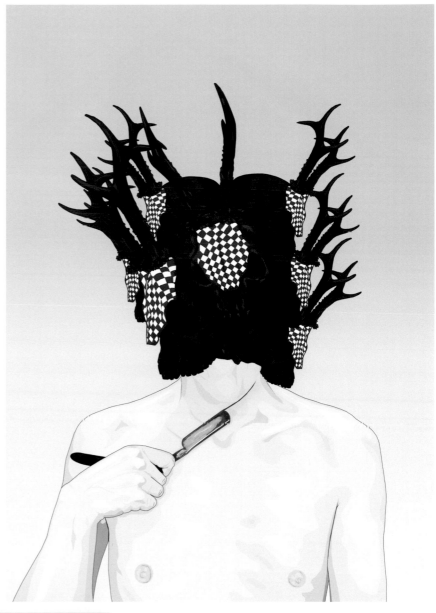

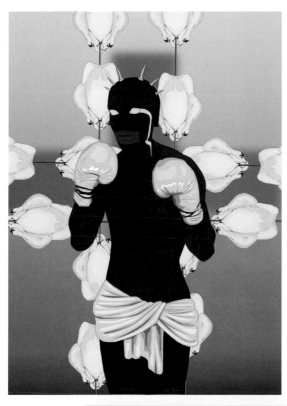

Espira
"Suffragette"
Format: Art print
Technique: Photoshop
2006

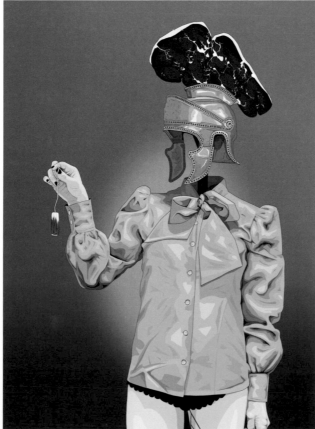

Benjamin Güdel
(2 illustrations)
Client: Carhartt Europe
Art Director: Oliver Drewes,
Work in Progress, Düsseldorf
Technique: Mixed media
2006

Benjamin Güdel
(3 illustrations)
Client: Die Weltwoche
Format: Editorial, movie news
Technique: Mixed media
2006

Interview Casarramona

Michel Casarramona is a Zurich-based illustrator, graphic designer and silkscreen specialist. Hailed for his contributions to the popular tome "The Art of Modern Rock", his iconic images of glorious old-fashioned pin-ups for the unwashed masses have become firmly entrenched in the annals of music history and seminal poster design. Casarramona has done work for bands from punk rock icons The Mekons to the unforgettable splatterfest of cabaret metal act GWAR. His striking depictions of camp birds, cool chicks and rough rockers join hand-lettered retro typefaces inspired by the 1950s and 60s to give an inimitable, faux-authentic look behind the scenes of luscious burlesque youth rebellion and outsider cool.

Background

Although I have always enjoyed drawing, even more so now than in my youth, I was never really addicted to it. My initial interest was probably sparked by classic cartoons—from Spiderman, Batman and Superman to Donald Duck, Tintin and Lucky Luke… The posters started with a string of concerts in the late 1980s, gigs in squats that I organised and promoted with my own flyers and posters. Naturally, we had to make do with the cheapest method, i.e. black and white photocopies.

A few years later, I decided to learn the ropes of graphic design at an applied arts college and a four-year apprenticeship. In the early 1990s came my first official commission, a concert poster for LUV, a Zurich-based music club. The resulting collaboration has lasted to this day, although the club itself no longer exists.

Inspiration and Influences

Although it was my love of cartoons that encouraged me to pick up the pen in the first place, I soon realised that I would never be able to muster the necessary patience or ambition to draw an entire comic book. There was always this distinct sense of joy and relief when I had finished a frame and could start on a new illustration. Also, Raymond Pettibon made a strong impression. I first came across his work on a Black Flag album cover. Further influences include people like José Muñoz, Lorenzo Mattotti, Charles Burns, Frank Frazetta, Daniel Clowes, Dave Cooper and Tim Biskup. I also draw a lot of inspiration from cartoon classics like Bugs Bunny, the Pink Panther and Tex Avery as well as traditional paintings by the likes of Toulouse-Lautrec, Hodler, Schiele, Klimt, Monet and Valloton or graphics and illustrations from the 1950s, 60s and 70s (e.g. René Gruau, Norman Rockwell, Jim Flora and Robert McGinnis).

Skills and Techniques

Before I start on a new illustration or draft graphic, I spend hours, even days, on assembling the visual source material. To this end, I scour my huge digital archive, a wealth of material accumulated over the last couple of years, as well as books and magazines reaching back to the 1960s. Some of these inspirations determine the overall framework, i.e. elements like technique, colour scheme and style. Others shape the objects or figures depicted, e.g. props, fashion or typography. All of this is mixed up with my own imagination and knack for turning it all into one coherent whole.

Nowadays, the pencil has become my most trusty tool. Hovering over the light table, I find myself sketching and re-sketching promising drafts until I have a working template, which I then photocopy and return to the light table for further revisions. These illustrations are later coloured in on a separate layer with the aid of an applicator. Alternatively, I use the computer to overlay the scanned drawings with vectorised sections of colour. I guess my approach is a little old-fashioned because my apprenticeship did not involve any computers.

Featured Works

The images assembled here make up an important part of my recent work. The apparent nostalgia stems from my choice of templates; I simply care less about modern graphics. In my opinion, the advent of computerisation has had a detrimental effect on the overall skills and knowledge in graphic design—and I don't mean this in judgement, but rather as an observation. When it comes down to it, I care less about the silkscreen process per se and more about the resulting colour schemes. Often enough, overprinting allows underlying layers to shine through, creating new shades in the process. Fortunately, I know an amazing printing expert who can be trusted to solve all of my silkscreen-related problems…

Casarramona
"10 Jahre Saus & Braus"
Client: Saus & Braus
Format: Poster
Technique: Pencil
2006

Casarramona
"Celtic Frost at the Mascotte"
Client: Celtic Frost
Format: Poster
Technique: Pencil
2007

Casarramona
(left)
"Burlesque Angelina Santos"
Client: Mata Hari Bar Zürich
Format: Poster
Technique: Pencil
2005

Casarramona
(right)
"Burlesque Felicity Lafortune"
Client: Mata Hari Bar Zürich
Format: Poster
Technique: Pencil
2005

Casarramona
(left)
"Burlesque Katyusha Marx"
Client: Mata Hari Bar Zürich
Format: Poster
Technique: Pencil
2005

Casarramona
(right)
"Gwar"
Client: Grabenhalle St. Gallen
Format: Poster
Technique: Pencil and brush
2007

Casarramona
"Stolze Open Air Zürich 2007"
Client: Stolzewiese
Open Air Zürich
Format: Poster
Technique: Pencil and brush
2007

Casarramona
"Super Bowl Zürich 2006"
Client: Super Bowl Zürich
Format: Poster
Technique: Brush and pencil
2006

Casarramona
(left)
"The Albin Horror Picture Show"
Client: Albin Snowboards
Format: Poster
Technique: Pencil
2007

Casarramona
(right)
"Super Bowl Zürich 2005"
Client: Super Bowl Zürich
Format: Poster
Technique: Pencil
2005

Casarramona
"Blue Grass Boogiemen 2007"
Client: Helsinki Klub, Zürich
Format: Poster
Technique: Pencil
2007

Casarramona
"Wordless Love"
Client:
"Wordless" street art exhibition
Format: Poster
Technique: Lithography
2005

Casarramona
(left)
"The Sadies" in Switzerland
Client: Various clubs
Format: Poster
Technique: Pencil
2007

Casarramona
(right)
"Blue Grass Boogiemen 2006"
Client: Helsinki Klub, Zürich
Format: Poster
Technique: Pencil
2006

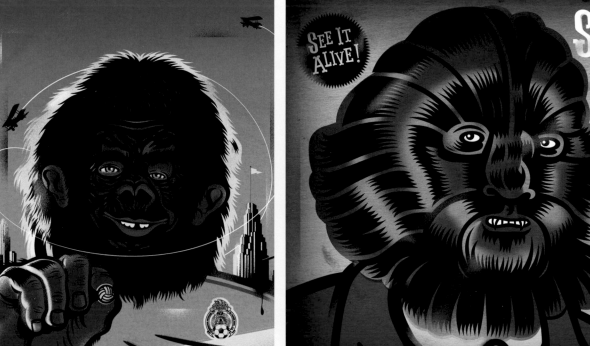

Dr. Alderete
"Mordida"
Client: Grijalbo
Art Direction: Renato Aranda
Format: Editorial
Technique: Hand-drawn,
CorelDRAW, Photoshop
2007

Dr. Alderete
"Police Dog"
Client: Grijalbo
Art Direction: Renato Aranda
Format: Editorial
Technique: Hand-drawn,
CorelDRAW, Photoshop
2007

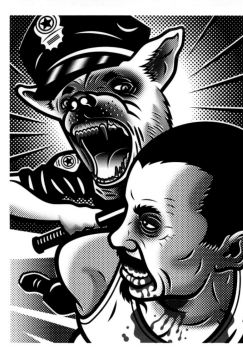
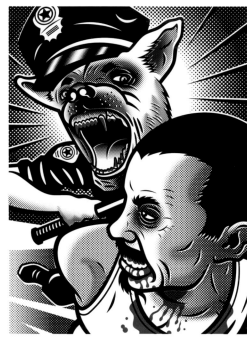

Dr. Alderete
(left)
"Mad Kong"
Client: Mad Magazine
Format: Magazine cover
Technique: Hand-drawn,
CorelDRAW, Photoshop
2006

Dr. Alderete
(right)
"Spike, the dog faced man"
Client: Luan Mart
Format: Art exhibition
Technique: CorelDRAW,
Photoshop
2005

Gary Taxali
"Portrait of Orson Wells"
Client: Entertainment Weekly
Format: Editorial
Technique: Mixed media
2006

Gary Taxali
"Save The Boreal"
Client: Greenpeace
Format: Archival print
Technique: Mixed media
2006

Gary Taxali
(left)
"Curb Your Enthusiasm"
Client: Men's Health Magazine
Format: Editorial
Technique: Mixed media
2006

Gary Taxali
(middle)
"Change Coin"
Client: Blue Q
Format: Grocery bag
Technique: Mixed media
2006

Gary Taxali
(right)
"Masturbation (After)"
Client: Men's Health Magazine
Format: Editorial
Technique: Mixed media
2005

Gary Taxali

The Heads of State
"The Future of Education"
Client: Ohio State
Alumni Magazine
Credits: Dusty Summers
Technique: Hand-drawn
with digital elements
2007

The Heads of State
(right)
"Negotiating"
Client: Decisions
Credits: Dusty Summers
Technique: Hand-drawn and
digital collage
2007

The Heads of State
(left)
"Globalizing Biotech"
Client: Journal of Life Sciences
Credits: Dusty Summers,
Jason Kernevich
Technique: Collage
2007

The Heads of State
(right)
"Micromanaging"
Client: American Spirit
Credits: Dusty Summers
Technique: Collage
2006

The Heads of State
"Using Social Networking"
Client: Convene
Credits: Dusty Summers
Technique: Hand-drawn
with digital elements
2007

The Heads of State
"Violence in the Office"
Client: McKinsey Quarterly
Credits: Dusty Summers,
Jason Kernevich
Technique: Hand-drawn
with digital elements
2007

The Heads of State
(left)
"Nerdcore"
Client: Esquire
Credits: Dusty Summers
Technique: Hand-drawn
and collage
2007

The Heads of State
(right)
"NYT 1"
Client: The New York Times
Book Review
Credits: Dusty Summers
Technique: Hand-drawn
with digital elements
2007

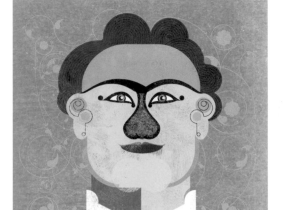

Mehdi Mahdavikia

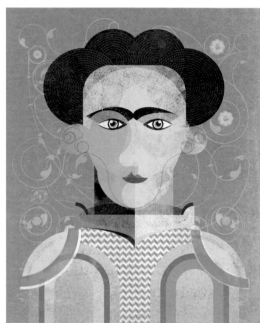

Ebrahim Mirzapour

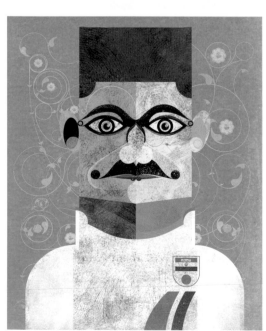

Ali Daei

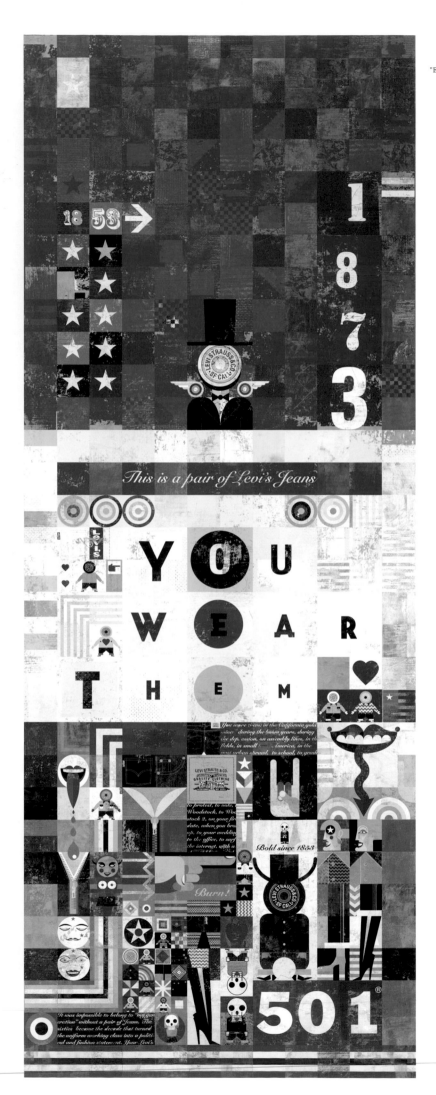

Christian Montenegro
(left)
"Melhi Madhdavikia" (top)
"Ebrahim Mirzapour" (middle)
"Ali Daei" (bottom)
Client: Ashi & Jerzovskaja
Format: Editorial
Technique: Digital
2005

Christian Montenegro
(right)
"You wear them"
Client: Levi's
Format: Mural
Technique: Digital
2006

Christian Montenegro
"My Generation"
Client: Levi's
Format: Mural
Technique: Digital
2006

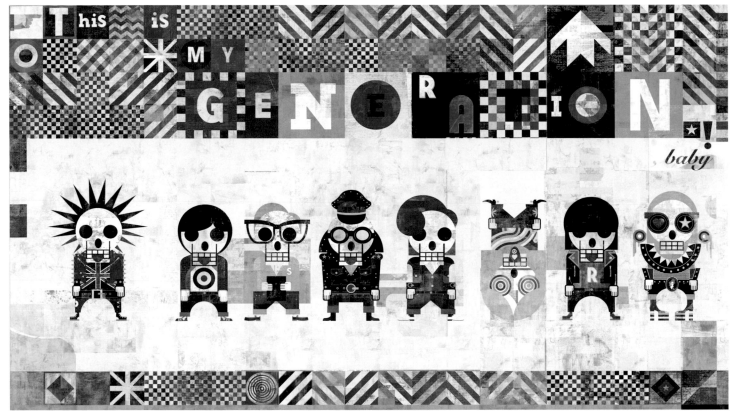

Christian Montenegro
"Arrogance" (left)
"Envy" (right)
Client: Grin and Shein Haus
Format: Editorial
Technique: Digital
2007

Christian Montenegro
(middle)
Client: The Guardian
Format: Newspaper
Technique: Digital
2006

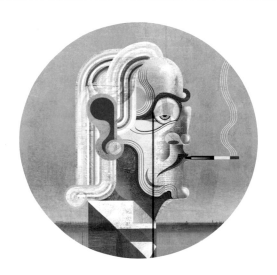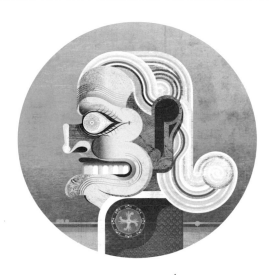

Christian Montenegro
"Oriental Landscape"
Client: Alice & Sens Design Ltd
Format: Textil design
Technique: digital
2007

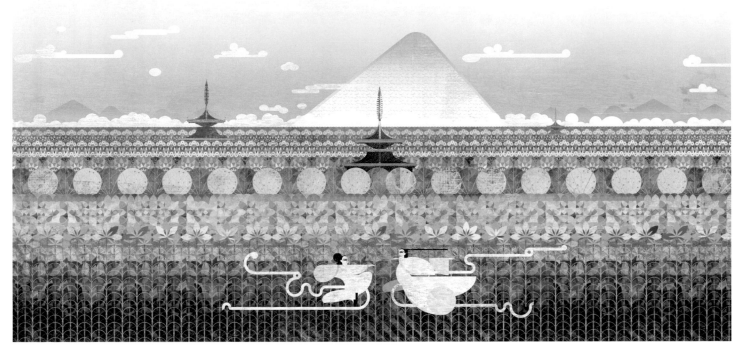

Christian Montenegro

Illusive 2 – Contemporary Illustration and its Context

Edited by Robert Klanten and Hendrik Hellige
Project Management & Art Direction: Hendrik Hellige for Gestalten · Layout Assistance: Hans Baltzer for Gestalten · Production Management: Vinzenz Geppert for Gestalten
Cover Graphics: Niels Zimmermann @ Mutabor Design · Art Direction: Robert Klanten, Hendrik Hellige
Chapter Introductions & Interviews: Sonja Commentz · Preface: Claudia Mareis · Proofreading: Helga Beck for Gestalten
Printed by C&C Offset, China

Published by Gestalten, Berlin 2009
ISBN: 978-3-89955-191-4
3rd printing, 2009

Bibliographic information published by Die Deutsche Bibliothek: Die Deutsche Bibliothek lists this publication in the Deutsche Nationalbibliografie; detailed bibliographic data is available on the internet at http://dnb.ddb.de.

Respect copyright, encourage creativity!

For more information please check www.gestalten.com

None of the content in this book was published in exchange for payment by commercial parties or designers; Gestalten selected all included work based solely on its artistic merit.

This book has been printed on FSC certified paper. It has also been printed according to the internationally accepted ISO 14001:2004 standards for environmental protection, which specify requirements for an environmental management system.

Mixed Sources
Product group from well-managed forests, controlled sources and recycled wood or fiber
www.fsc.org Cert no. SGS-COC-003548
© 1996 Forest Stewardship Council

Gestalten is a climate neutral company and so are our products. We collaborate with the non-profit carbon offset provider myclimate (www.myclimate.org) to neutralize the company's carbon footprint produced through our worldwide business activities by investing in projects that reduce CO_2 emissions (www.gestalten.com/myclimate).

myclimate
Protect our planet